DOMICILIUM
DECORATUS

DOMICILIUM DECORATUS

Photography by Grey Crawford and Mark Edward Harris

KELLY WEARSTLER

HILLCREST ESTATE
BEVERLY HILLS, CALIFORNIA

ReganBooks
An Imprint of HarperCollinsPublishers

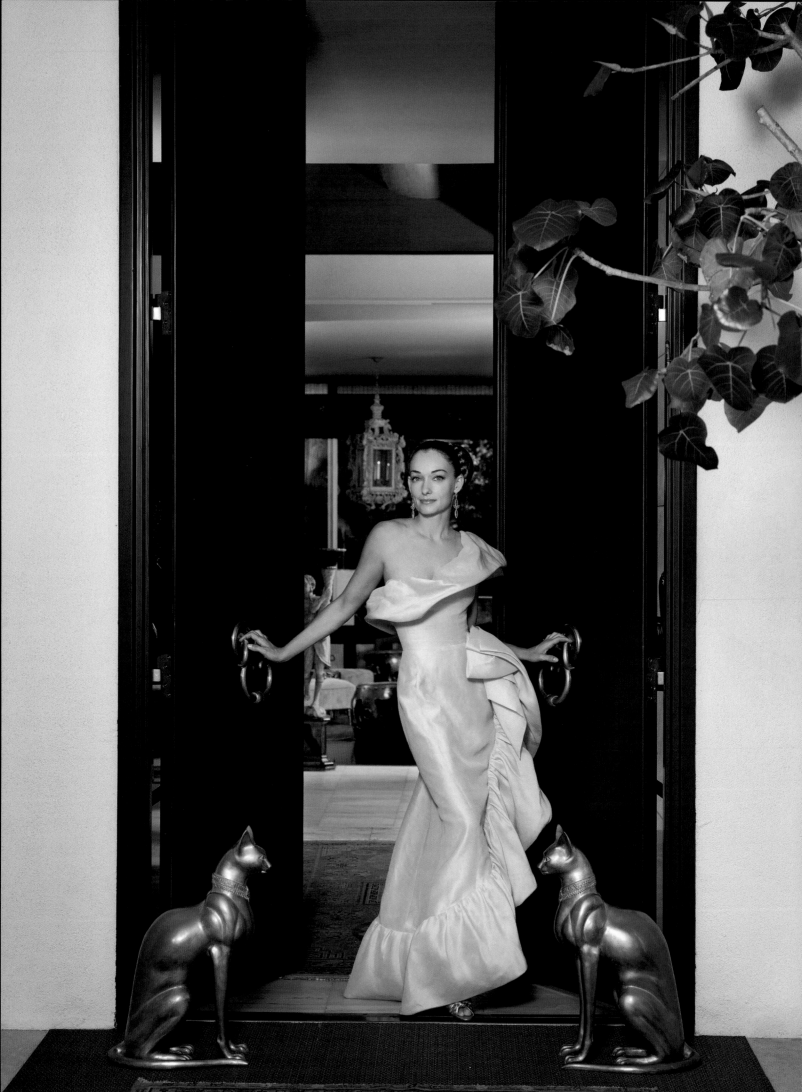

WELCOME

Like so many living things, the home is a many-layered being that becomes more and more beautiful as its elements and experiences grow. No creative project in my life so far has revealed this quite as poignantly as my family's residence, the Hillcrest Estate.

Though its sleek modern frame, relaxed floor plan, and poised design might suggest otherwise, its transformation challenged and charged me to the core. The property's unreserved scale—14-foot ceilings and windows, disparate spaces that melt together, landscapes unmistakable through walls of glass, and roomscapes visible from terraces and gardens—inspired grandeur, but could have invited severity. Its décor and effects—collected over several years and five continents—needed loving placement within the rooms and meaningful dialogue with each other. And its residents—my husband, Brad; sons, Oliver and Elliott; dog, Brea; and myself, dizzied by a succession of interim residences—craved a home both toddler-safe and visually sophisticated.

I found the key to Hillcrest, to making it warm and rich, in layers. Adding surfaces and textures and facets until every space felt exquisite and personal, it grew to become our own domicilium decoratus: a home beautified for living.

Kelly Wearstler

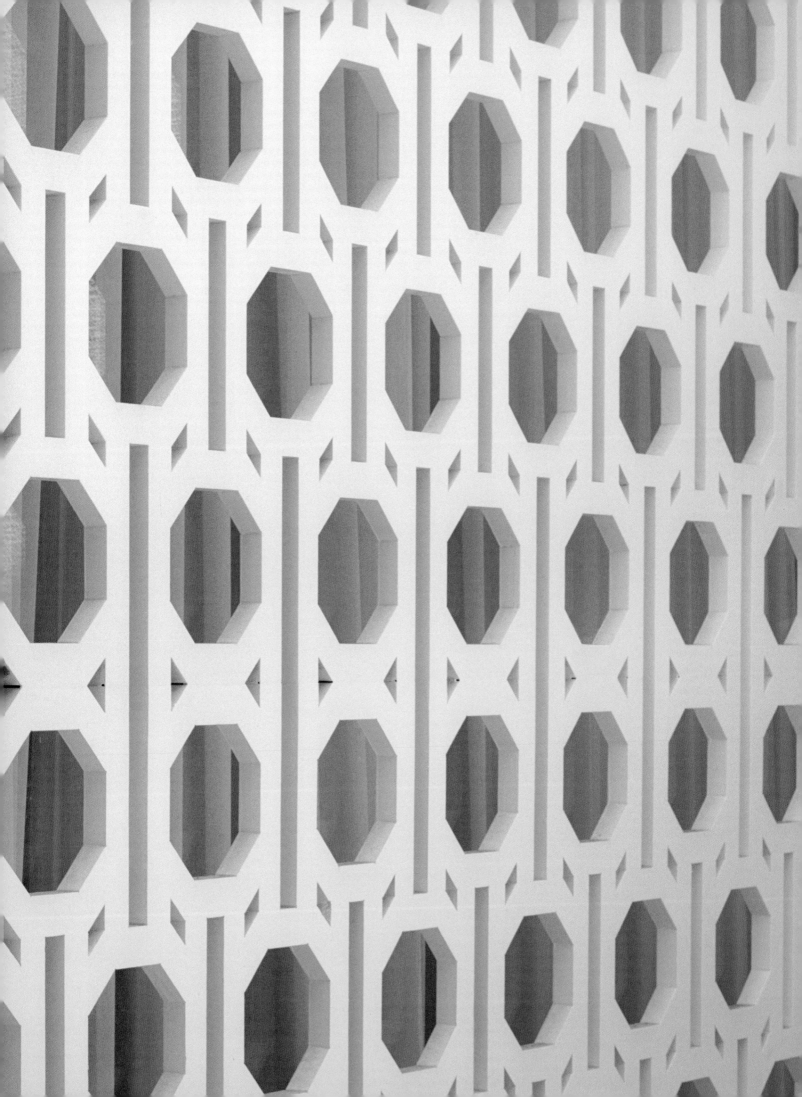

ENTRY VESTIBULE

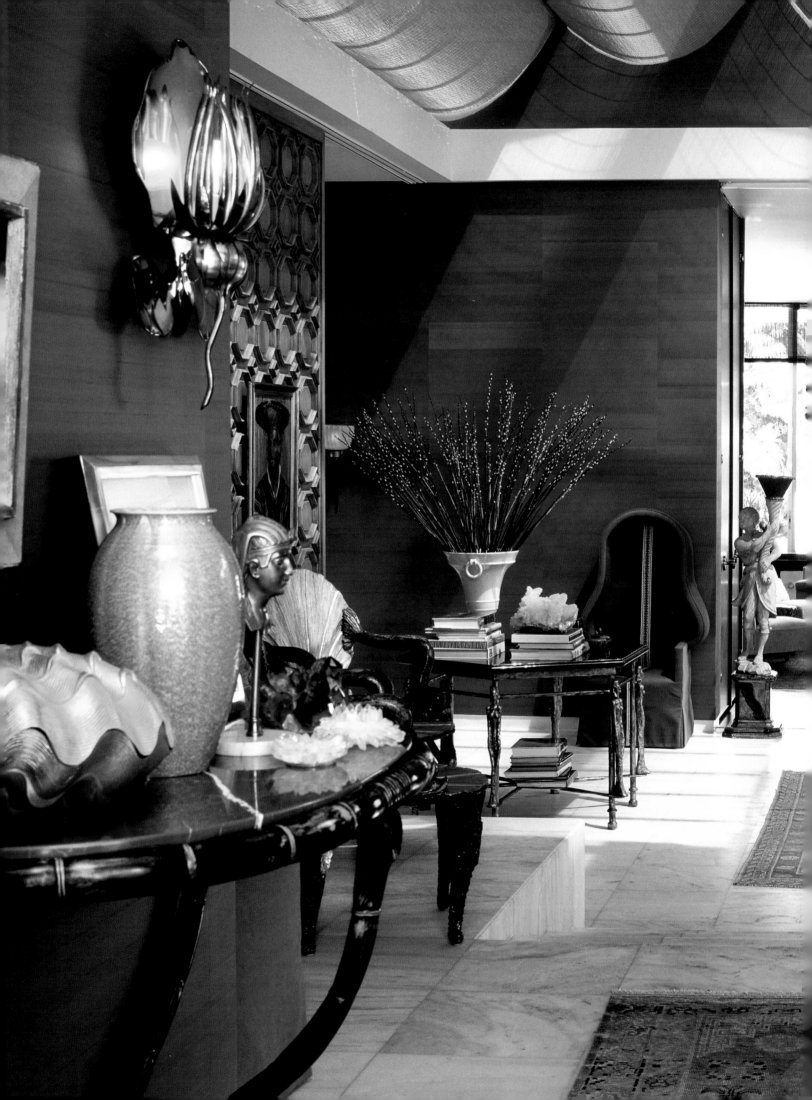

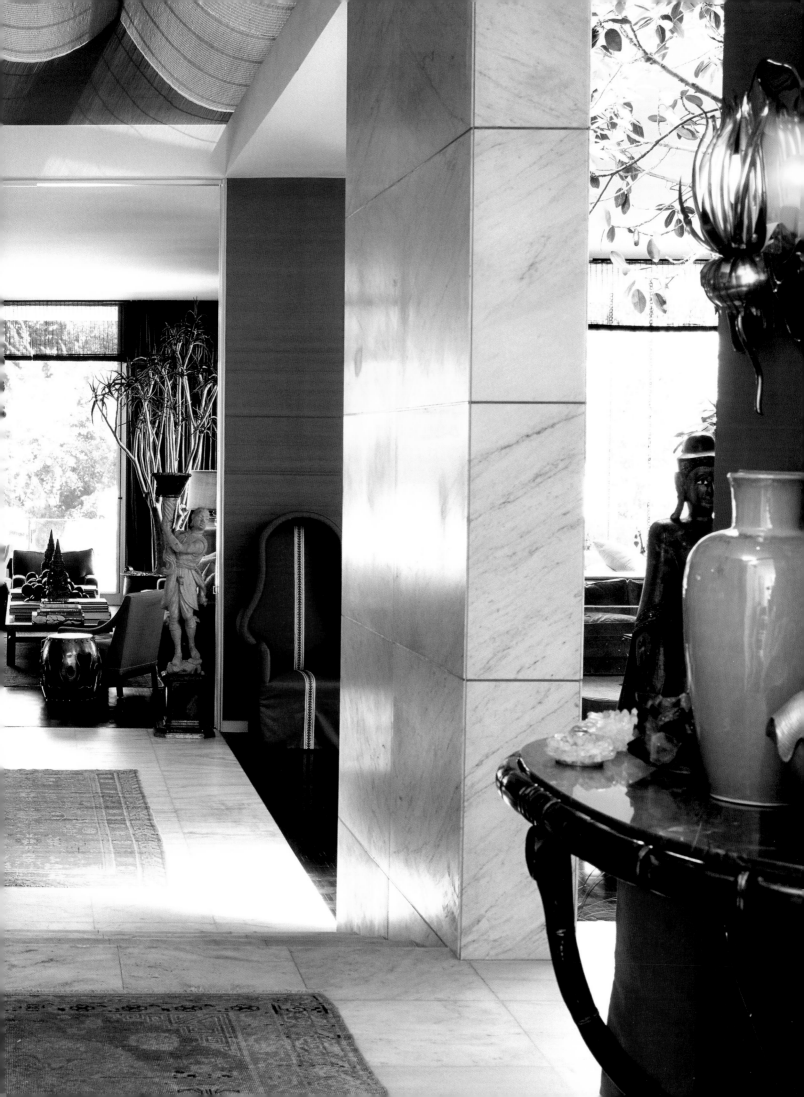

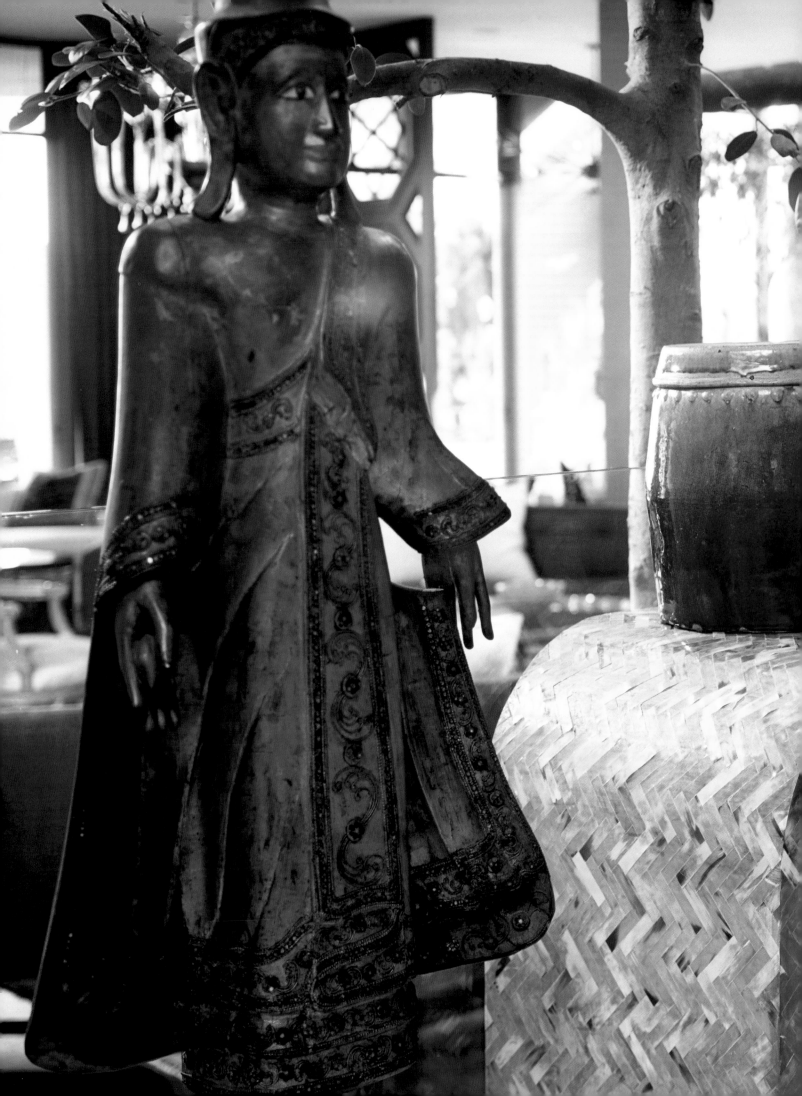

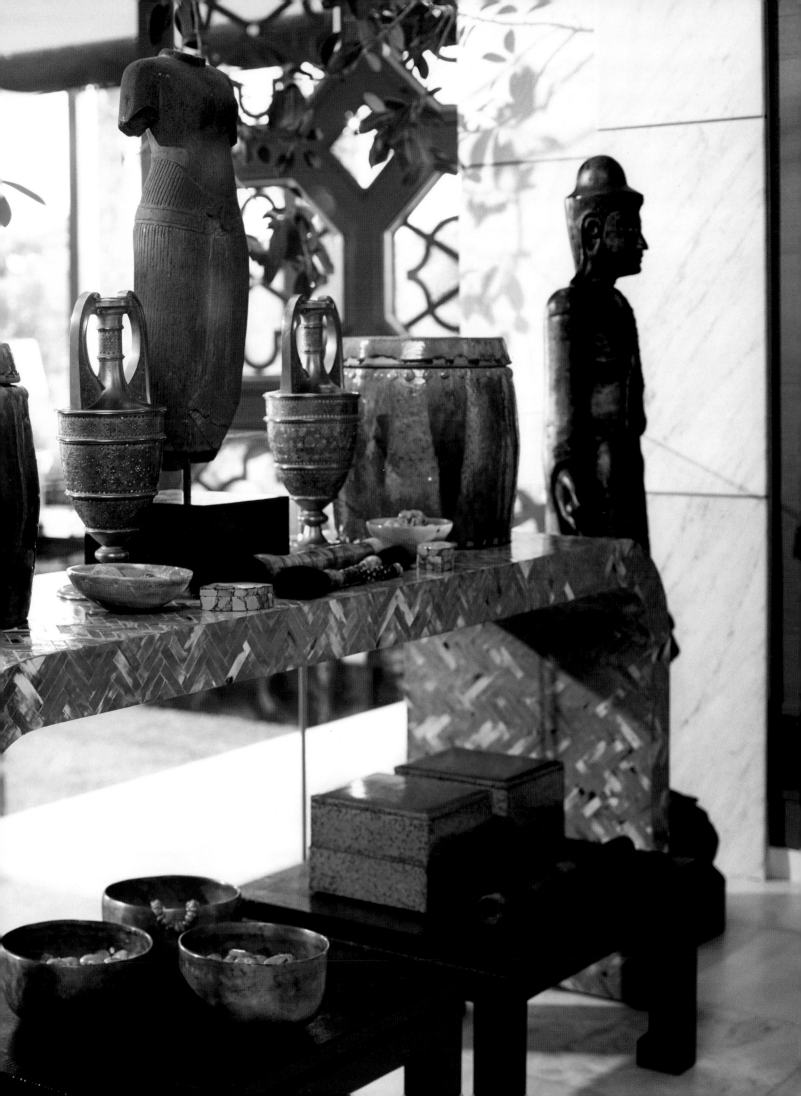

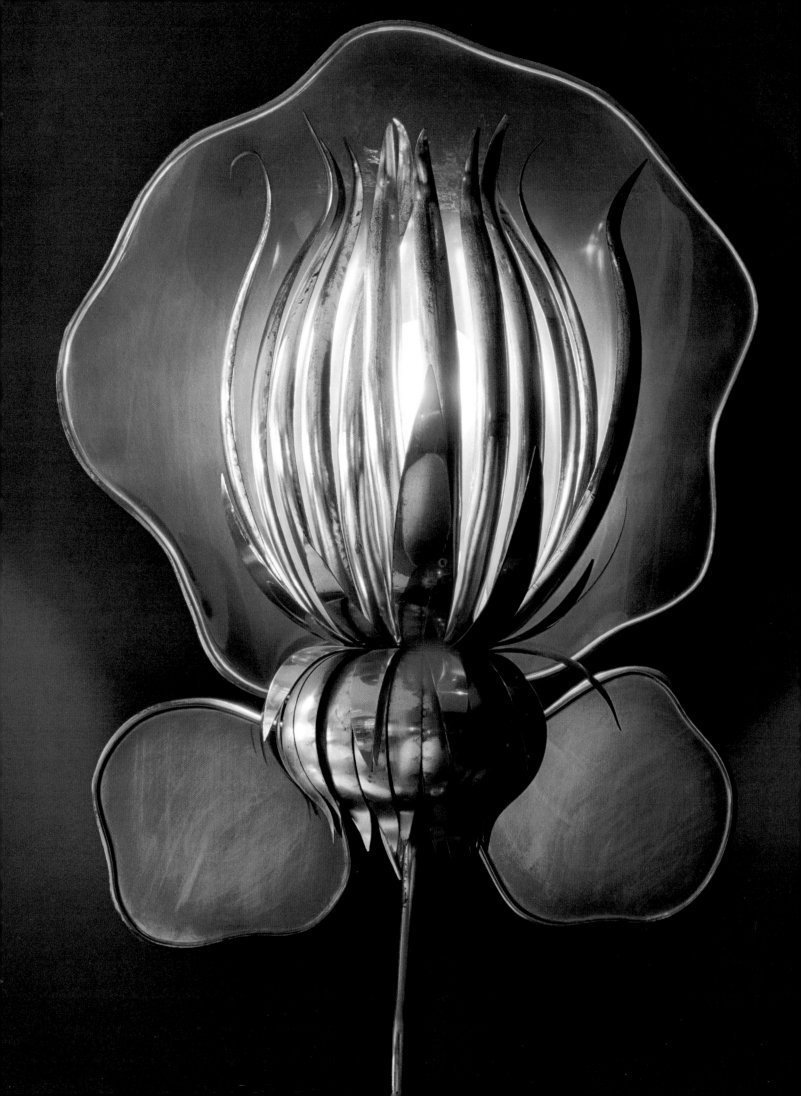

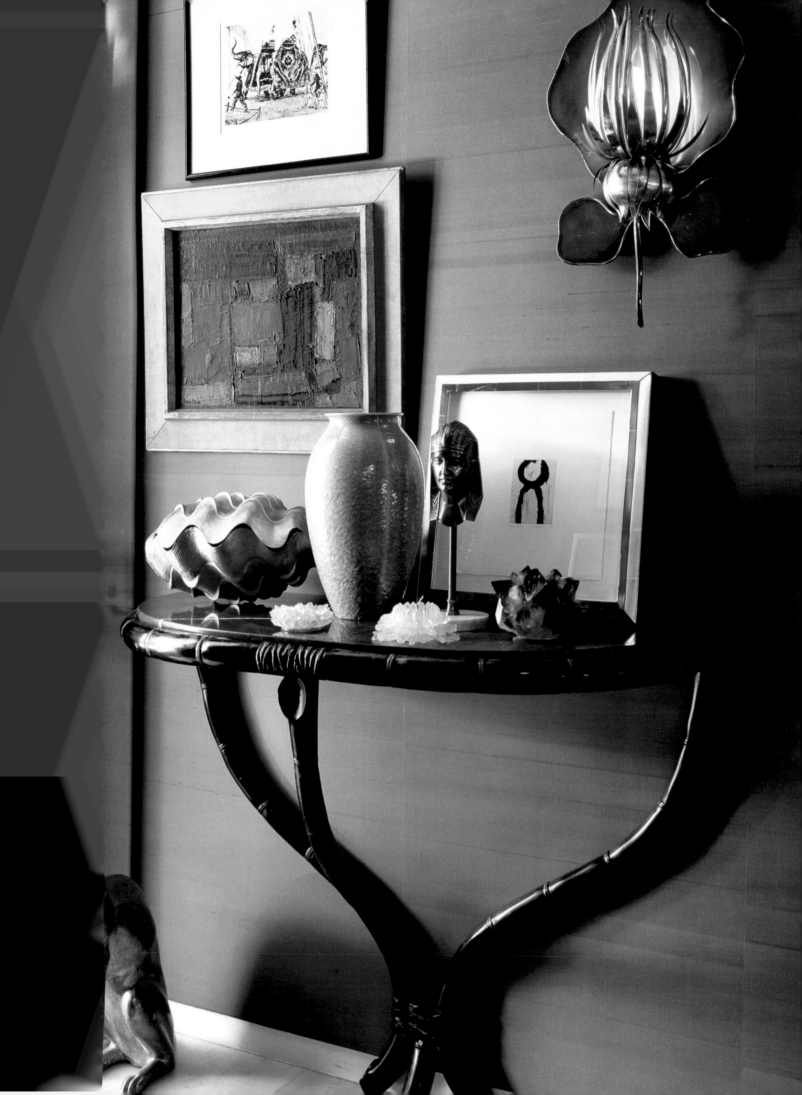

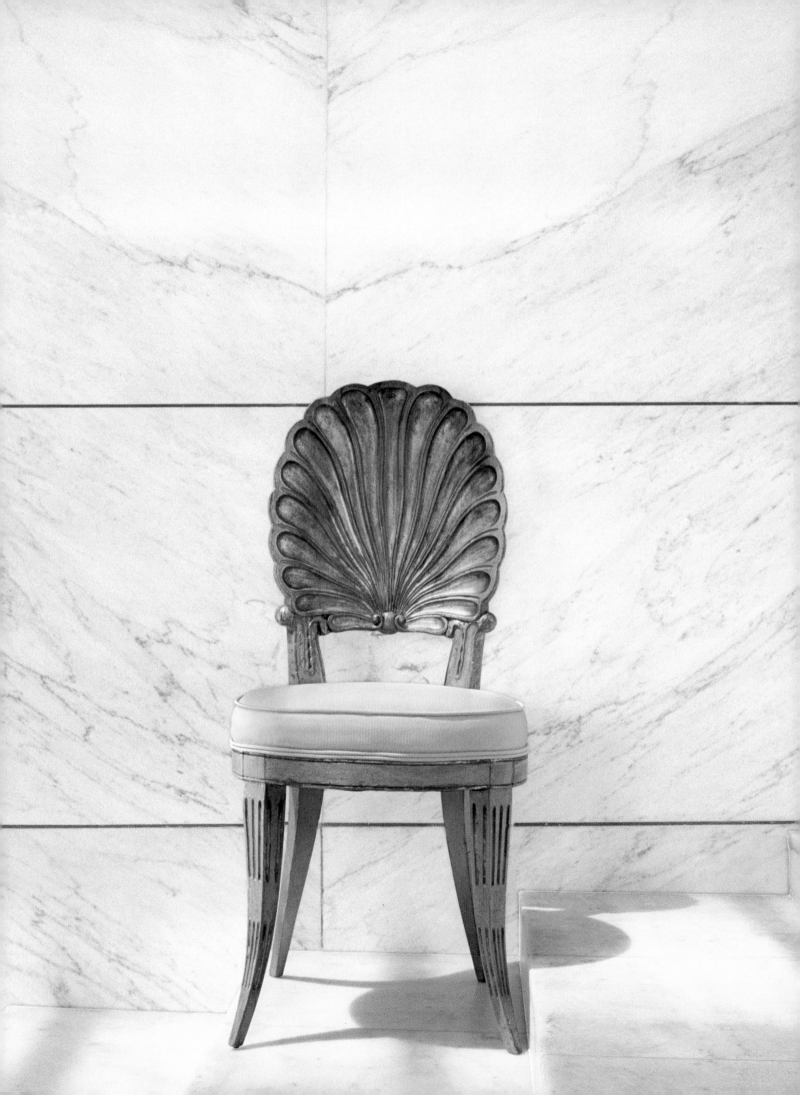

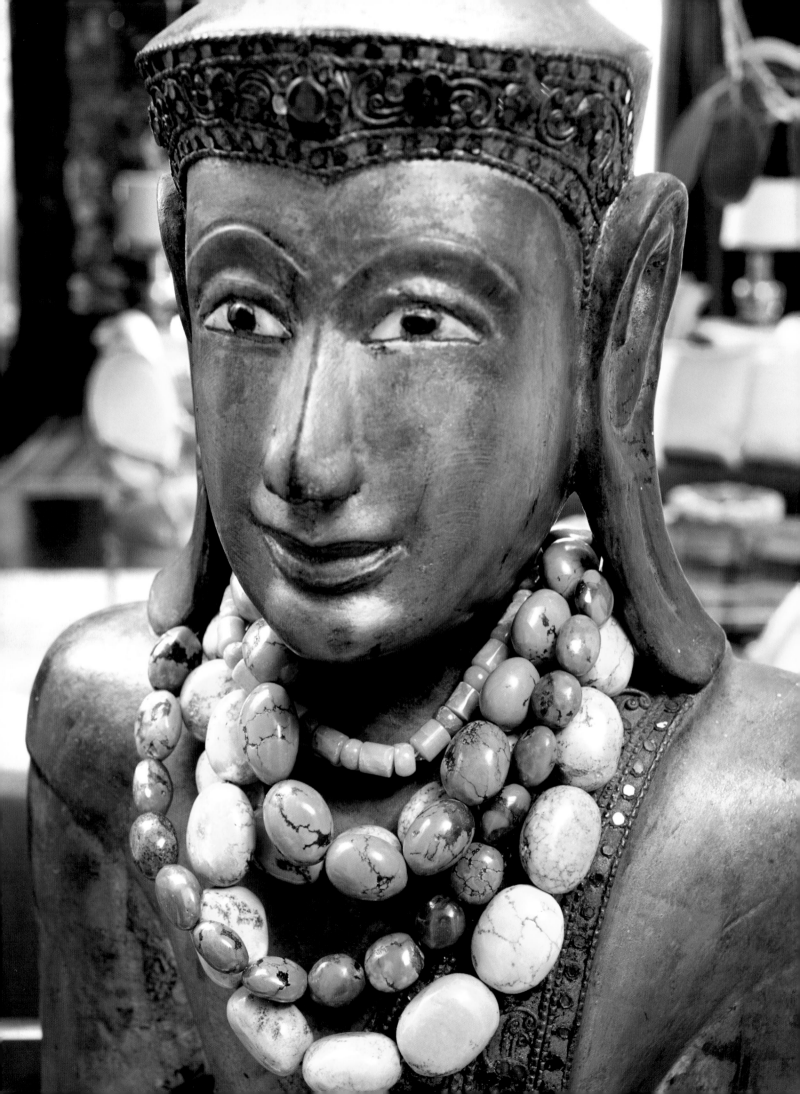

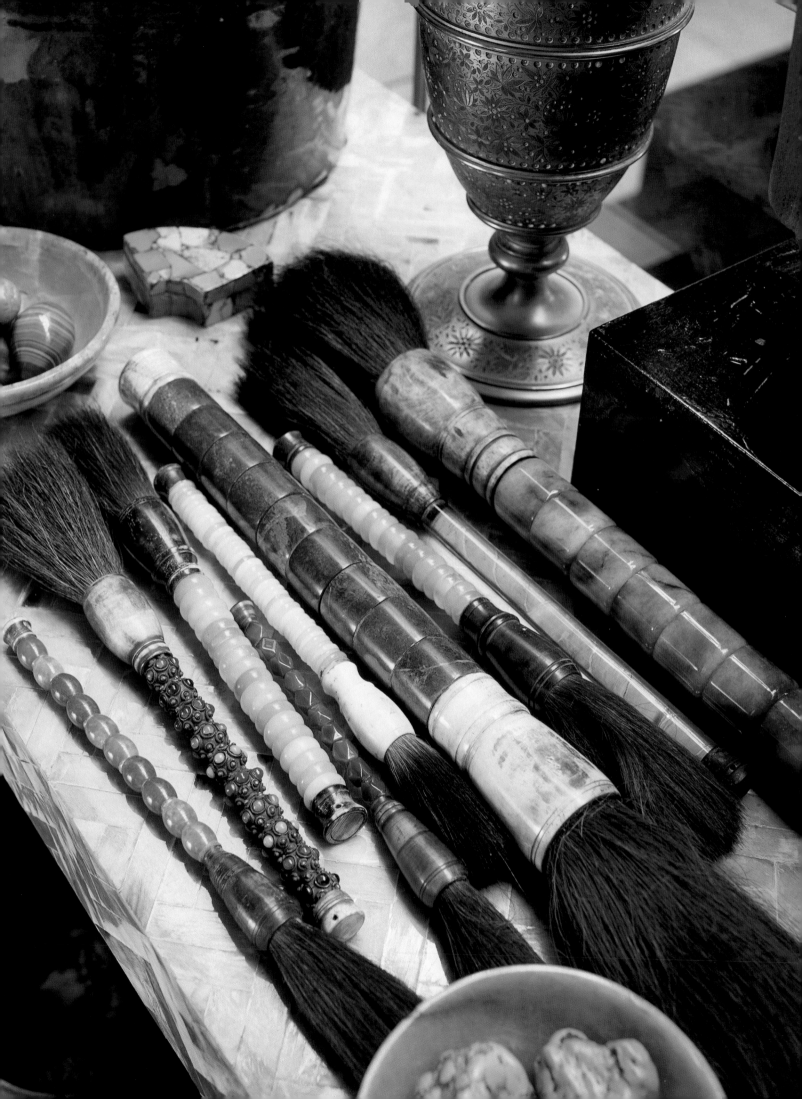

Our own giving tree, sheltering and enlivening the heart of the house.

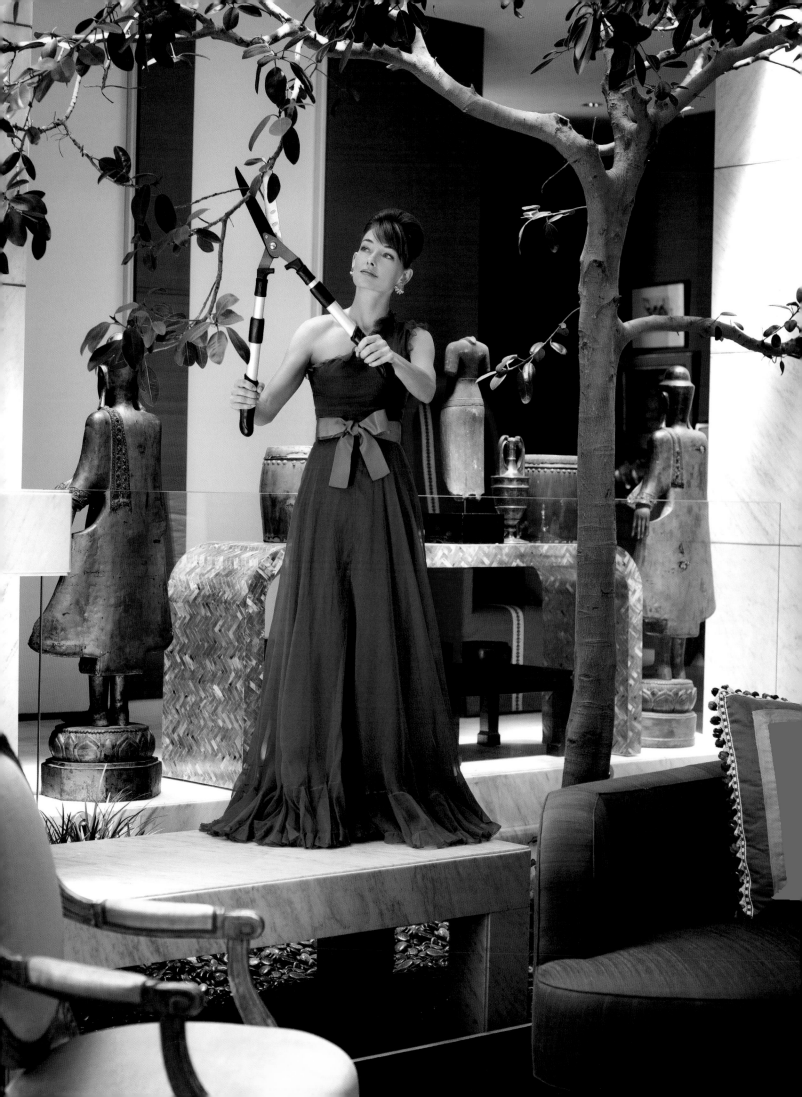

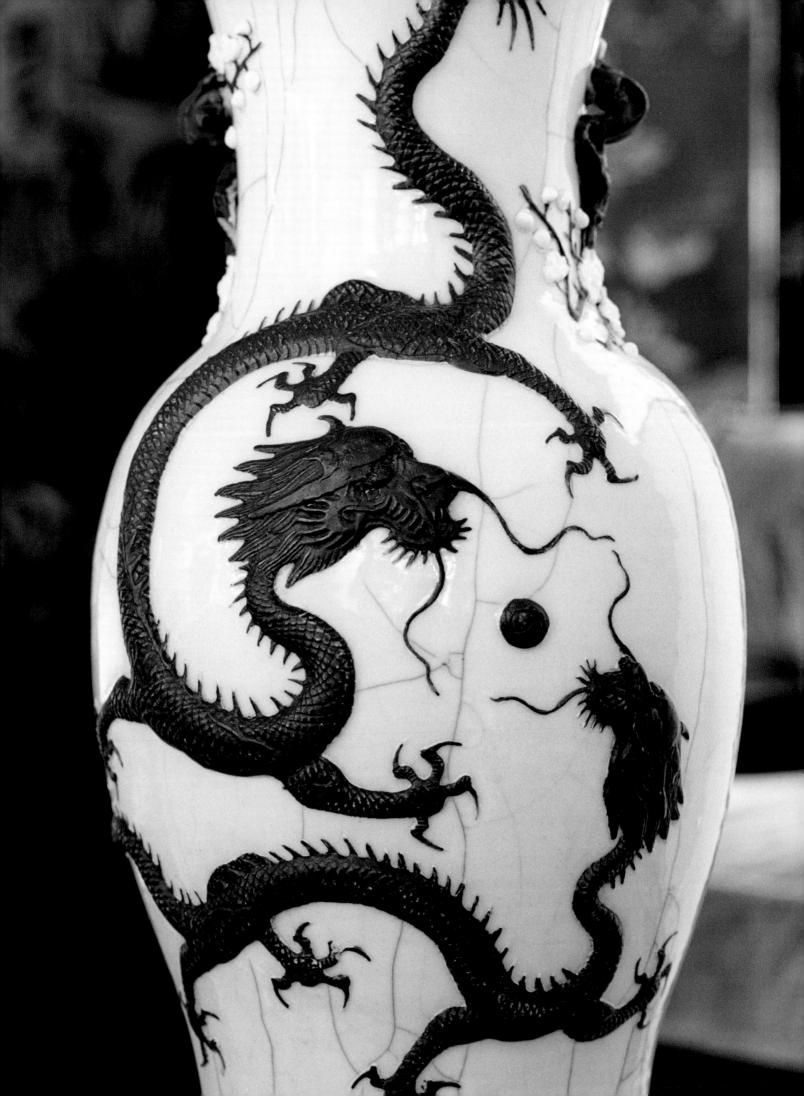

LIVING ROOM

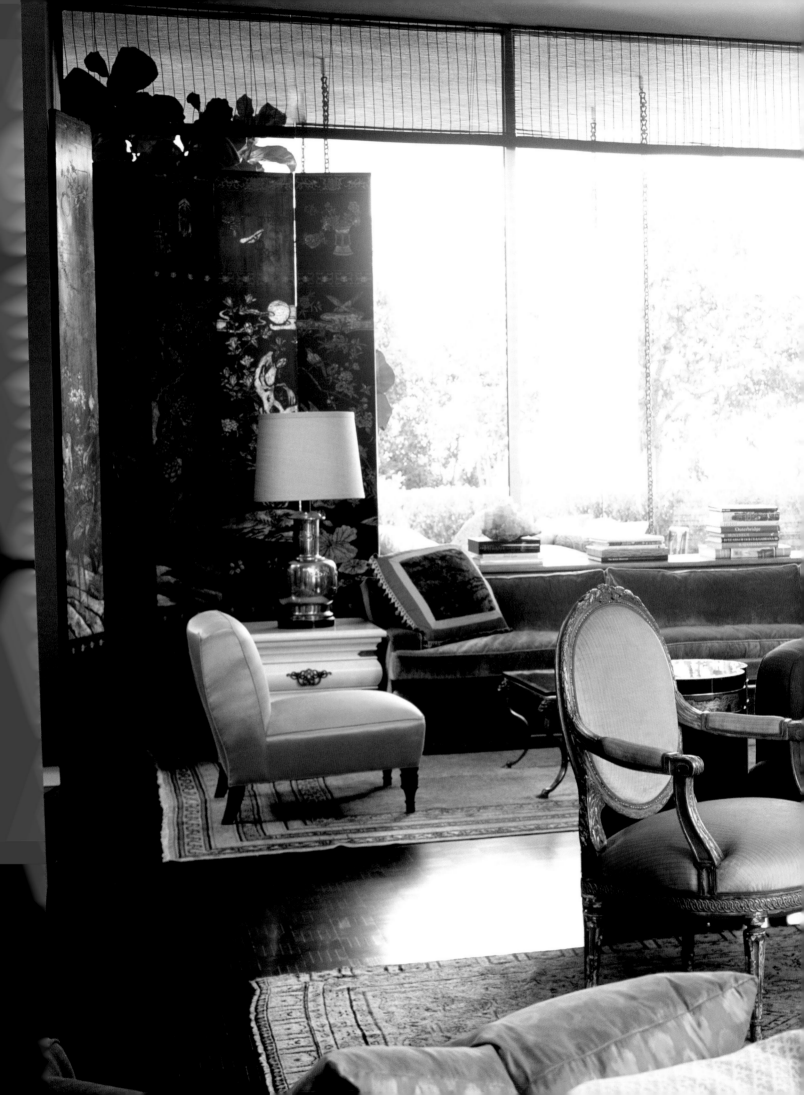

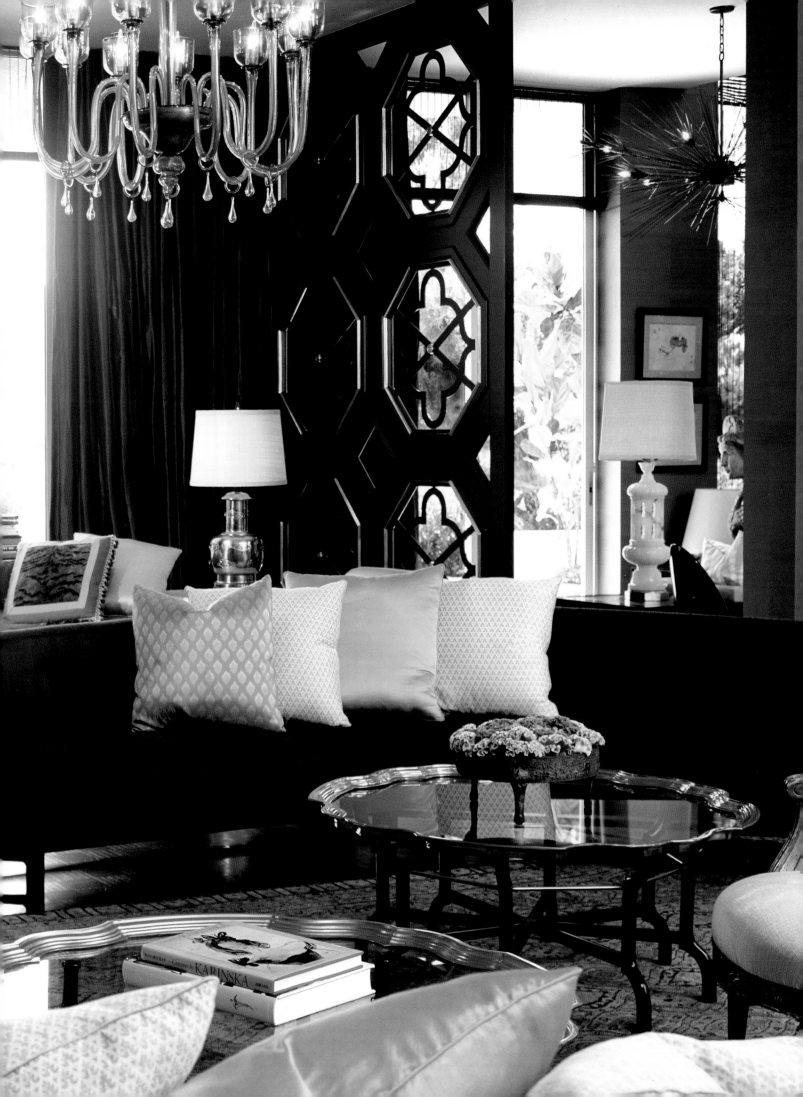

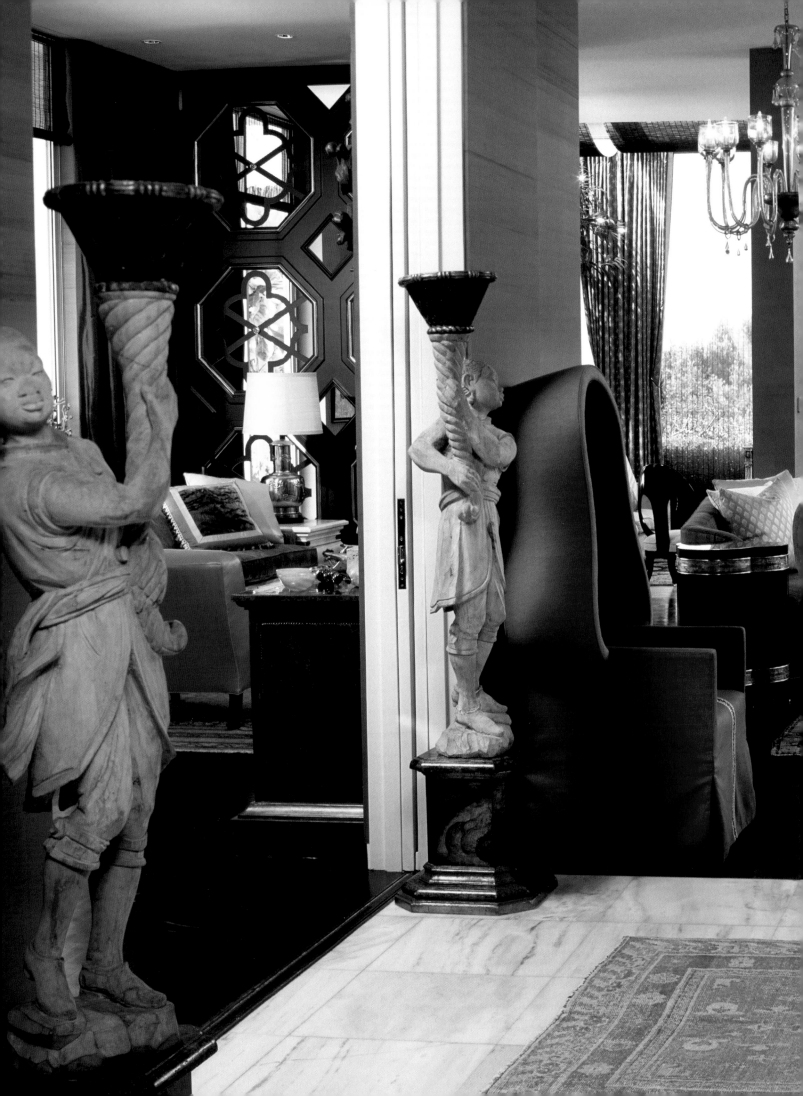

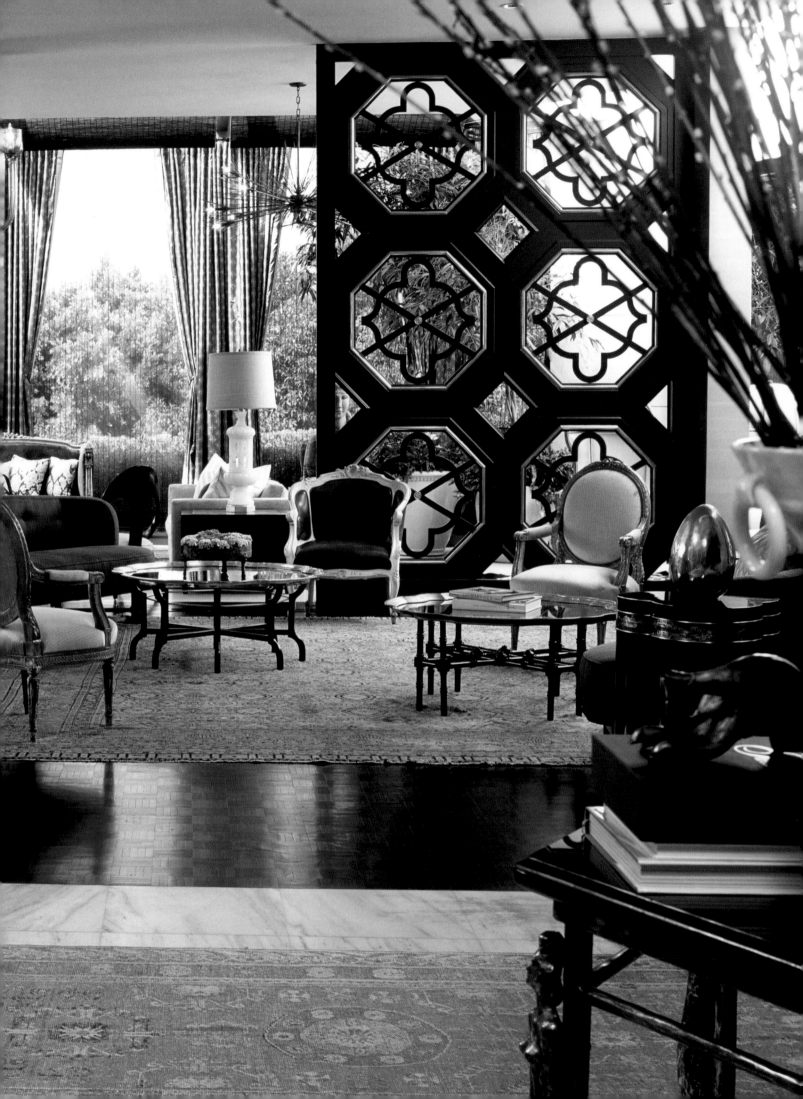

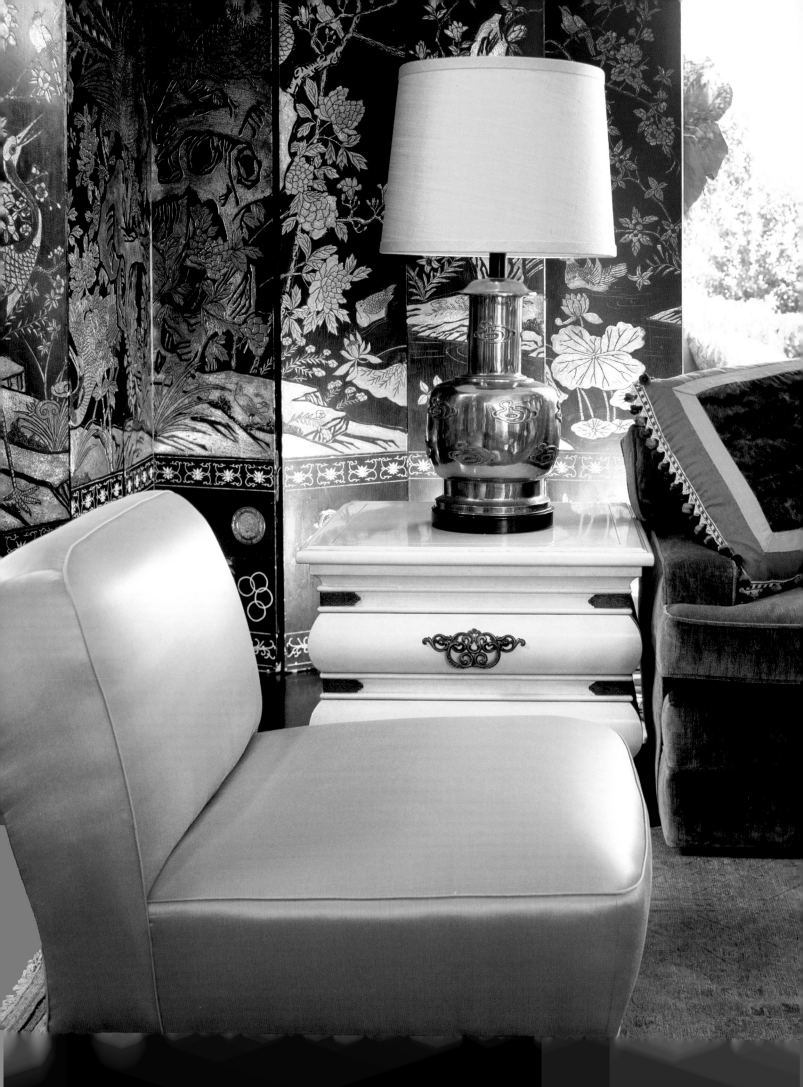

定册妃齊有
安社稷之起

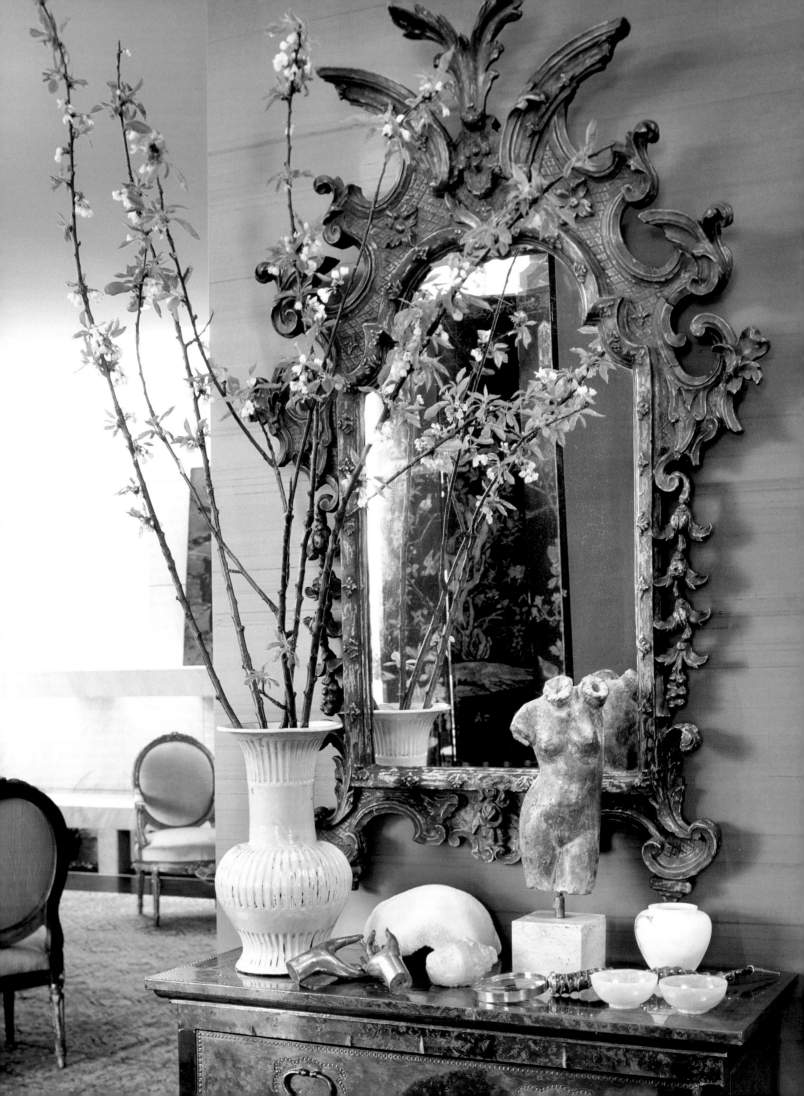

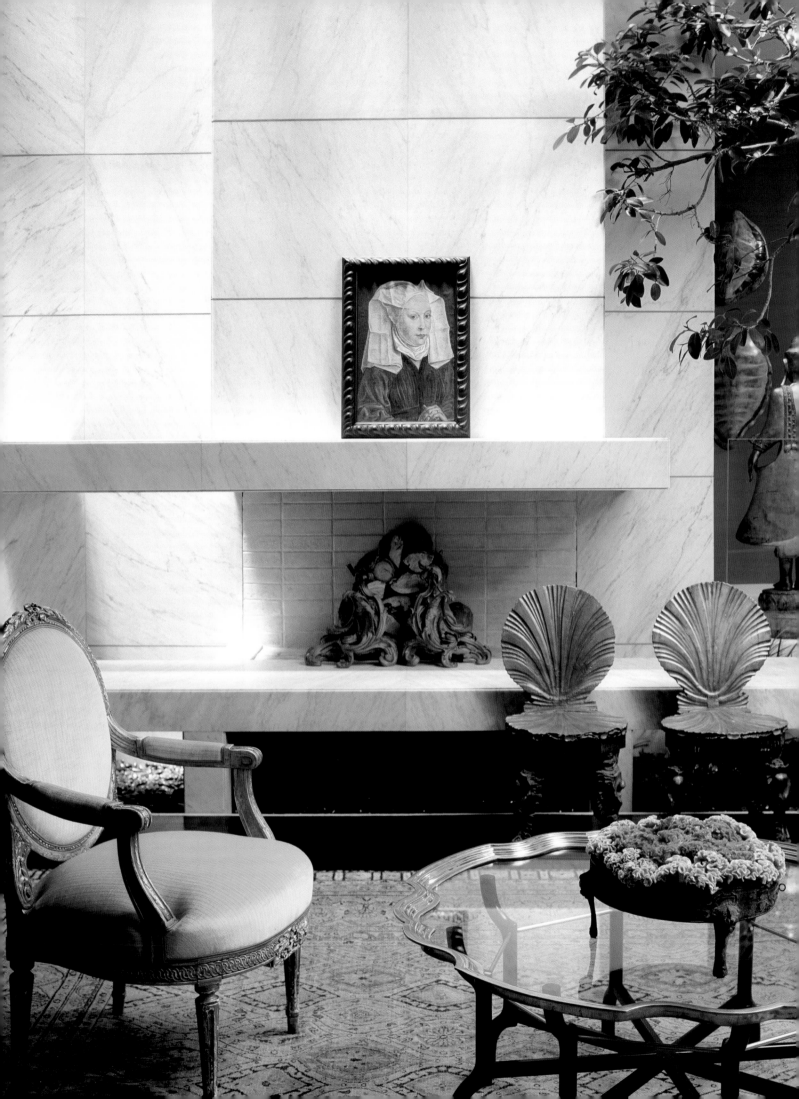

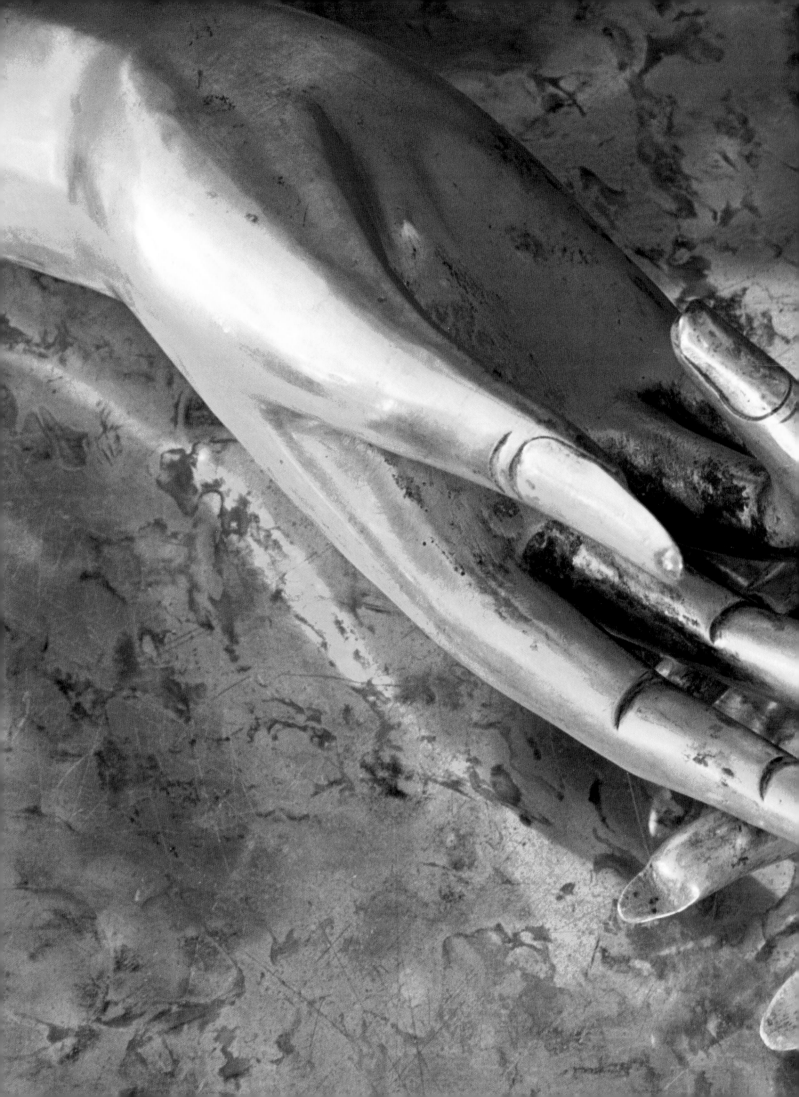

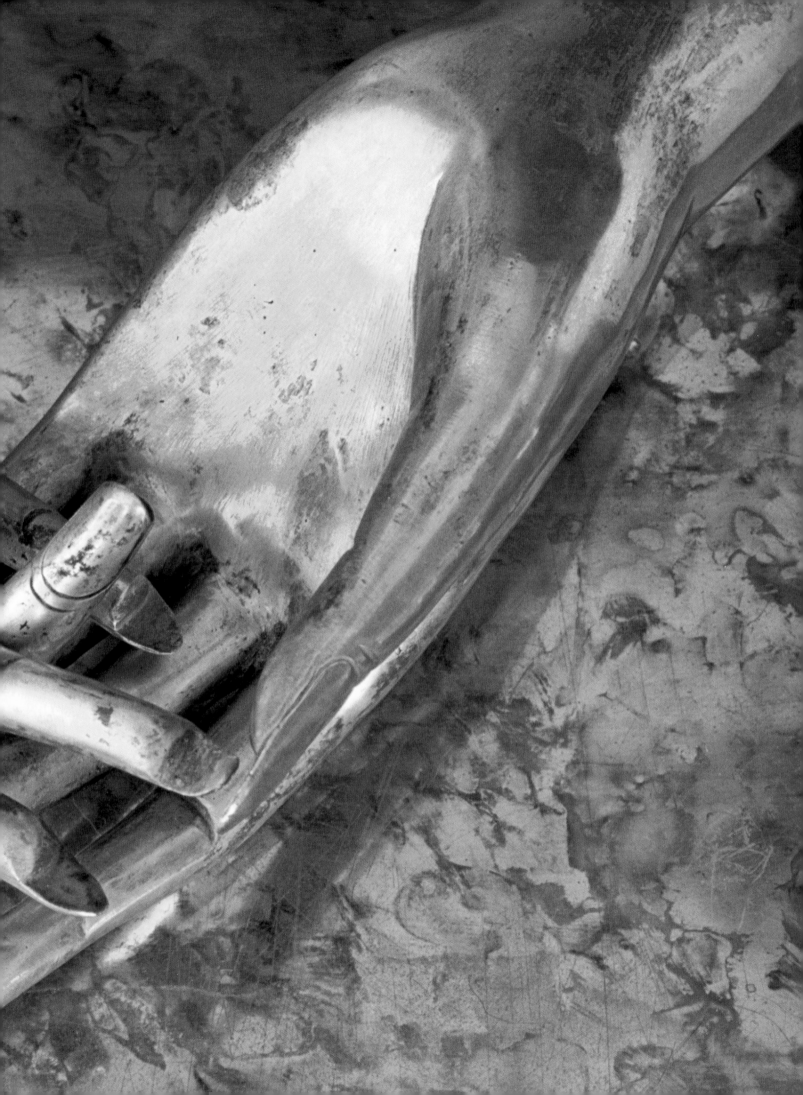

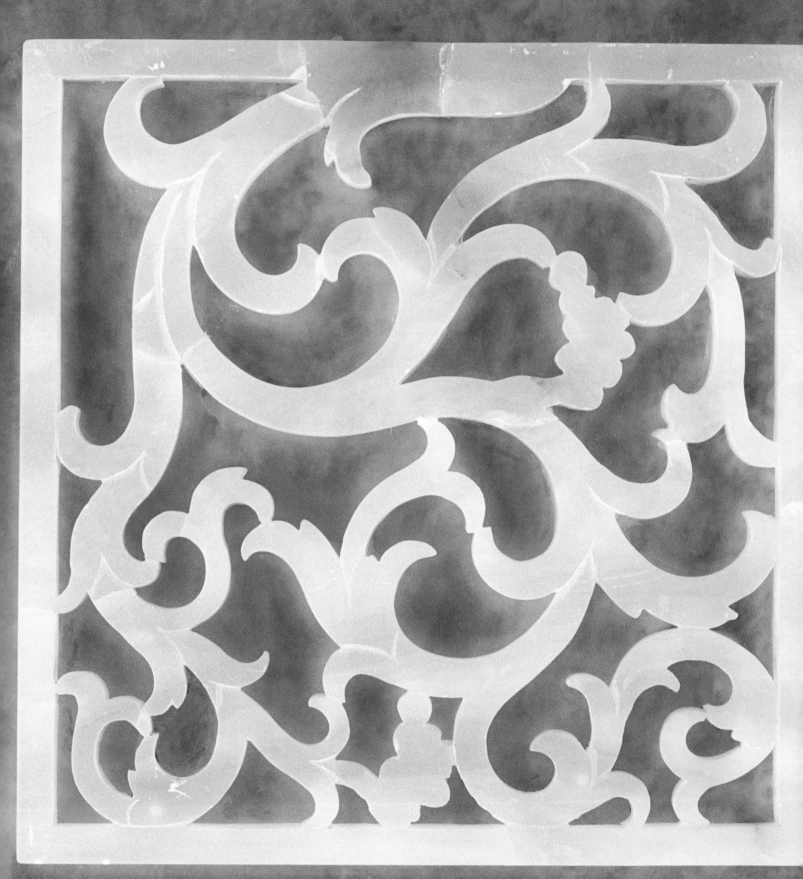

POWDER ROOM

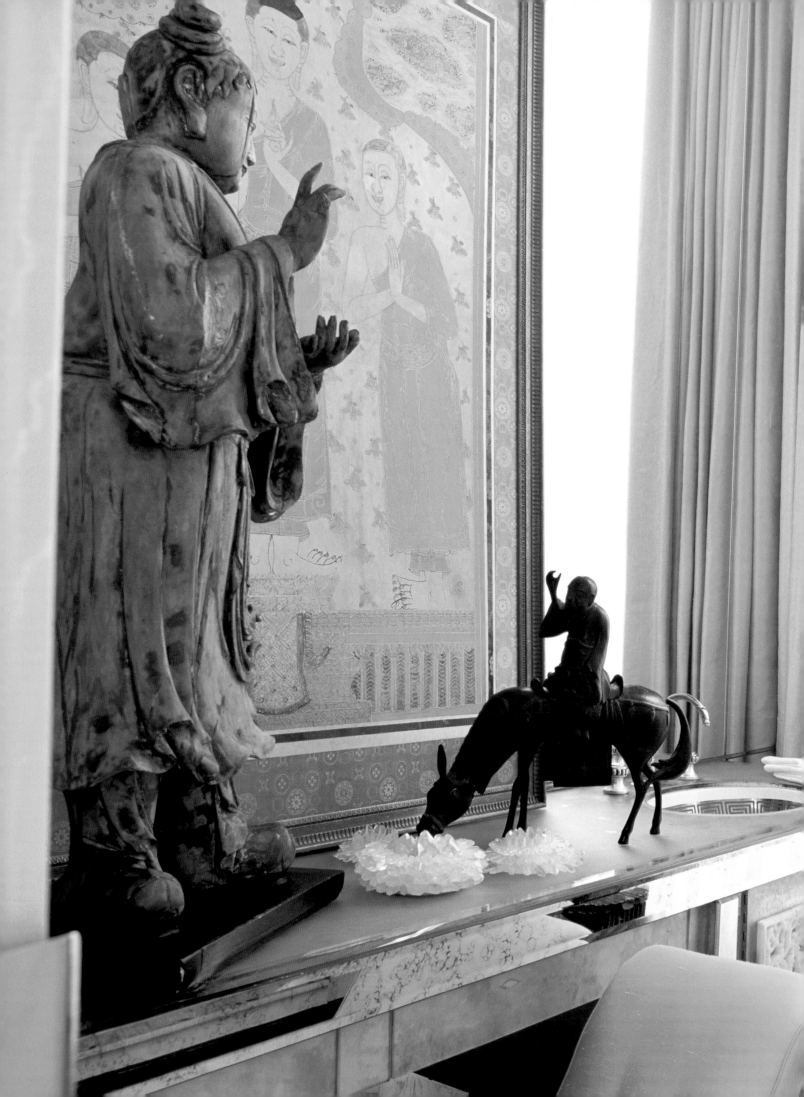

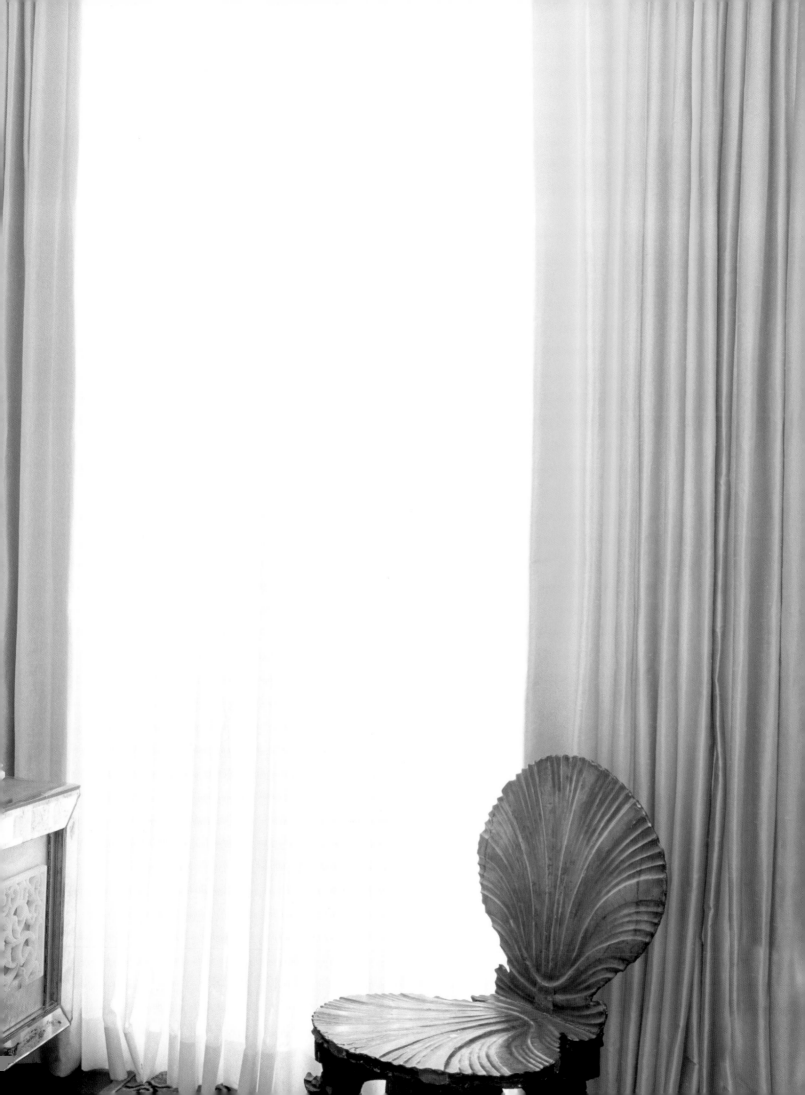

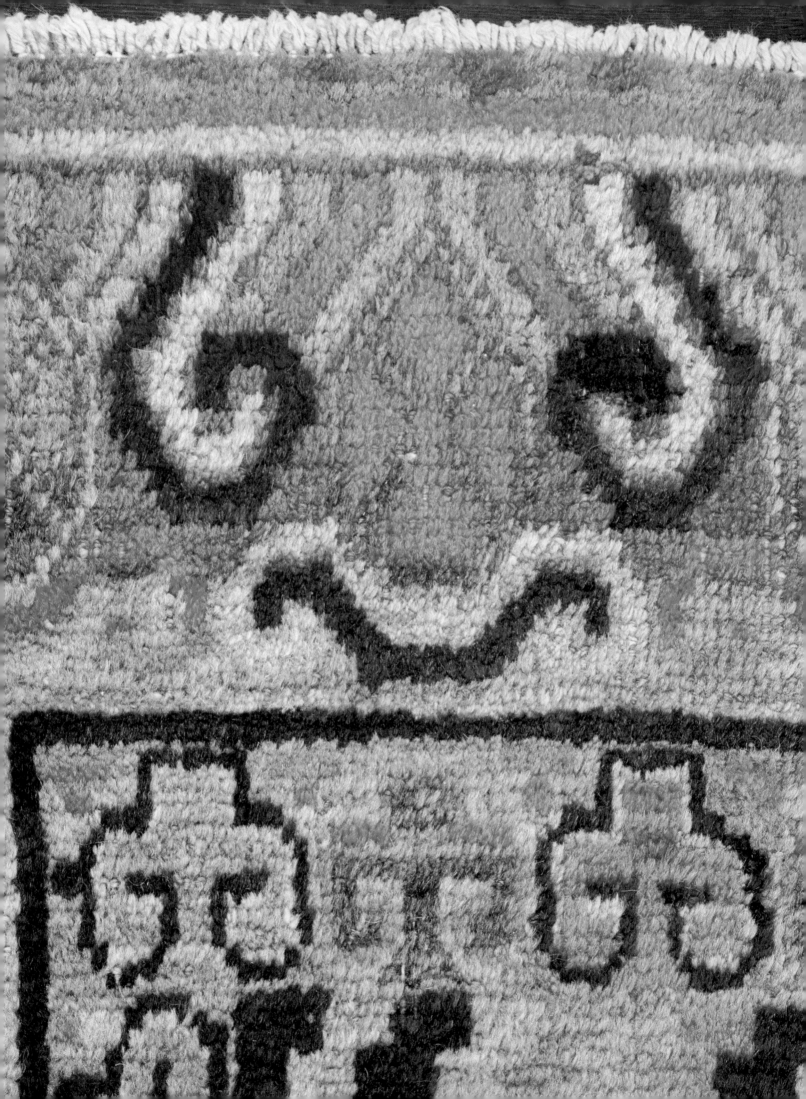

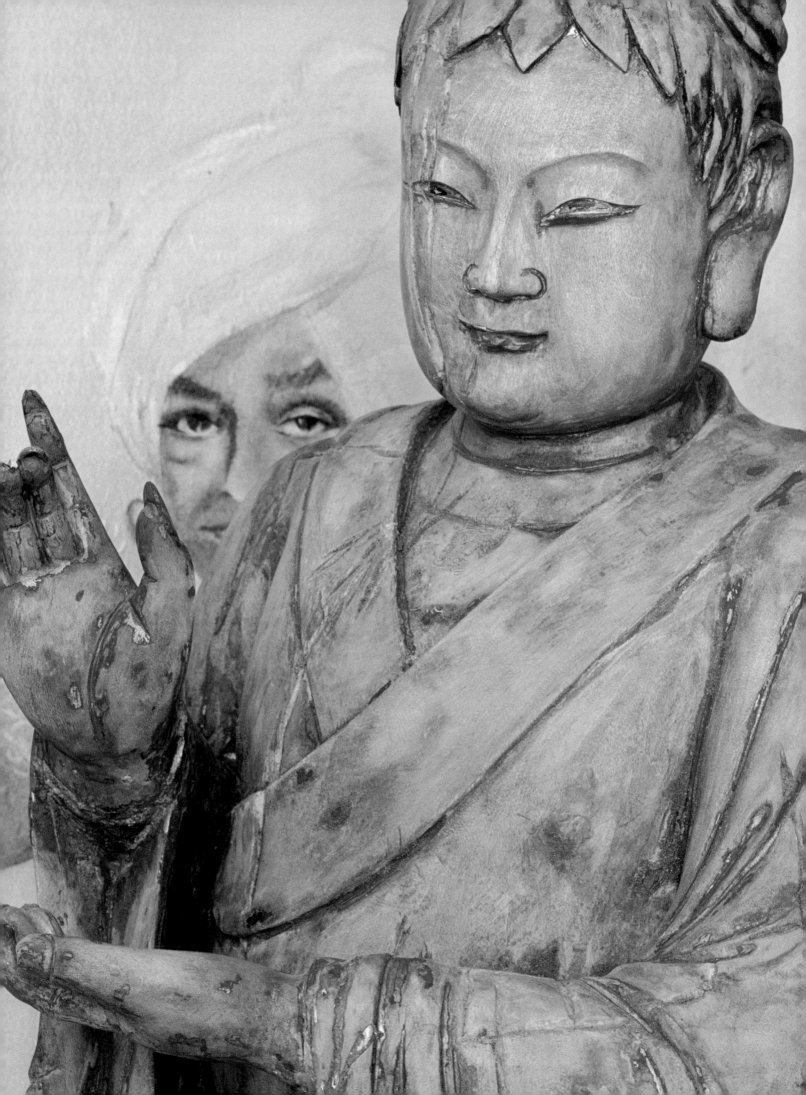

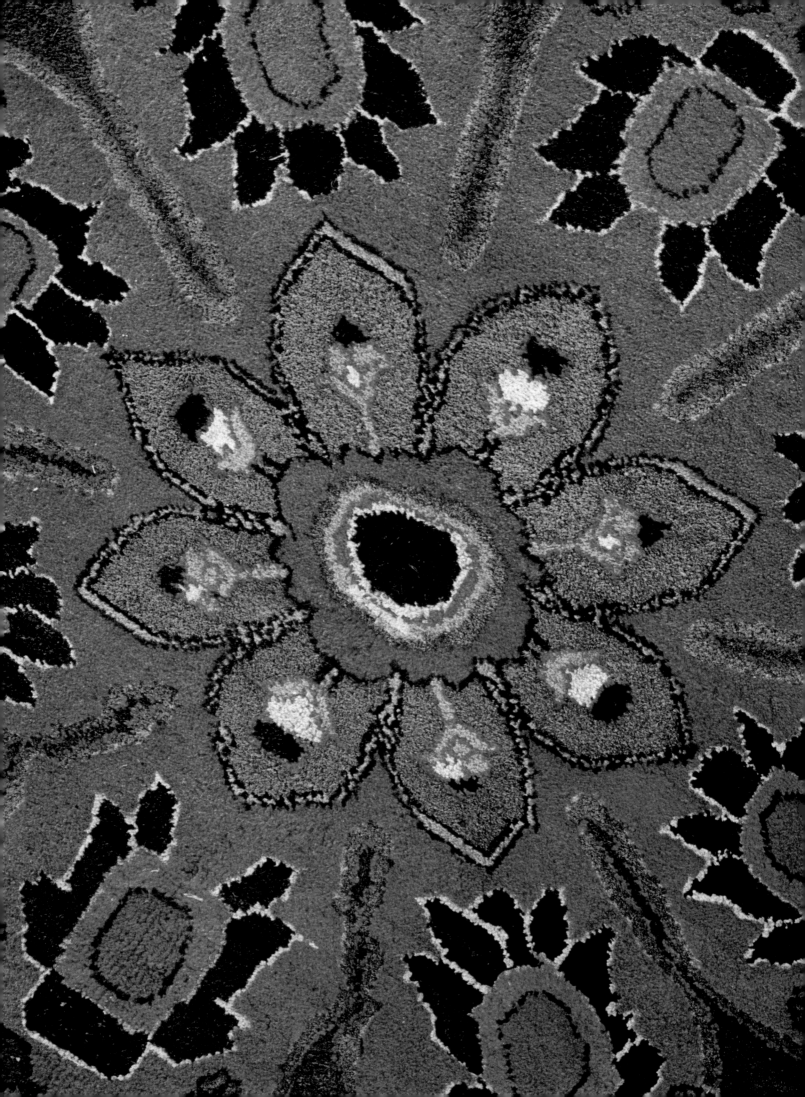

LIBRARY

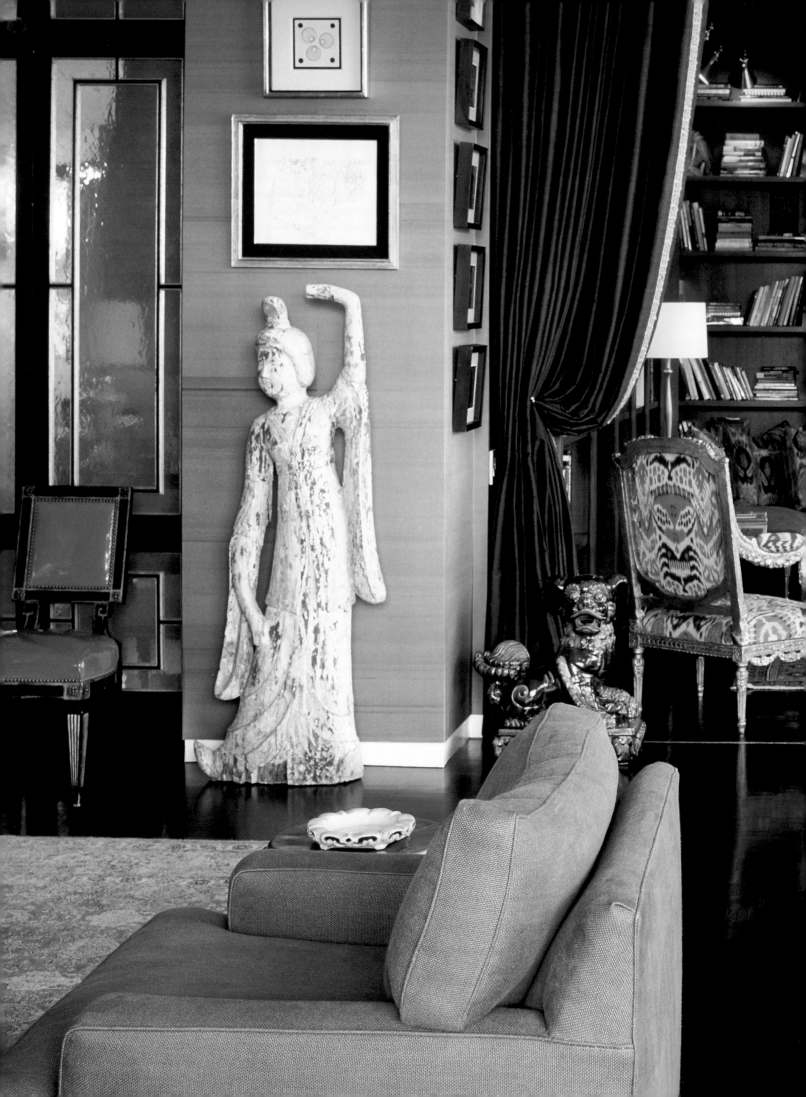

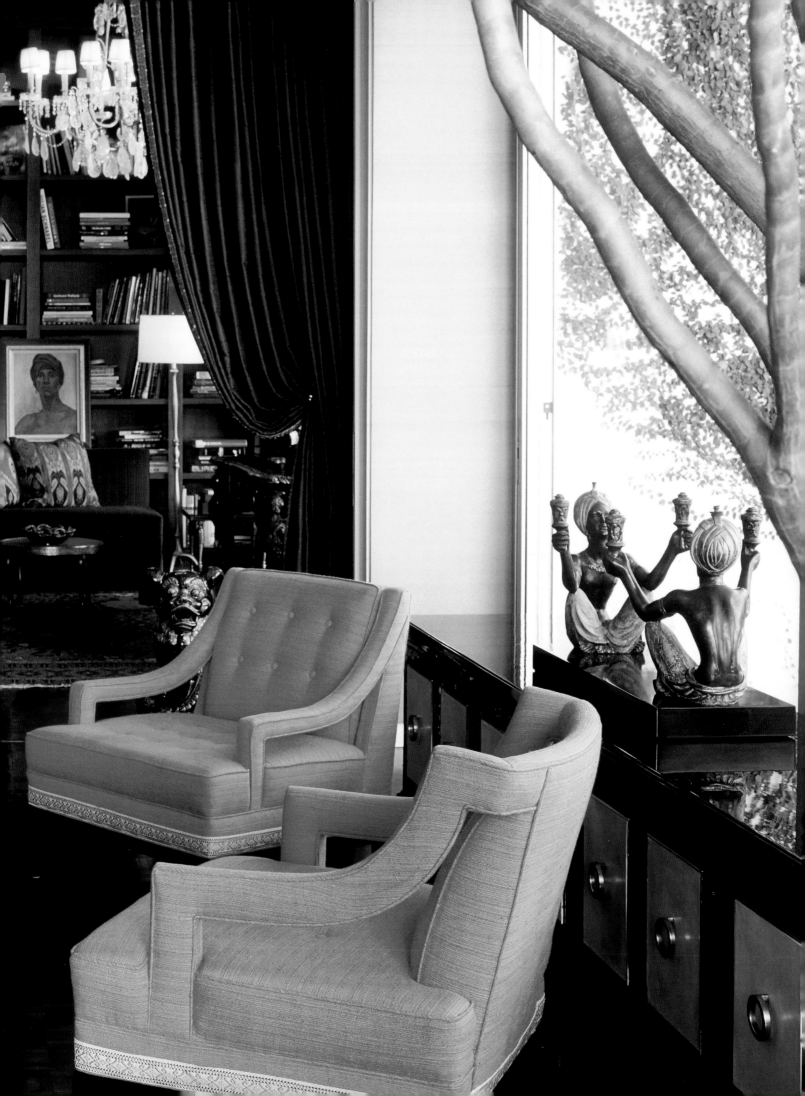

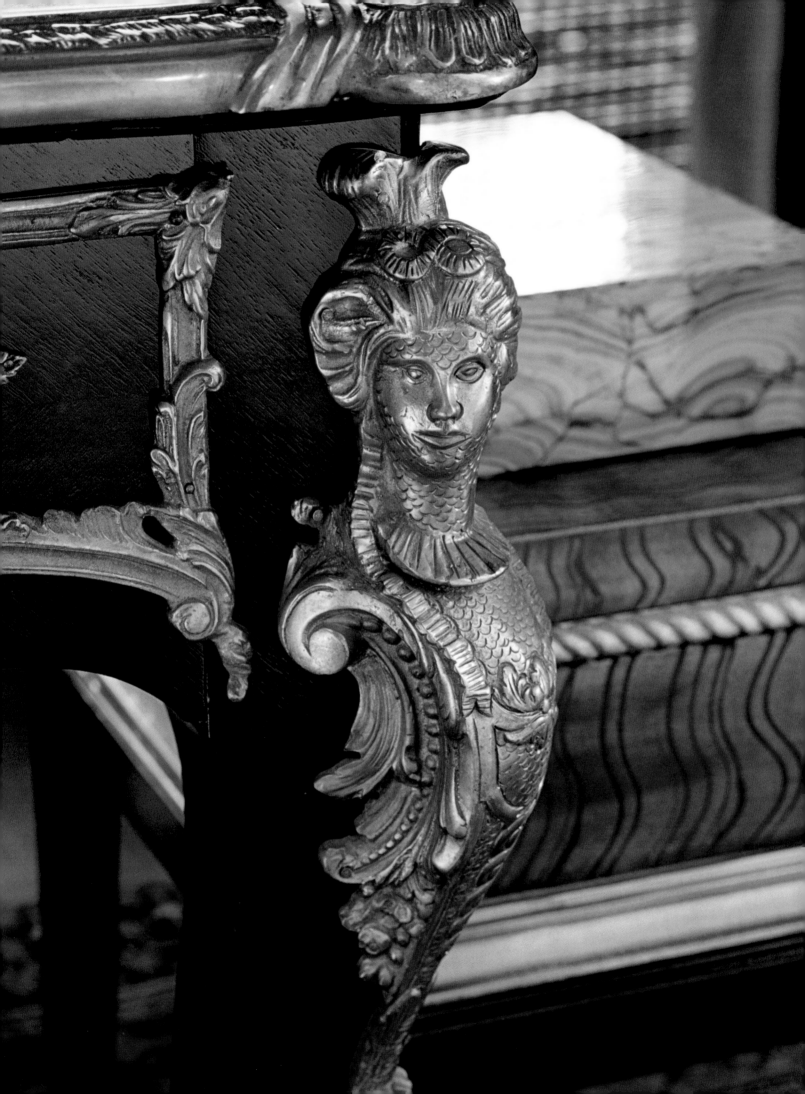

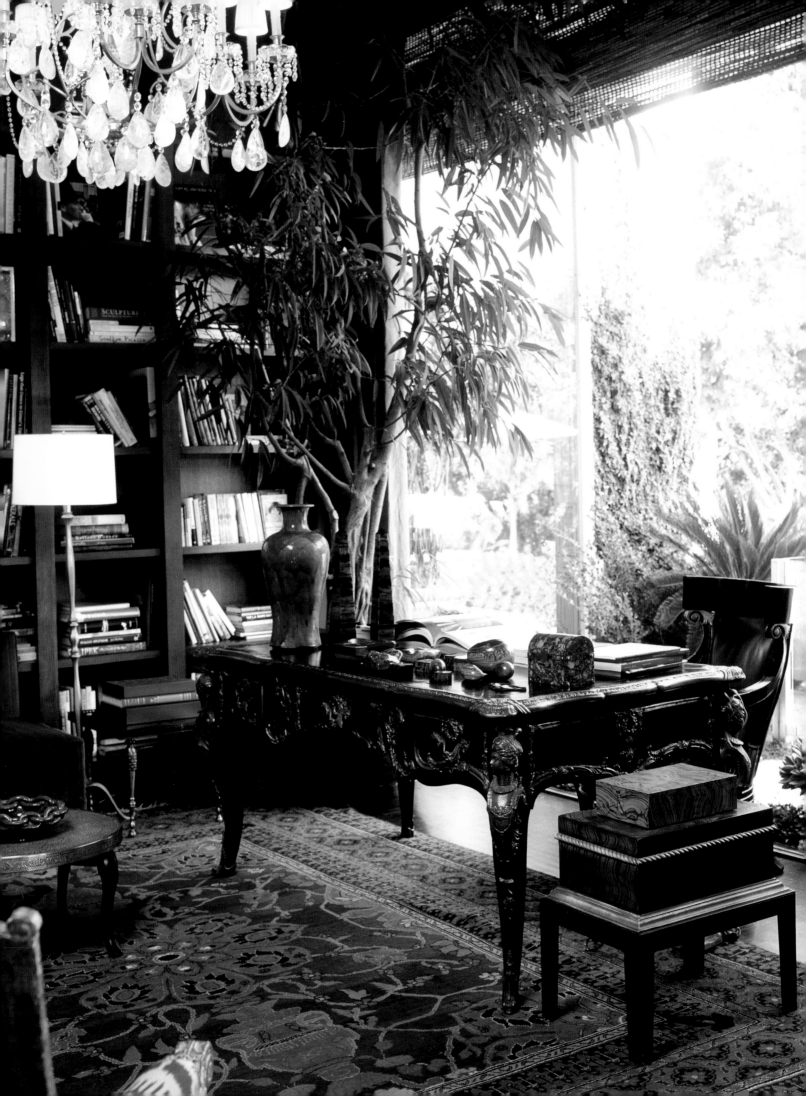

Every home tells a story drawn from fact, fiction, and fable.

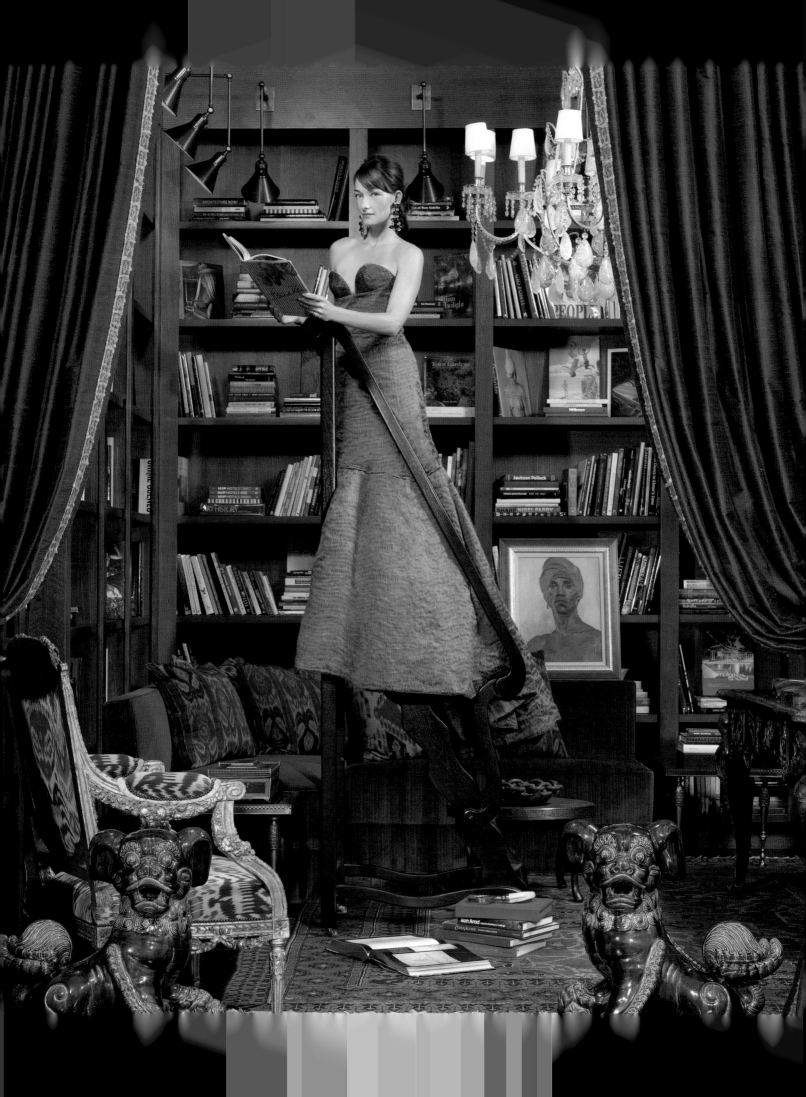

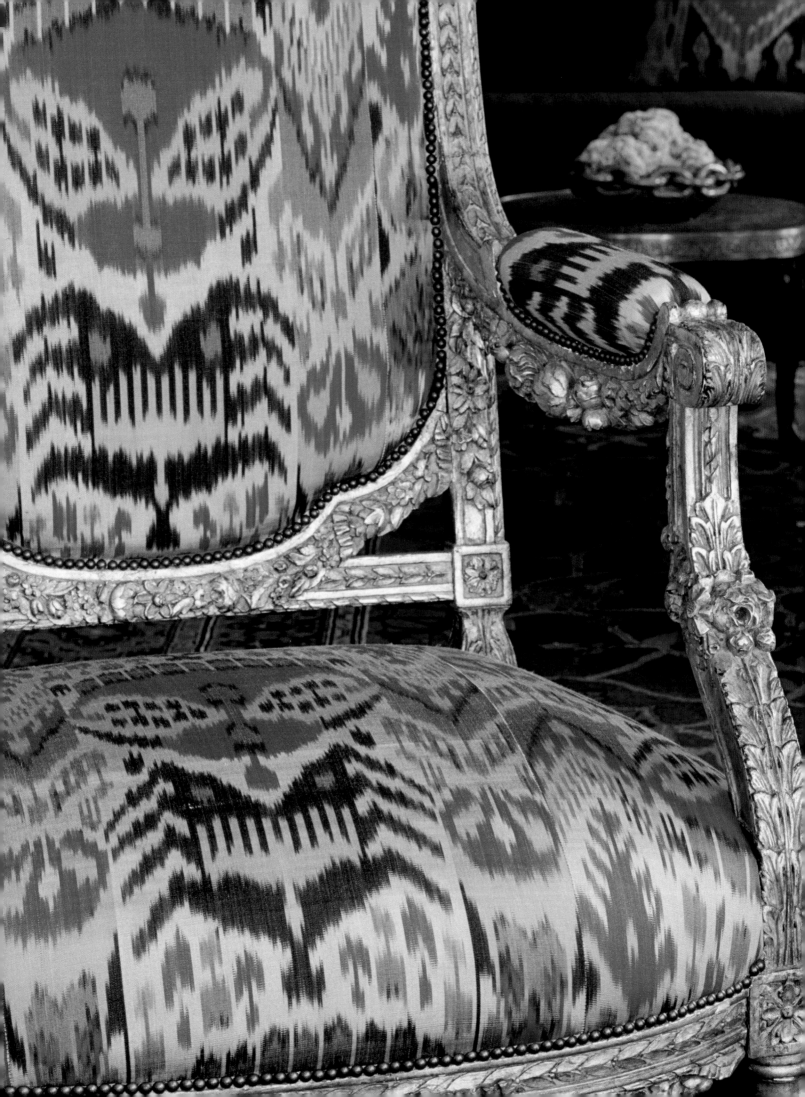

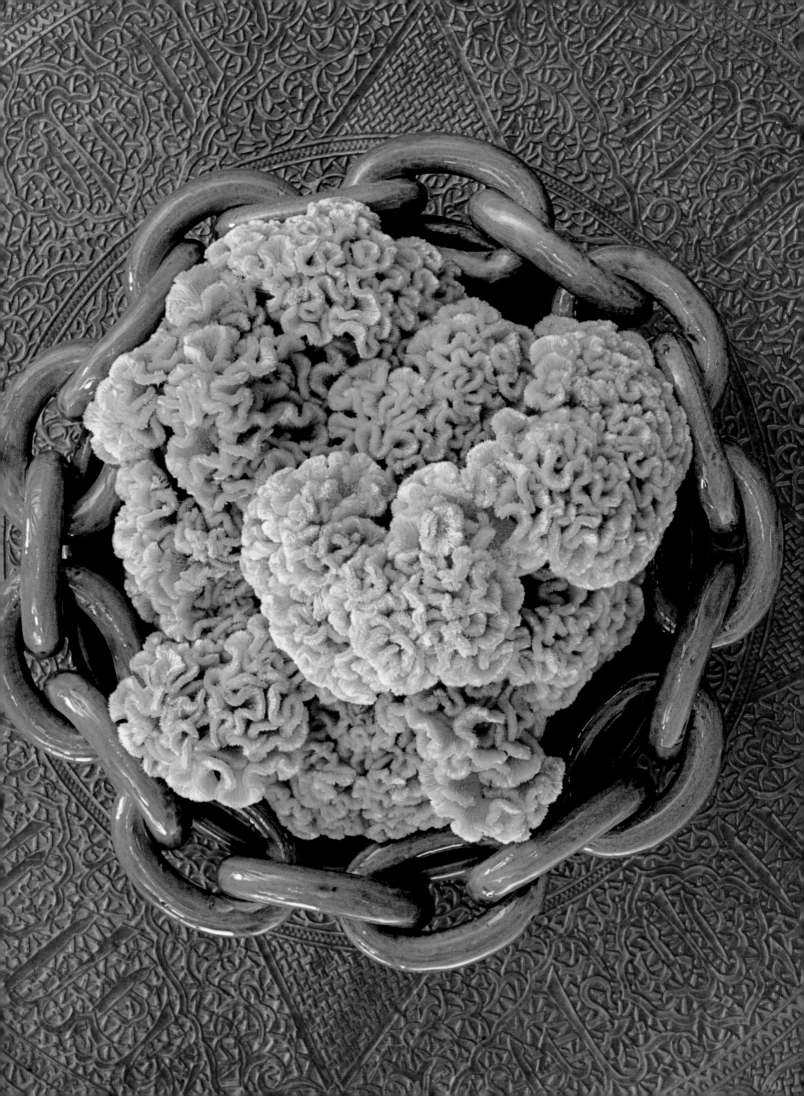

CHRISTIE'S NEW YORK — Important Jewels — 14 DECEMB[ER]

CHRISTIE'S NEW YORK — COSTUME AND TEXTILES — 15 MARCH 2005

CHRISTIE'S SOUTH KENSINGTON — 20TH CENTURY DECORATIVE ART & DESIGN — 9 MARCH 2005

CHRISTIE'S NEW YORK — THE HOUSE SALE — 1-2 MARCH 2005

CHRISTIE'S NEW YORK — POST-WAR AND CONTEMPORARY ART AFTERNOON SESSION — 11 NOVEMBER 2004

CHRISTIE'S NEW YORK — The House Sale — 29 NOVEMBER - 1 DECEM[BER]

CHRISTIE'S NEW YORK — THE HOUSE SALE — 1 & 2 FEBRUARY 2005

CHRISTIE'S NEW YORK — PROPERTY FROM THE ESTATE OF MRS. CHARLES W. ENGELHARD — 18 MARCH 2005

CHRISTIE'S NEW YORK — MAGNIFICENT JEWELS — 12 APRIL 2005

CHRISTIE'S SOUTH KENSINGTON — FURNITURE AND DECORATIVE OBJECTS — 19 APRIL 2005

CHRISTIE'S LONDON — ENGLISH AND CONTINENTAL FURNITURE — 21 APRIL 2005

CHRISTIE'S LONDON — ORIENTAL RUGS AND CARPETS — 28 APRIL 2005

CHRISTIE'S LONDON — ARLINGTON STREET - A WILLIAM KENT HOUSE — 11 MAY 2005

CHRISTIE'S LONDON — IMPORTANT ENGLISH FURNITURE AND CARPETS — 9 JUNE 2005

CHRISTIE'S NEW YORK — IMPORTANT 20TH CENTURY DECORATIVE ART & DESIGN — 9 JUNE 2005

CHRISTIE'S SOUTH KENSINGTON — MODERN DESIGN — 5 JUNE 2005

CHRISTIE'S LONDON

CHRISTIE'S SOUTH KENSINGTON

CHRISTIE'S NEW YORK

CHRISTIE'S NEW YORK

CHRISTIE'S SOUTH KENSINGTON

CHRISTIE'S SOUTH KENSINGTON

CHRISTIE'S LOS ANGELES

CHRISTIE'S SOUTH KENSINGTON

CHRISTIE'S NEW YORK

CHRISTIE'S SOUTH KENSINGTON

CHRISTIE'S LONDON

CHRISTIE'S SOUTH KENSINGTON

CHRISTIE'S SOUTH KENSINGTON

CHRISTIE'S AMSTERDAM

Important British Art
including Property from the London Residence of the late Sir Paul Getty, K.B.E.

Furniture and Decorative Objects

Important 20th Century Decorative Art & Design

100 YEARS OF GEORG JENSEN: THE ROWLER COLLECTION

Furniture, Decorative Objects and Textiles

European Furniture, Works of Art, Tapestries and Carpets

The Duquette Collections

Post-War and Contemporary Art

POST-WAR AND CONTEMPORARY ART MORNING SESSION

THE HOUSE SALE

IMPRESSIONIST AND MODERN WORKS ON PAPER
INCLUDING WORKS FROM THE DR GEORG AND JOSI GUGGENHEIM FOUNDATION

20th Century British Art

EUROPEAN FURNITURE, WORKS OF ART, TAPESTRIES AND CARPETS

European Furniture, Decorative Objects, Picture Frames & Pictures – At Home

20th Century Decorative Arts

24 NOVEMB

8 DECEMBE

8 DECEMBE

19 JANUARY 2005

15 DECEMBE

24 NOVEMB

12-14 MARCH

20 OCTOB

11 NOVEMBER 2004

11–12 JANUARY 2005

2 DECEMB

10 FEBRUARY 2005

25 JANUARY 2005

3 AND 4 NOVEMB

16 NOVEMB

ORANGERIE

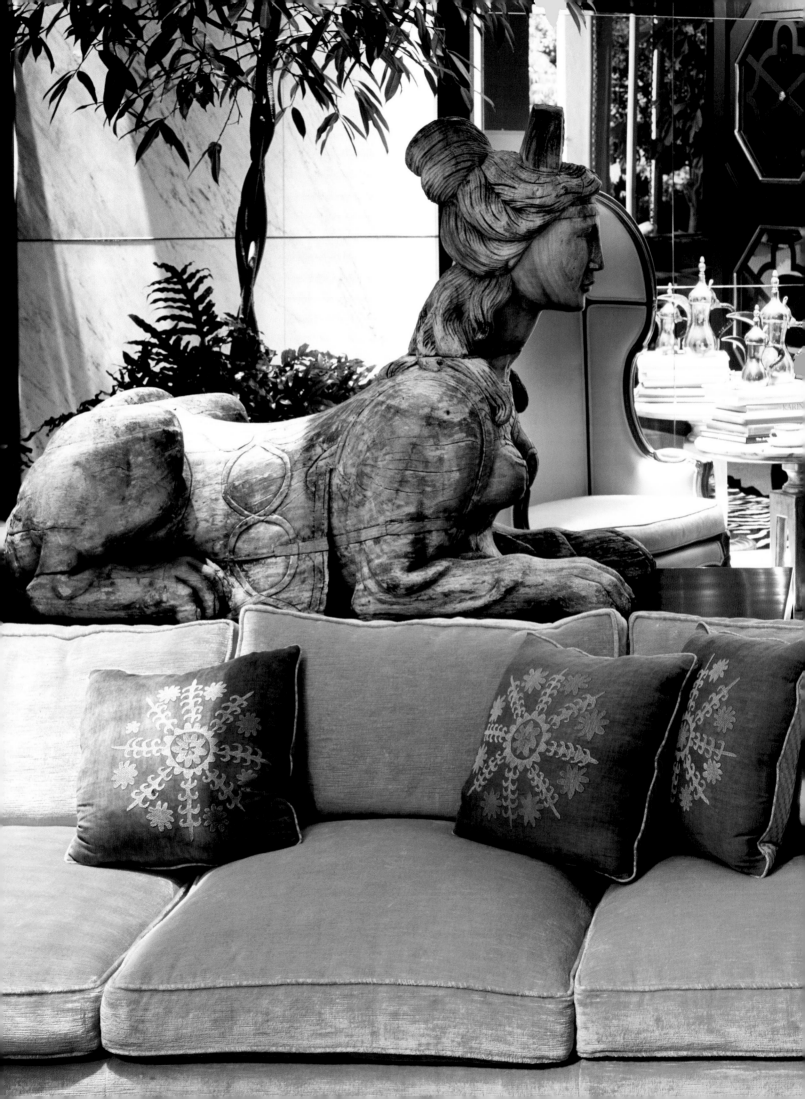

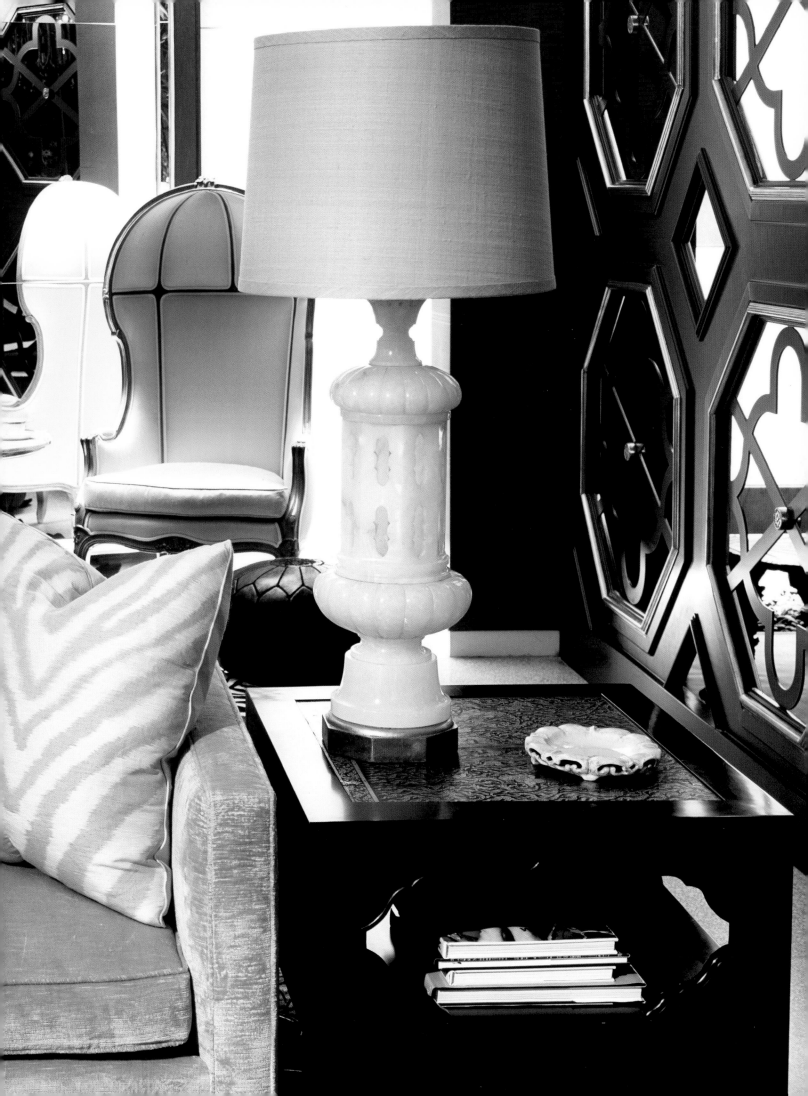

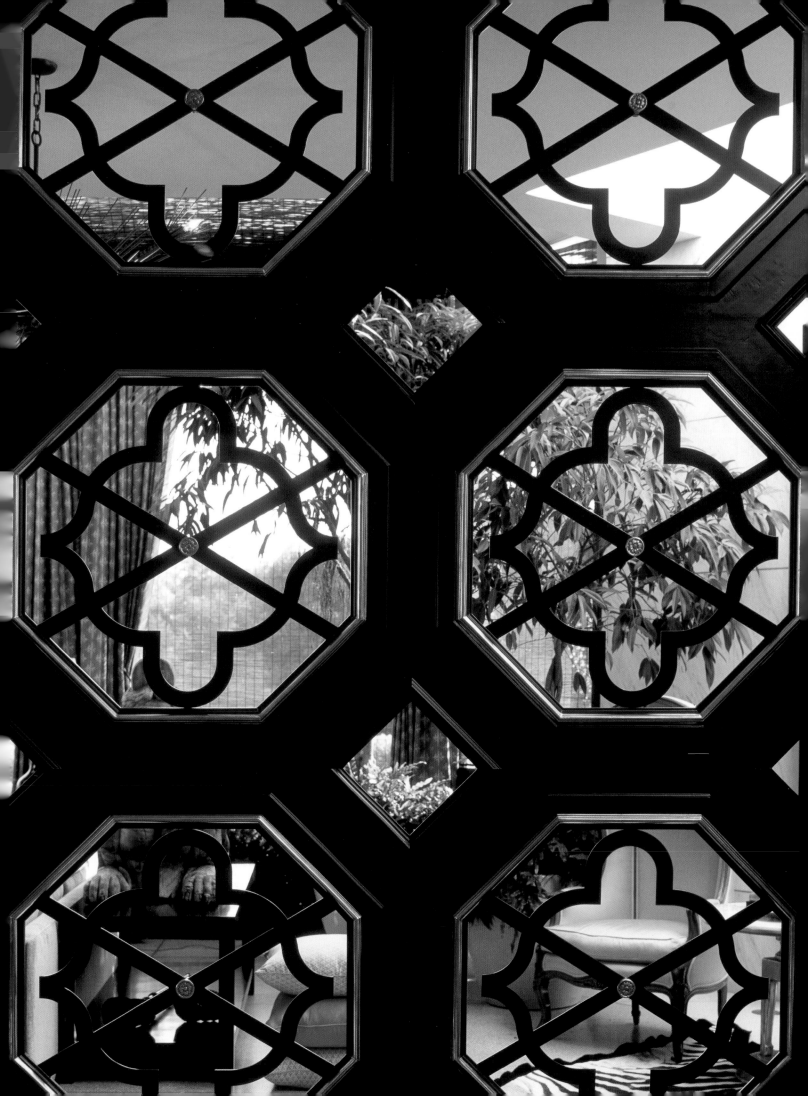

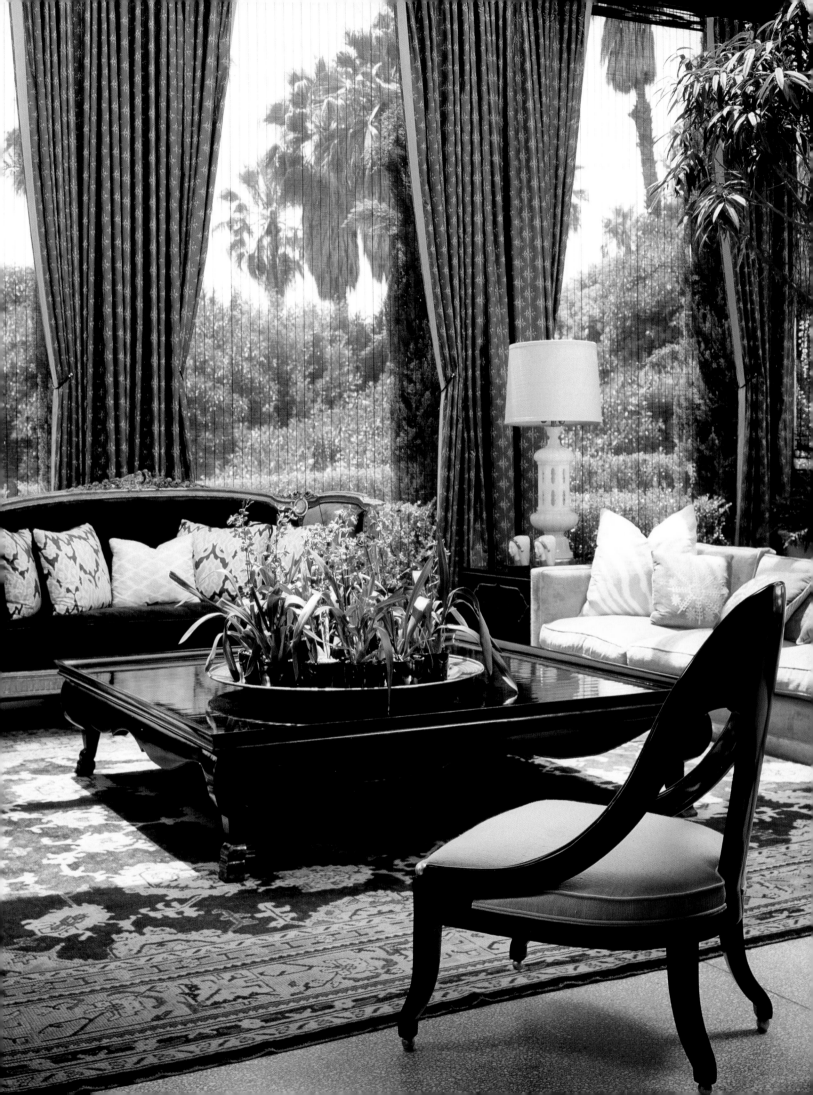

Each room deserves dignity, respect, and a healthy dose of laughter.

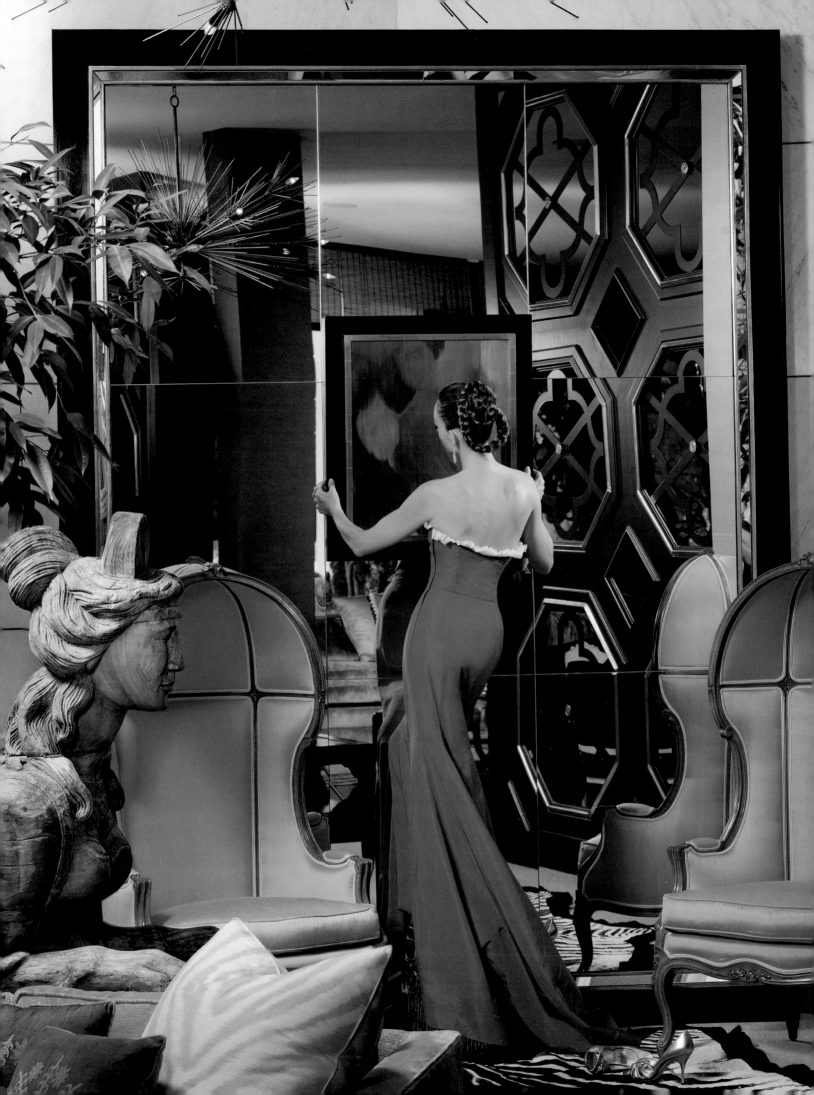

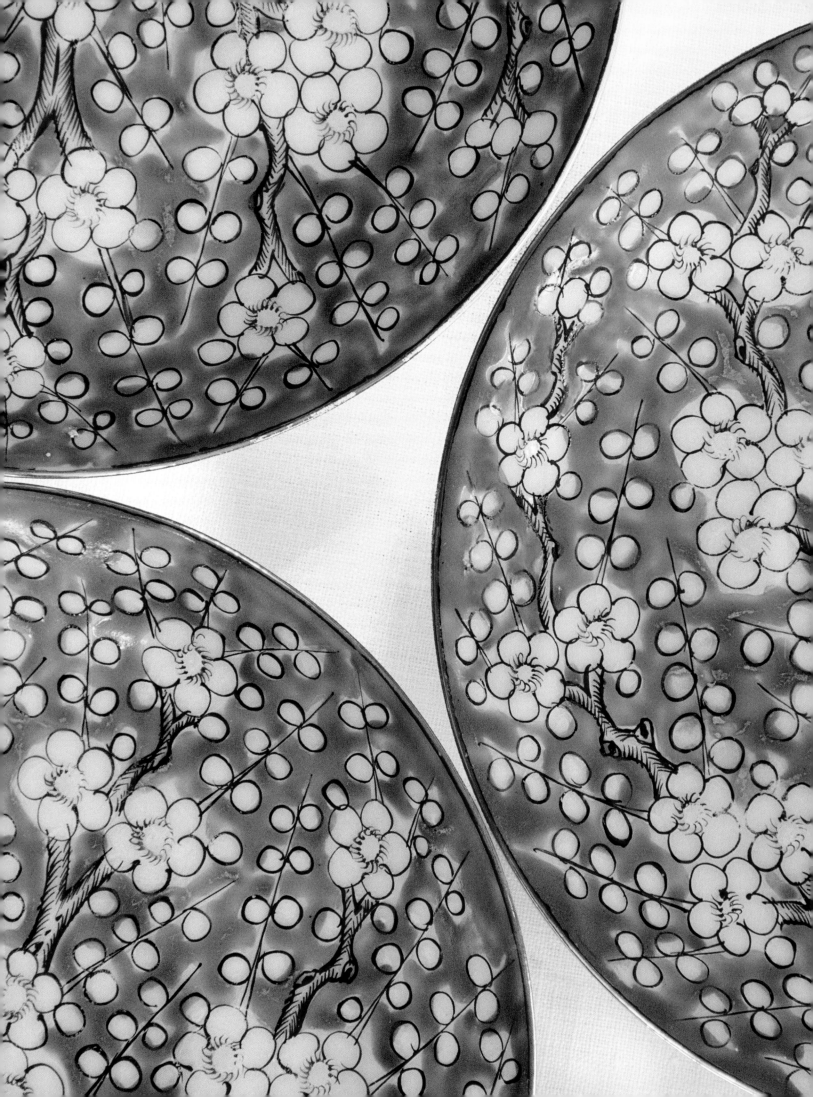

KITCHEN

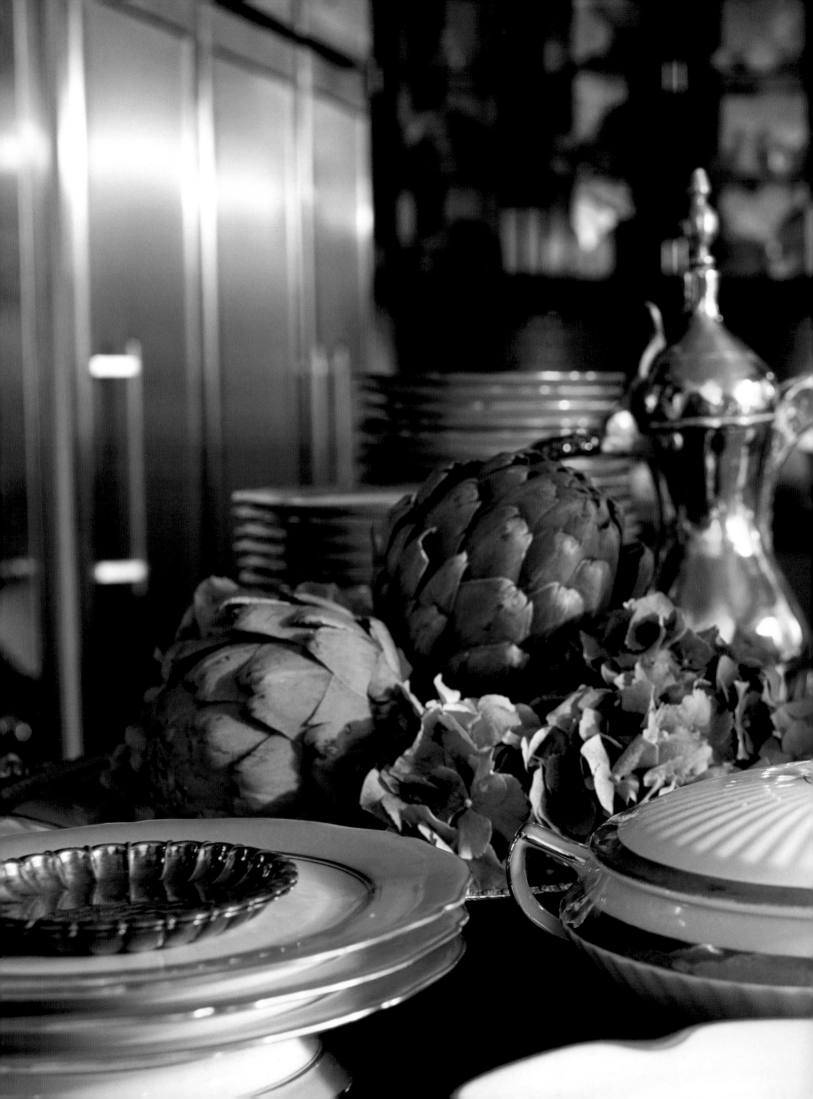

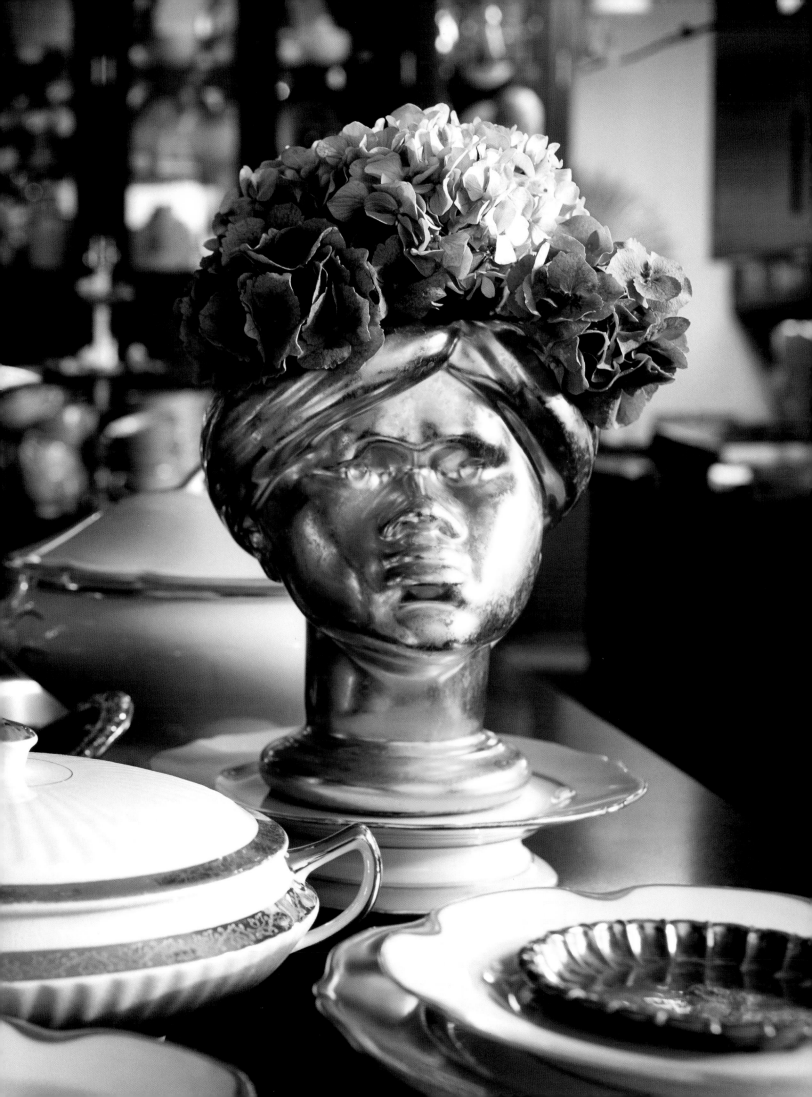

Parade the porcelain, celebrate the stemware,
but keep the sippy cups in a drawer.

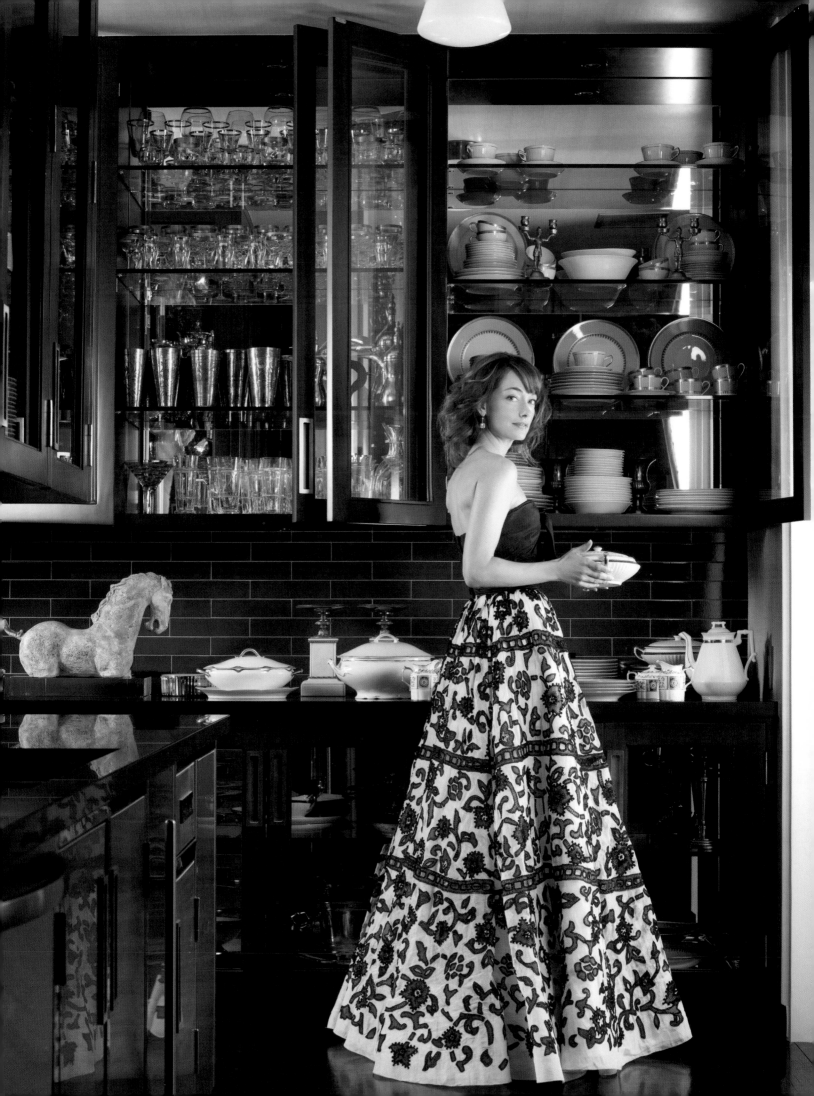

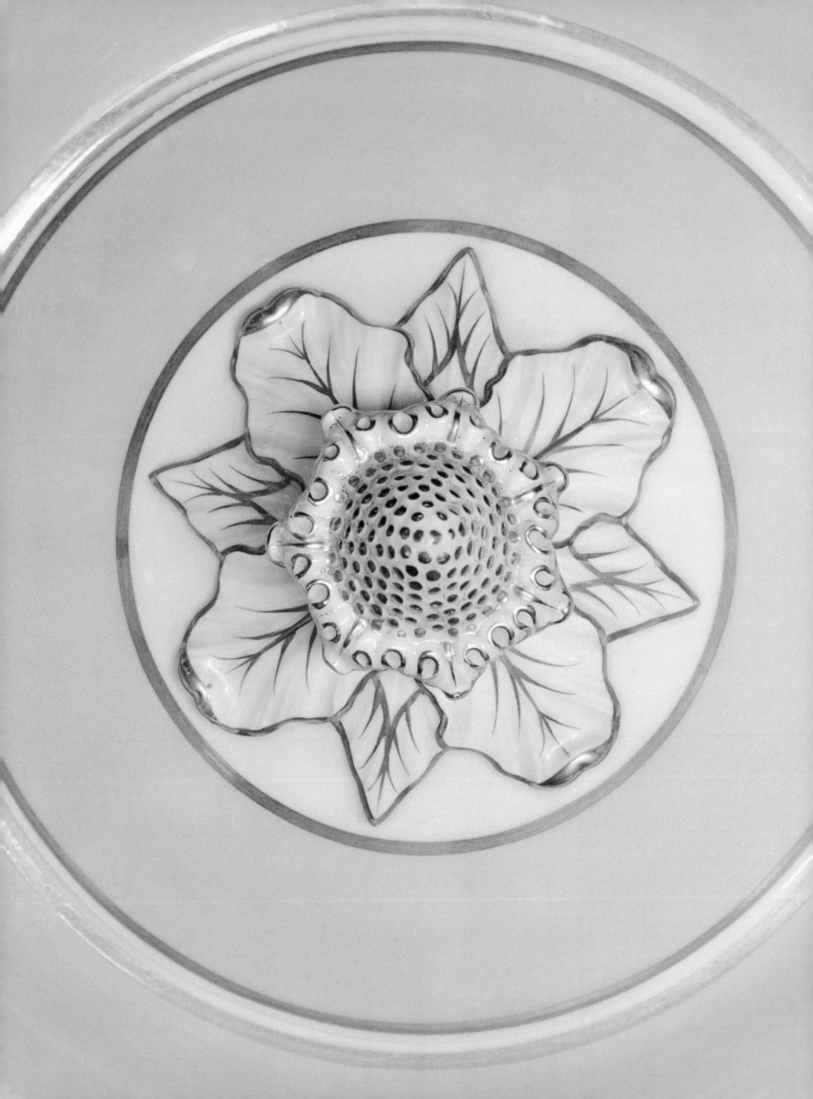

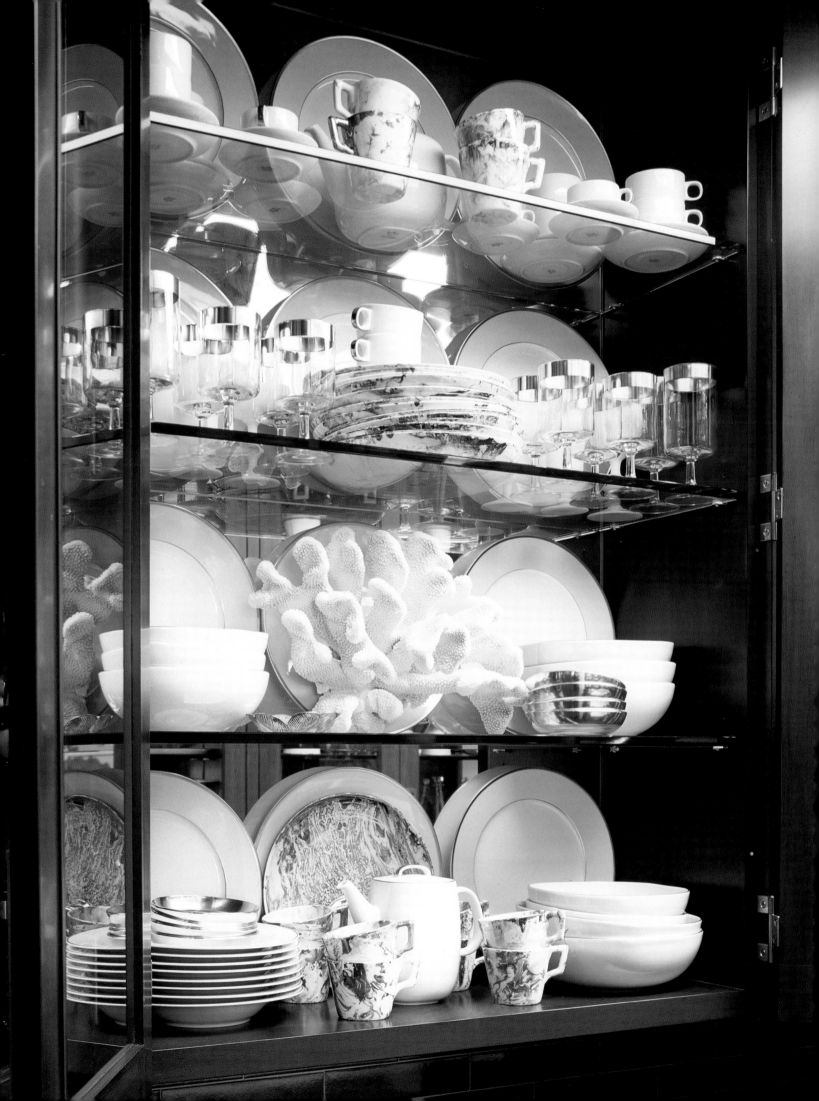

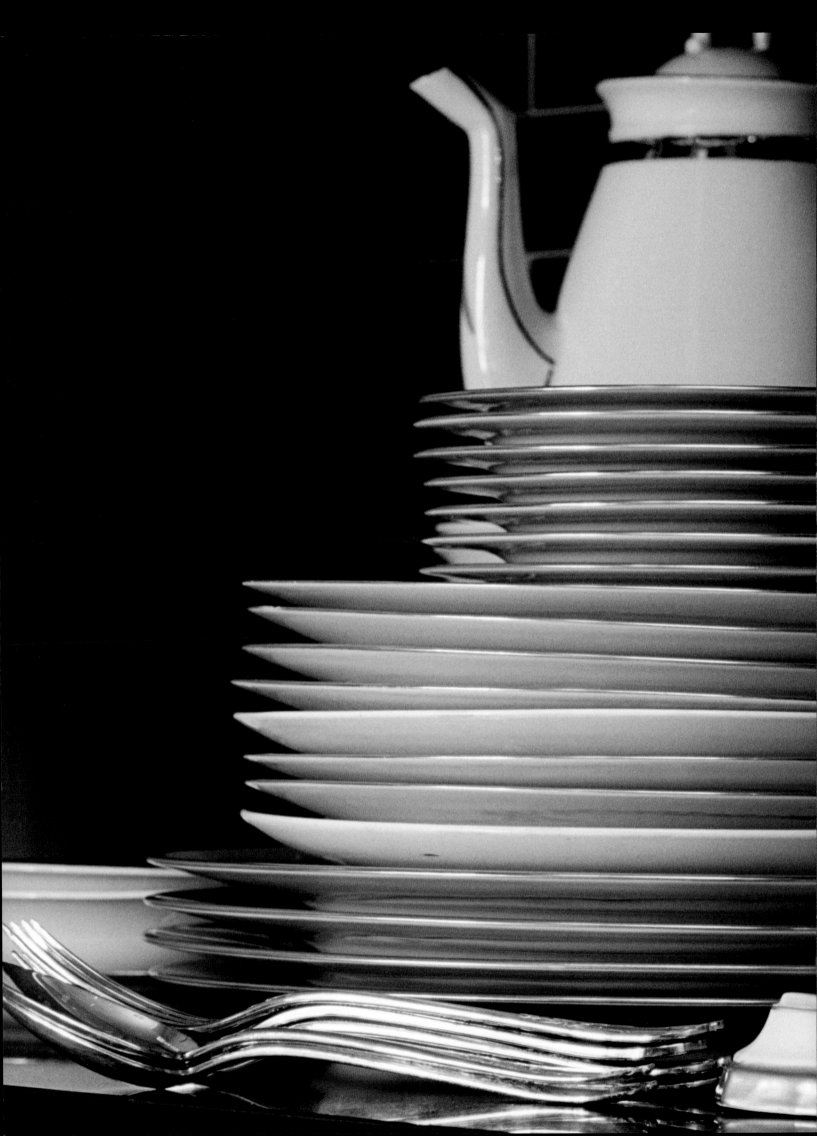

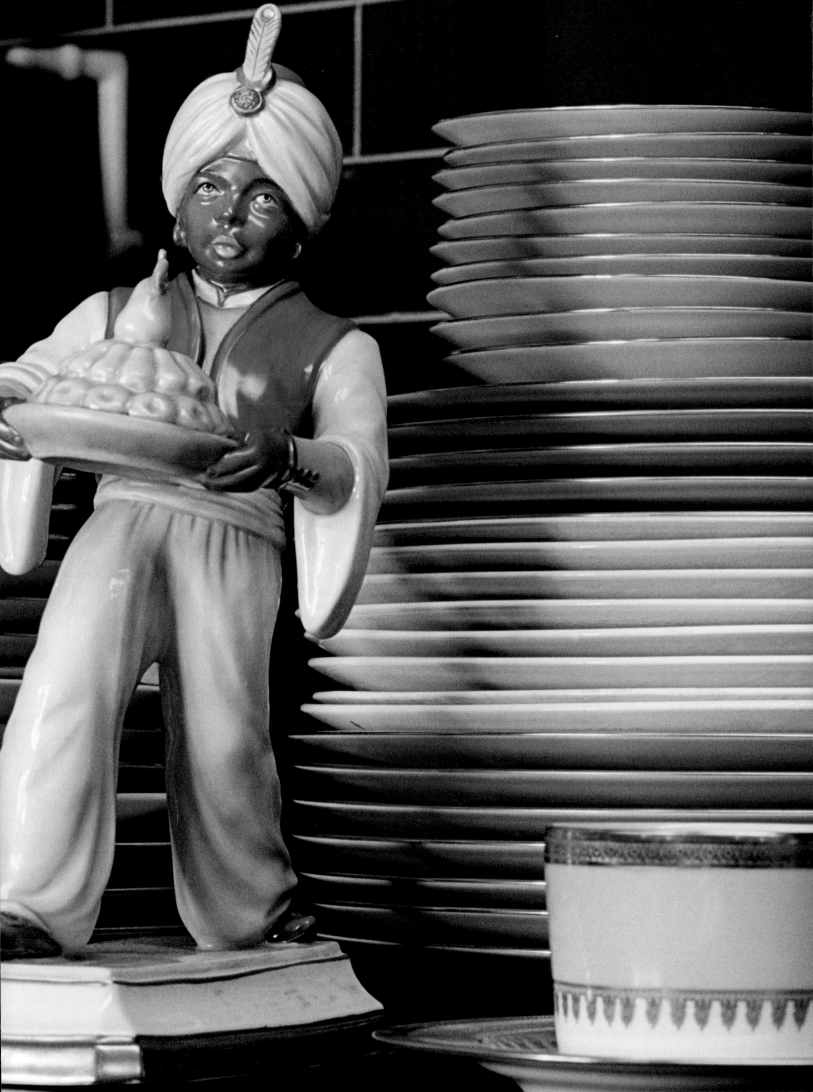

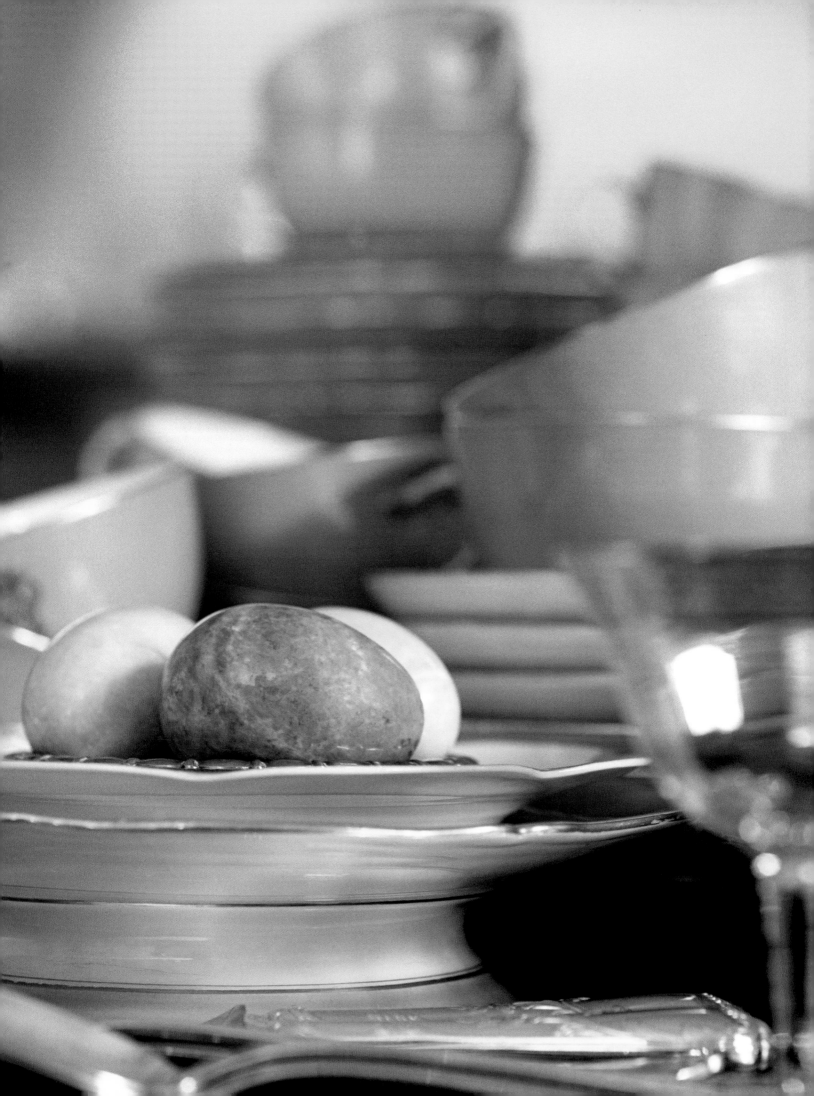

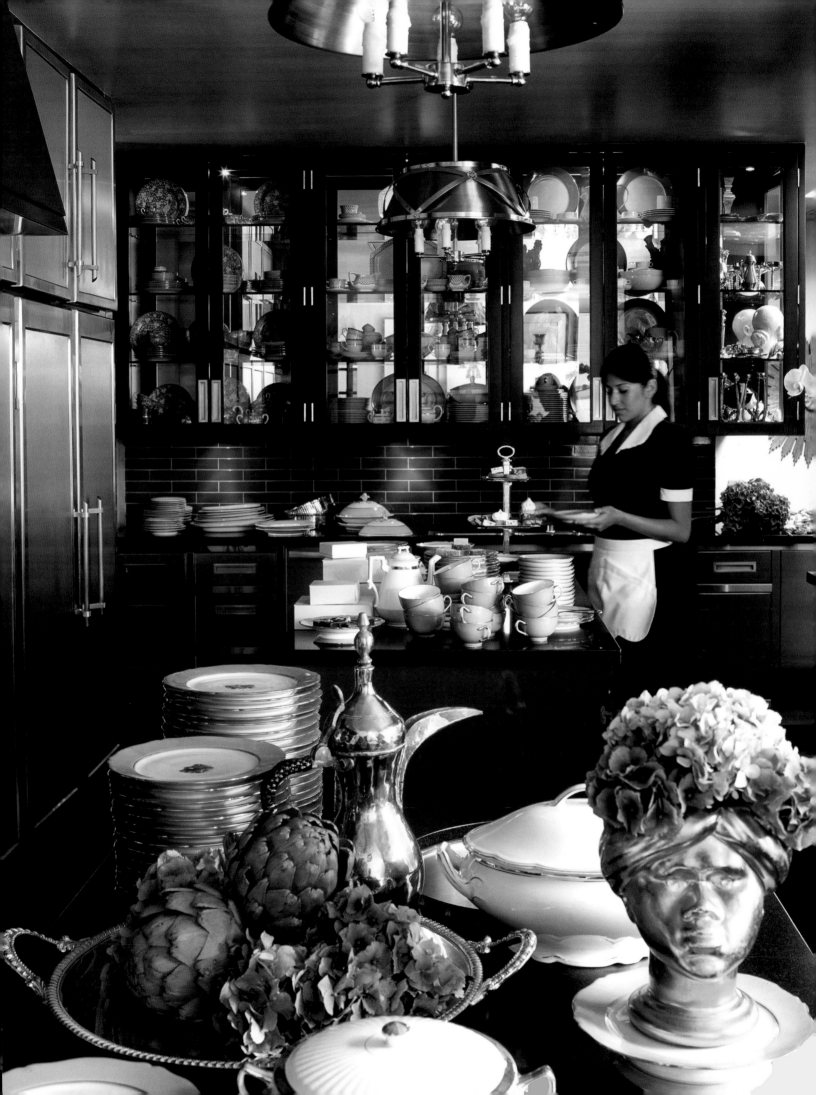

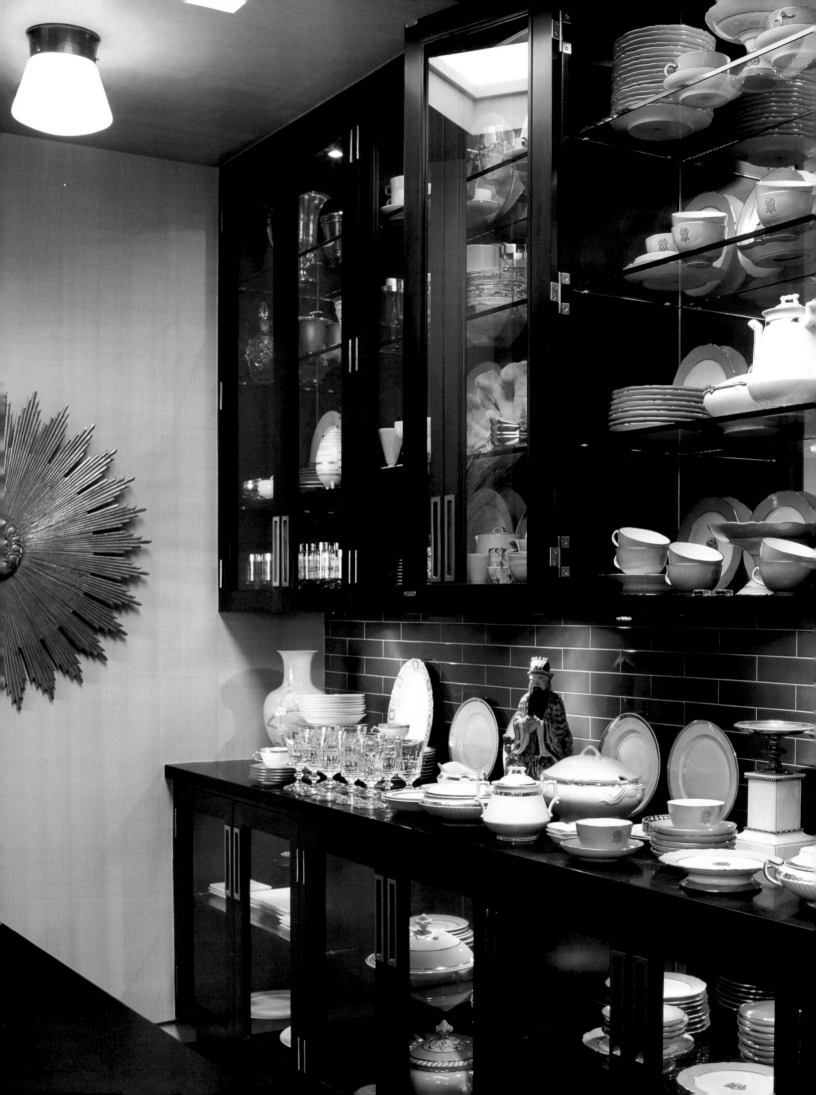

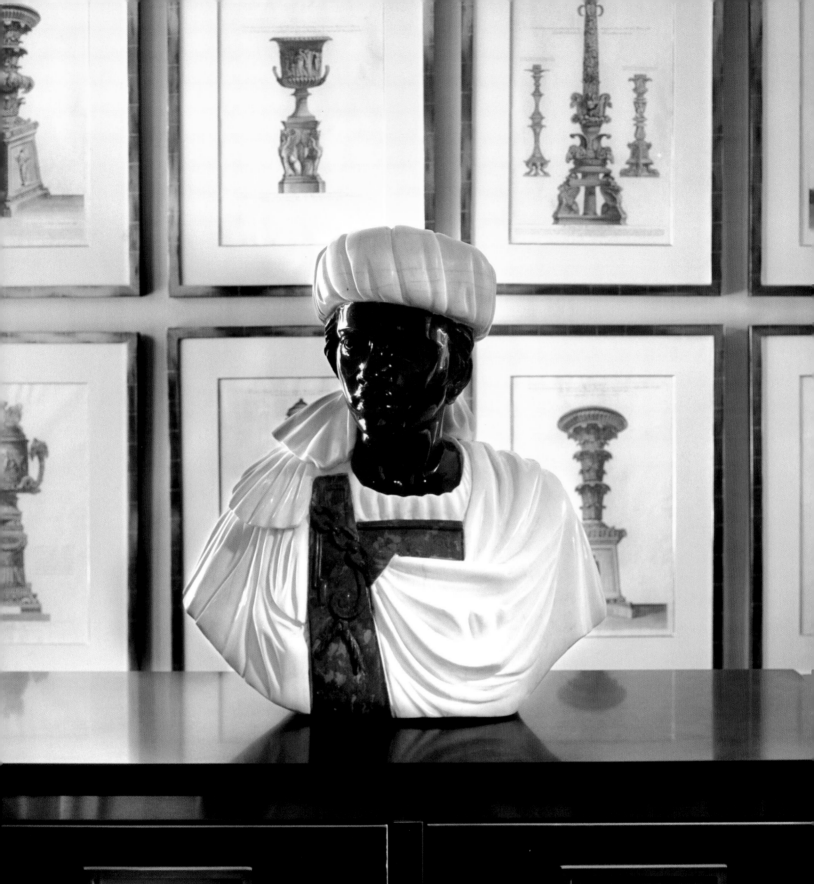

DINING ROOM

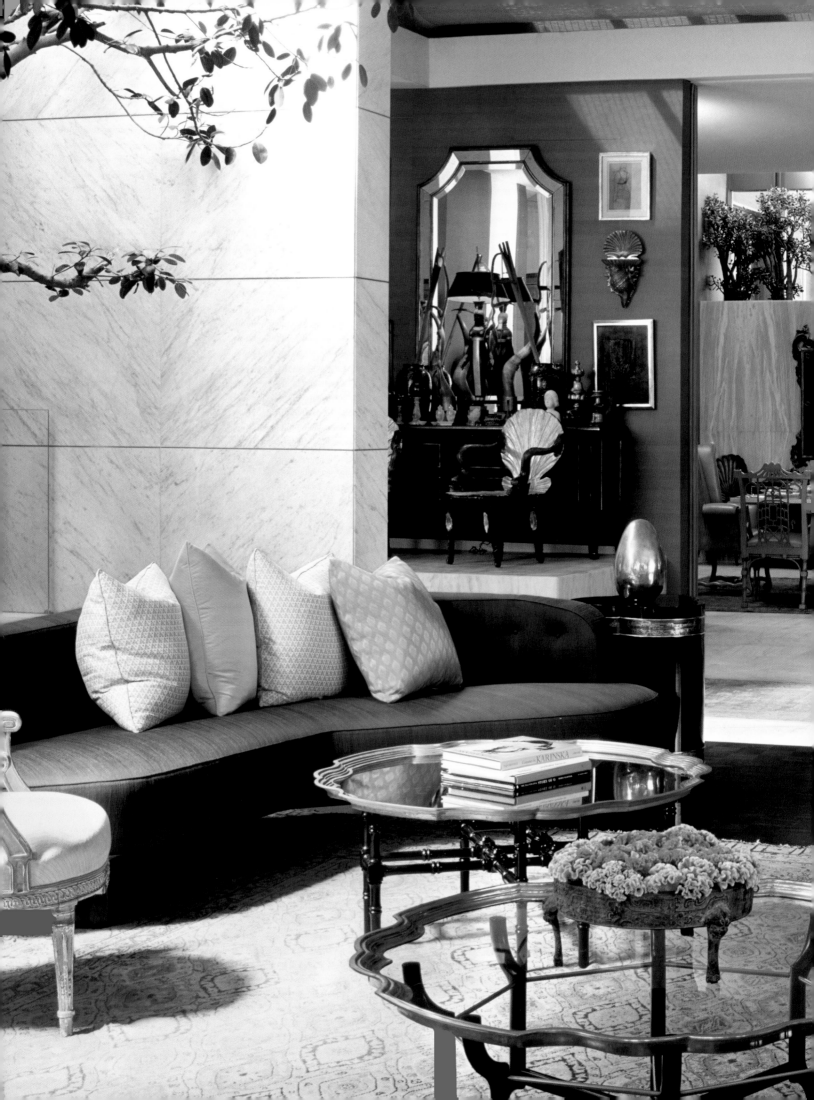

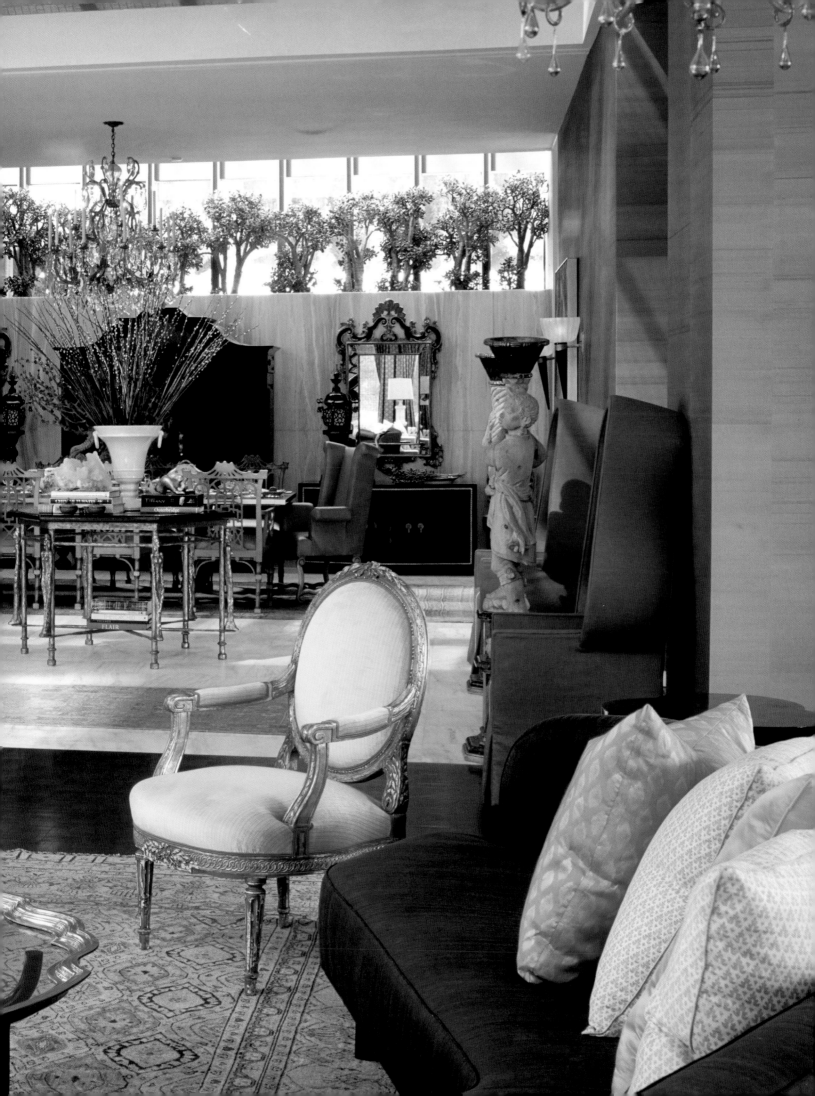

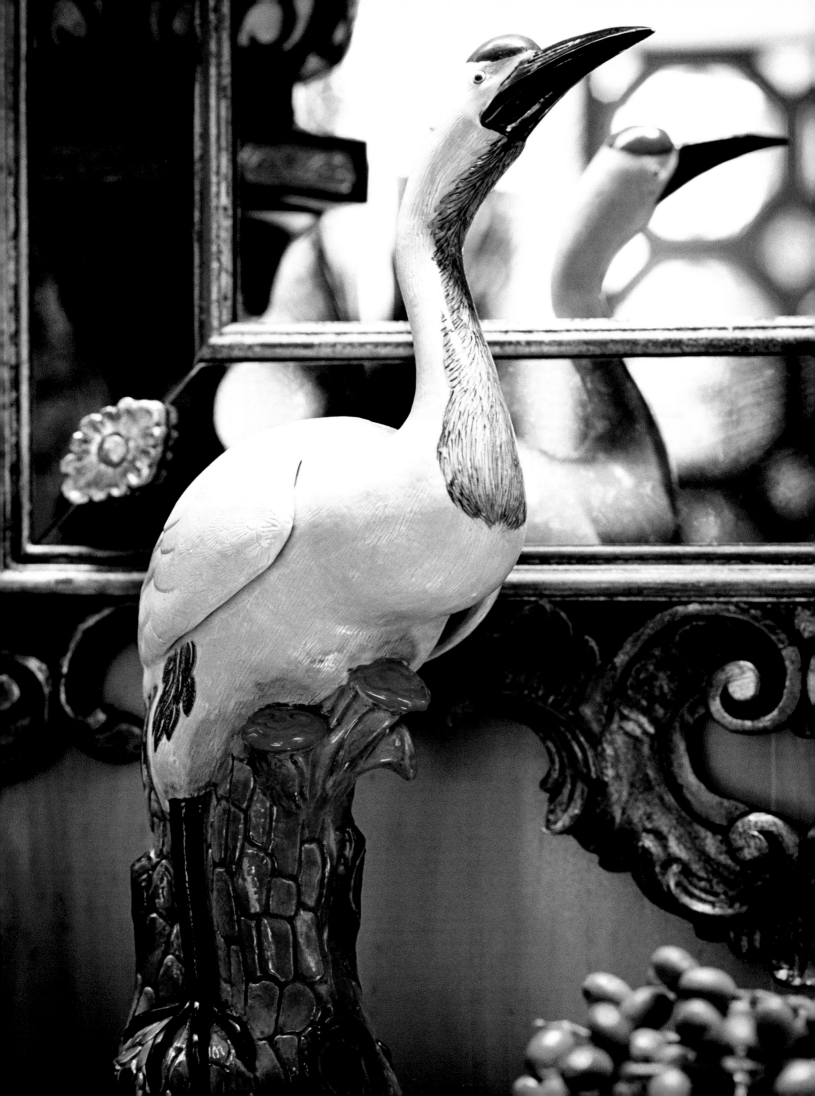

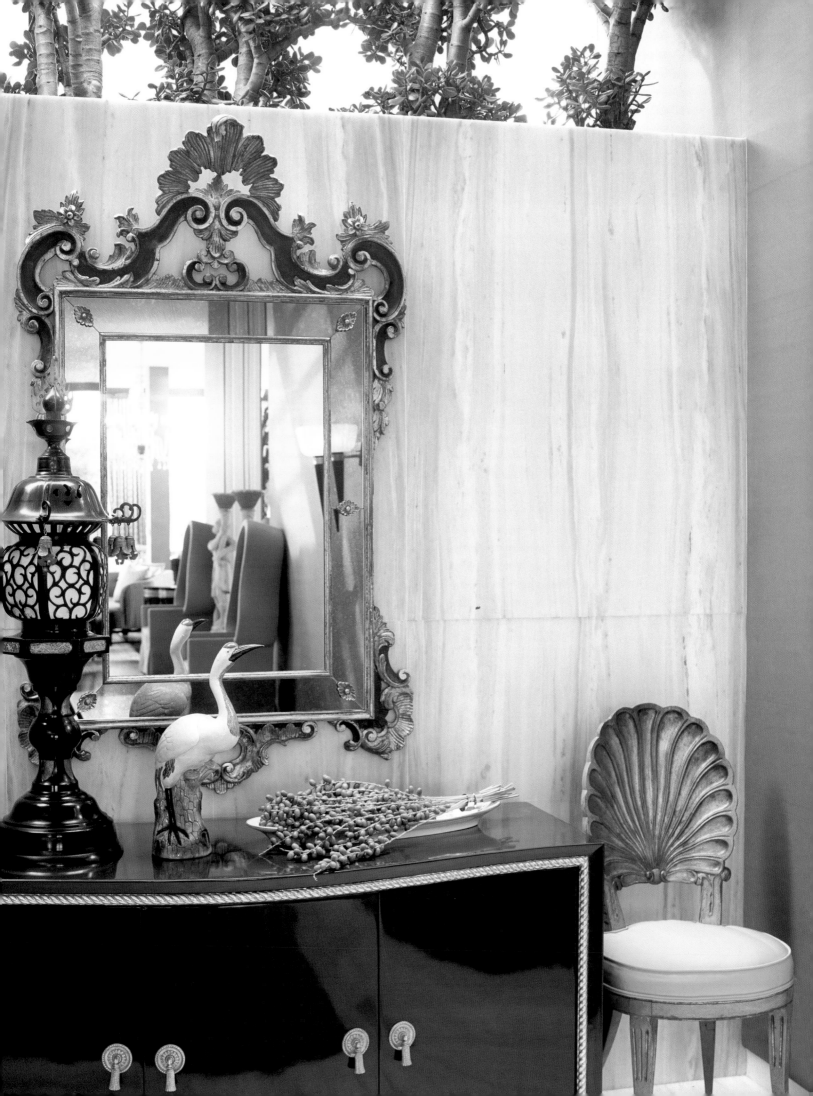

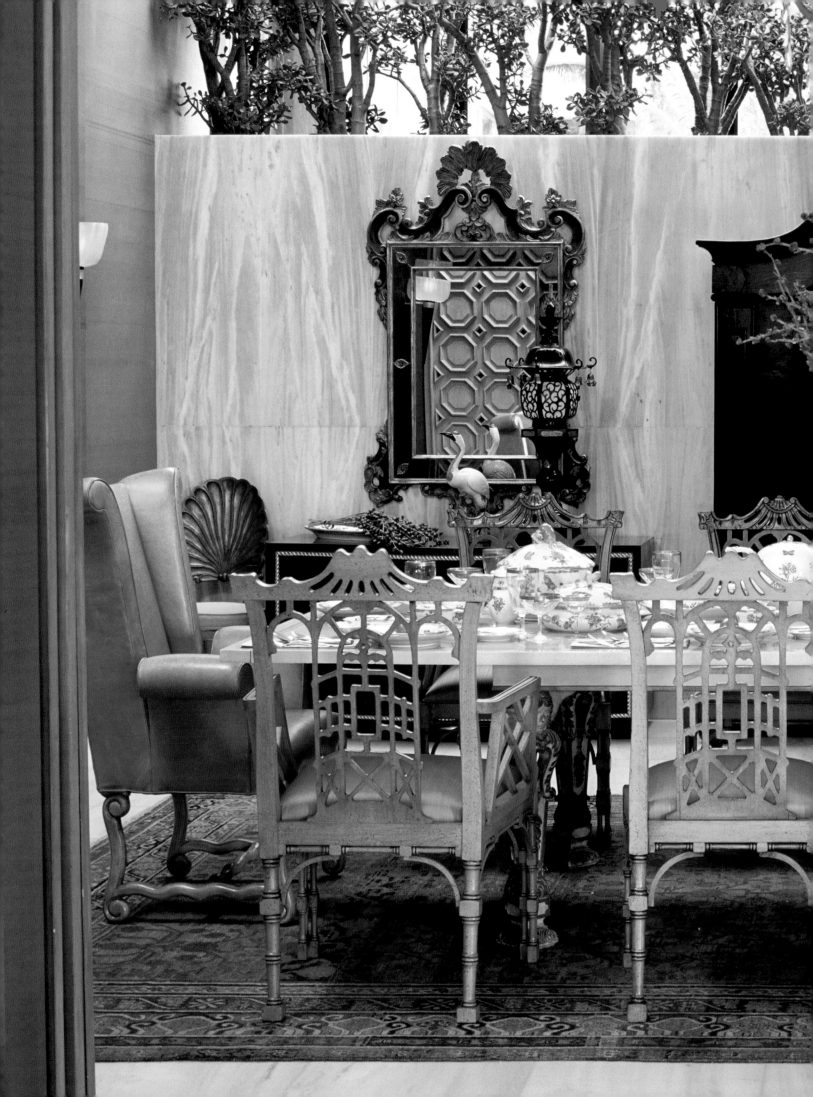

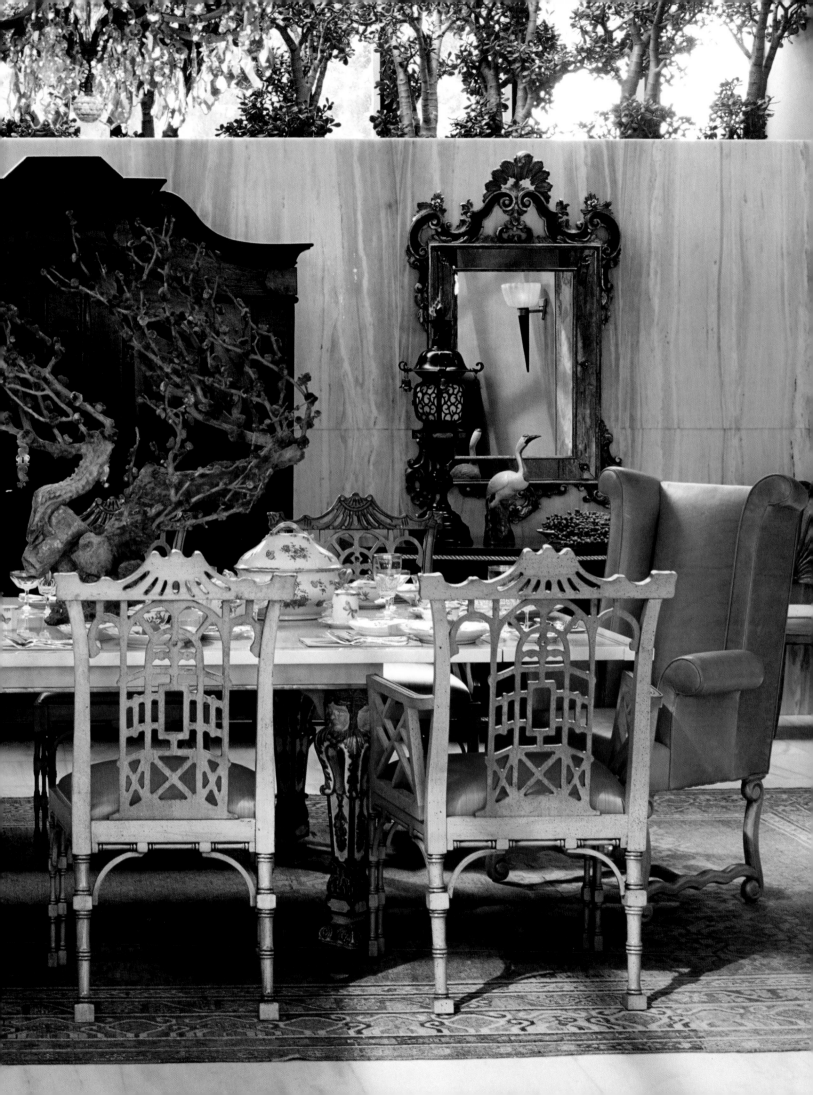

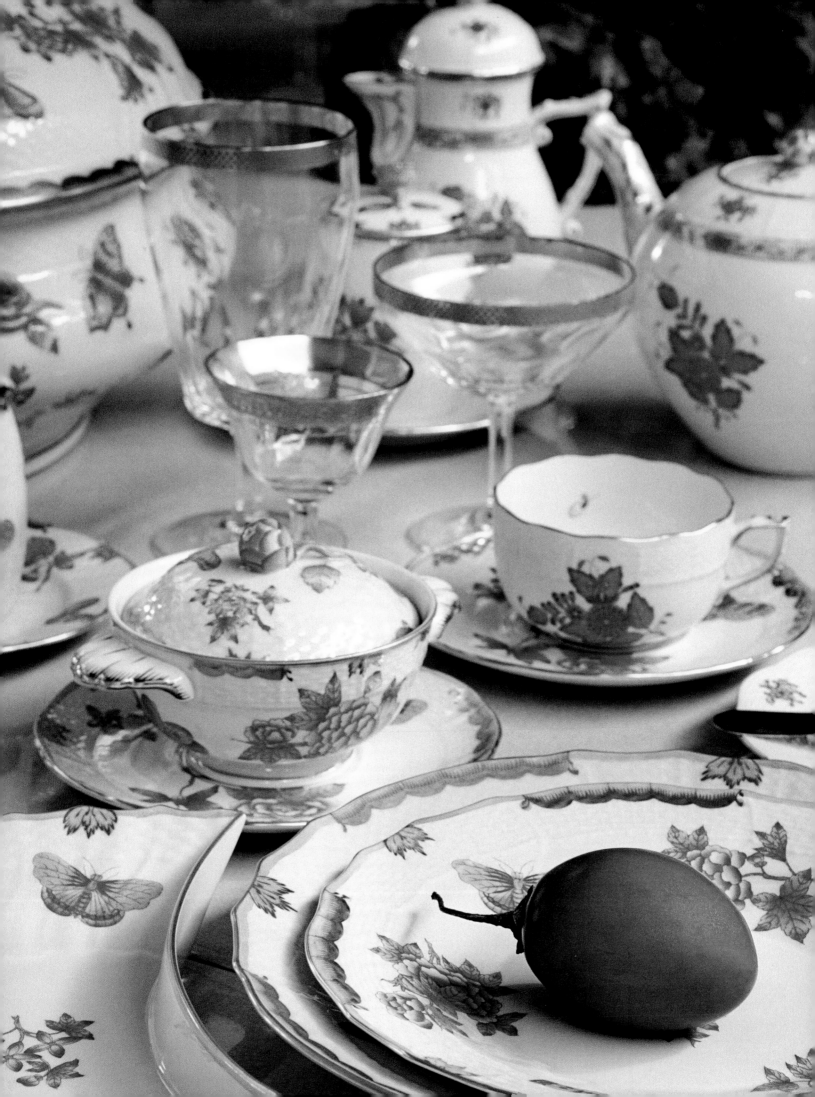

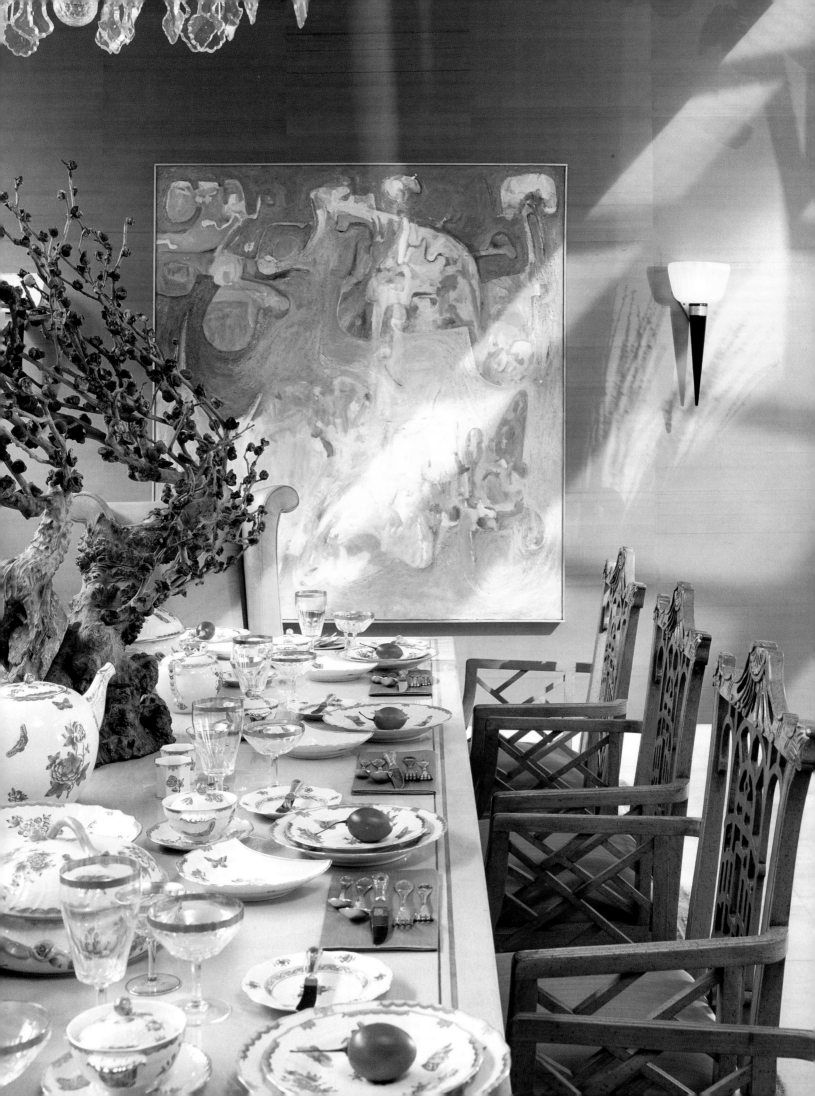

INTERIOR COURTYARD

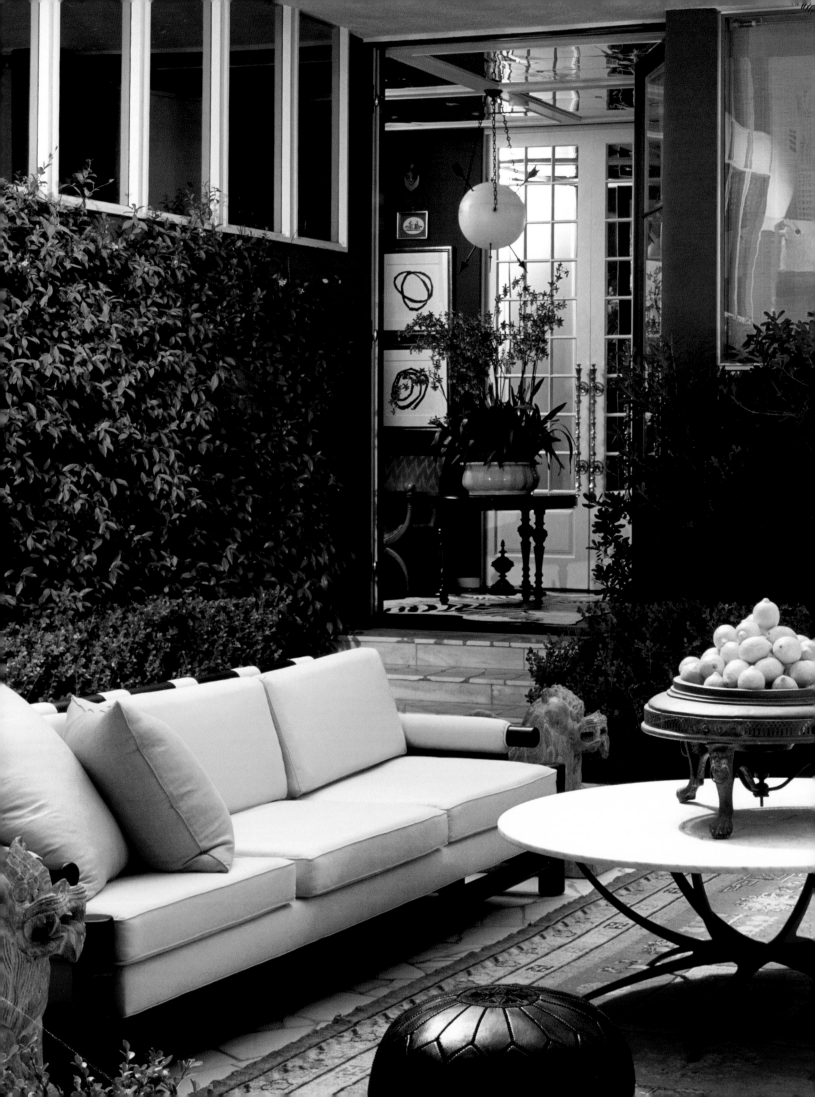

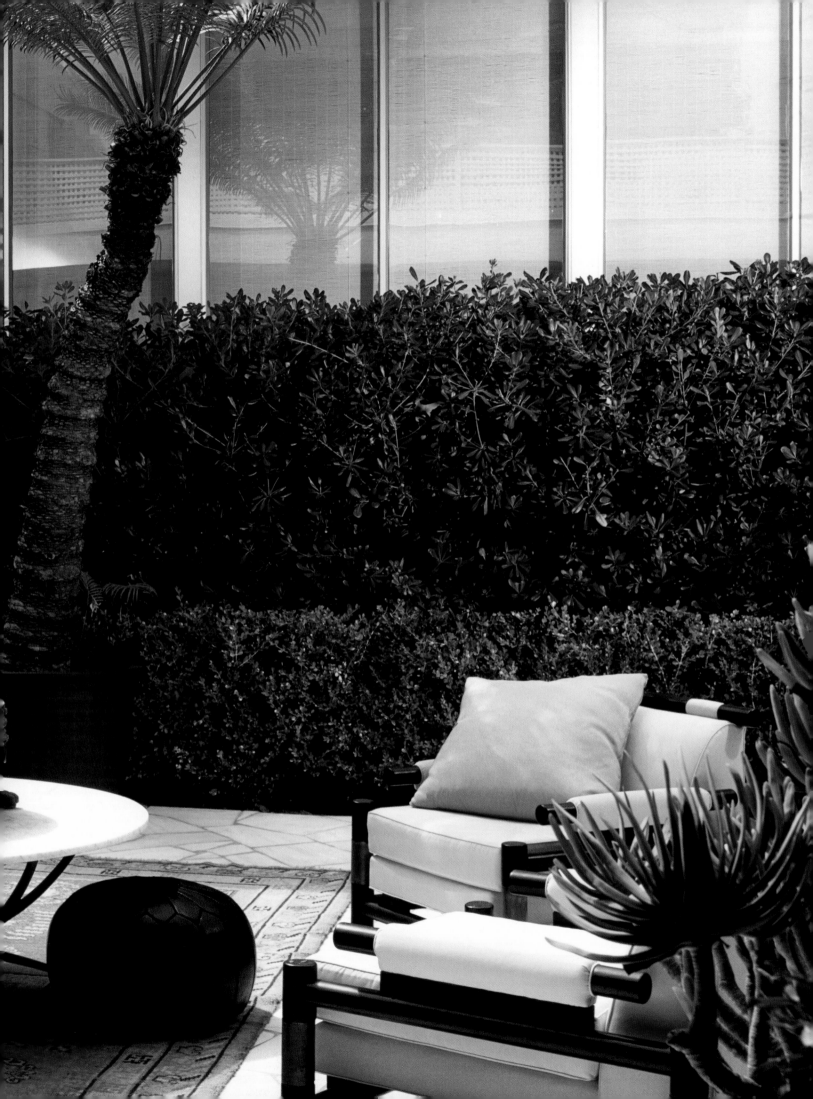

MASTER SUITE

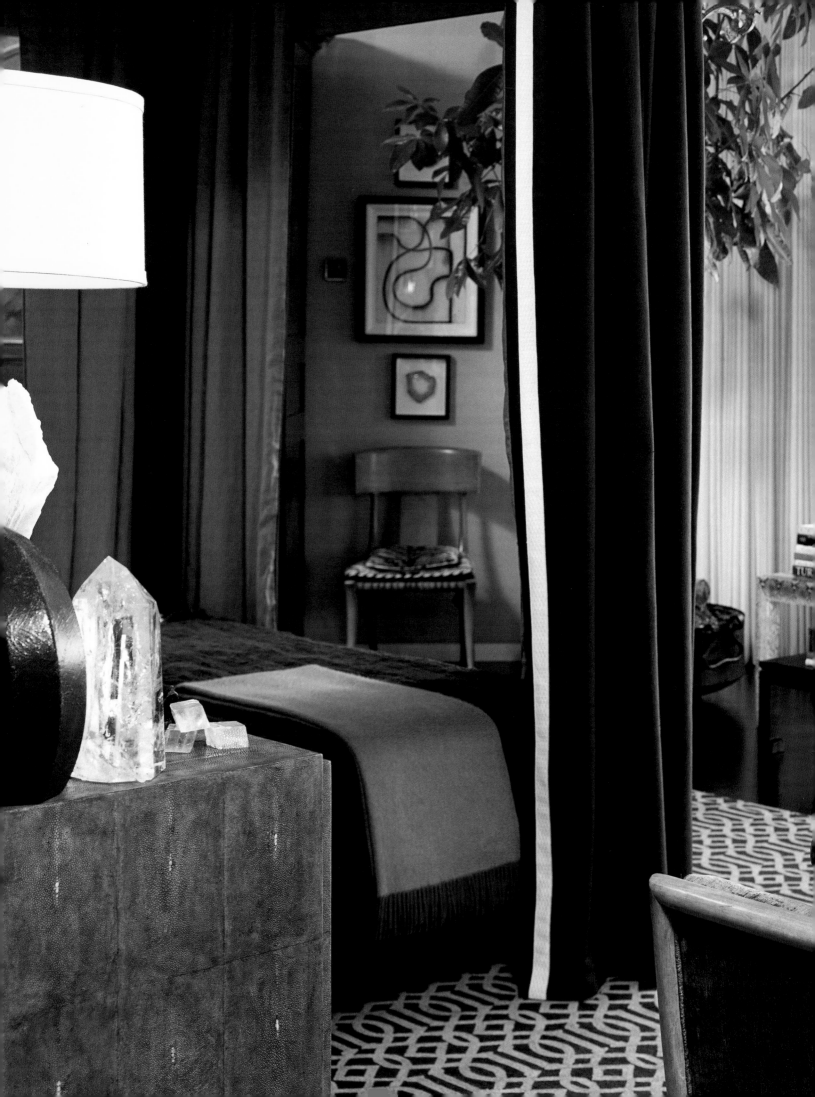

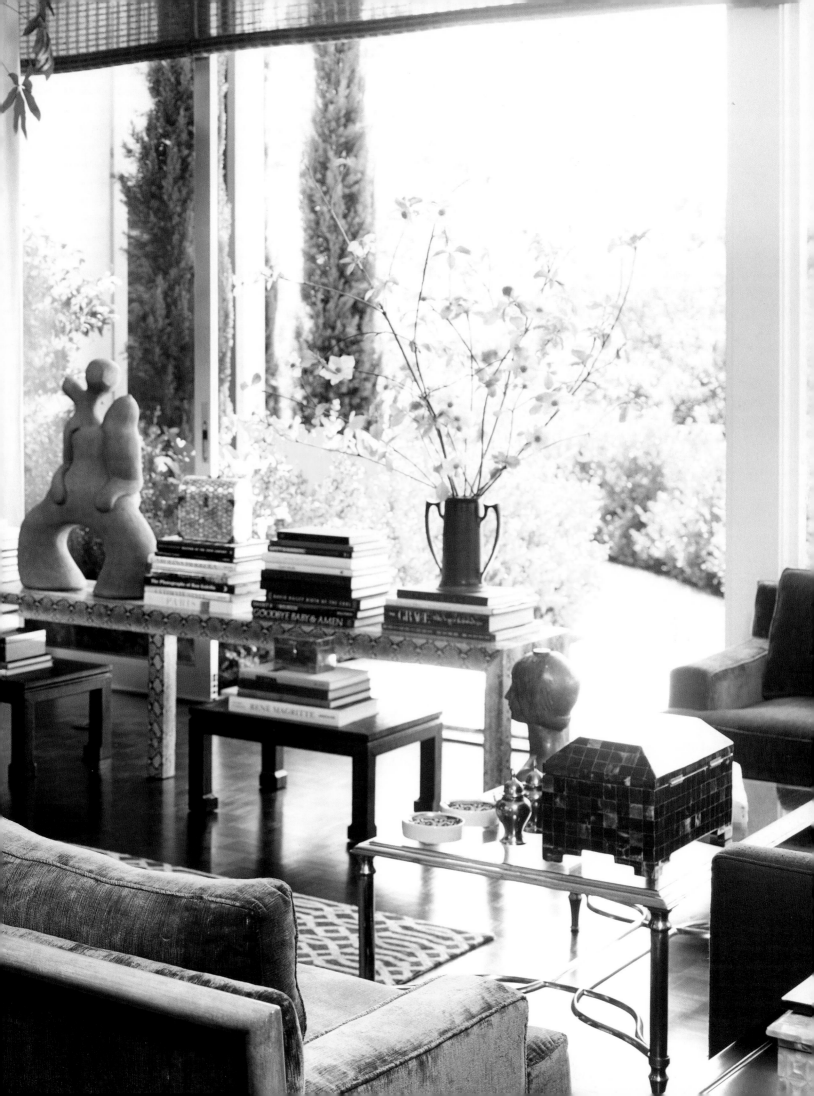

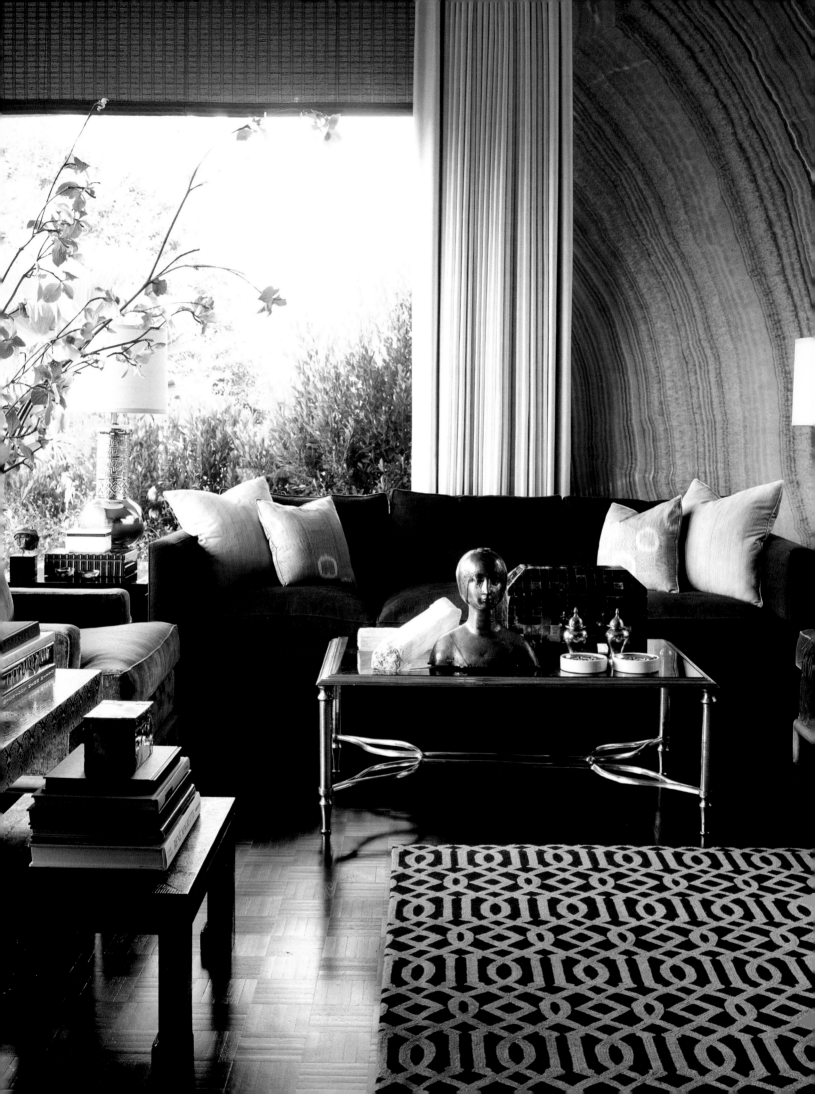

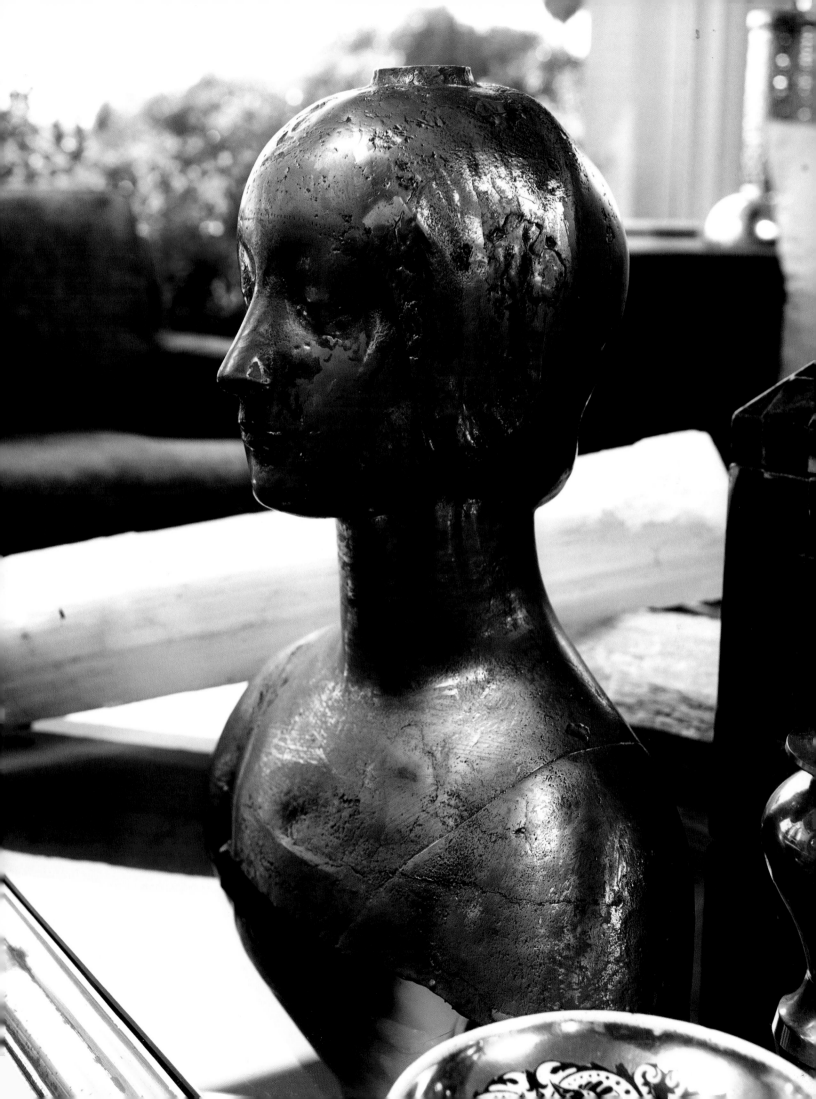

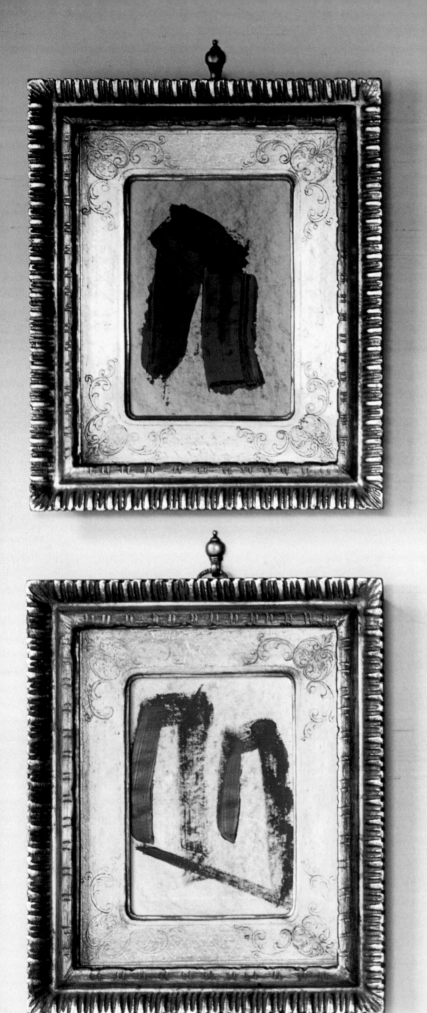
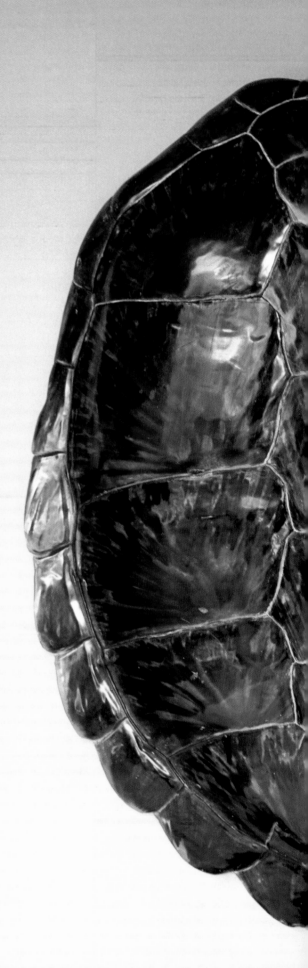

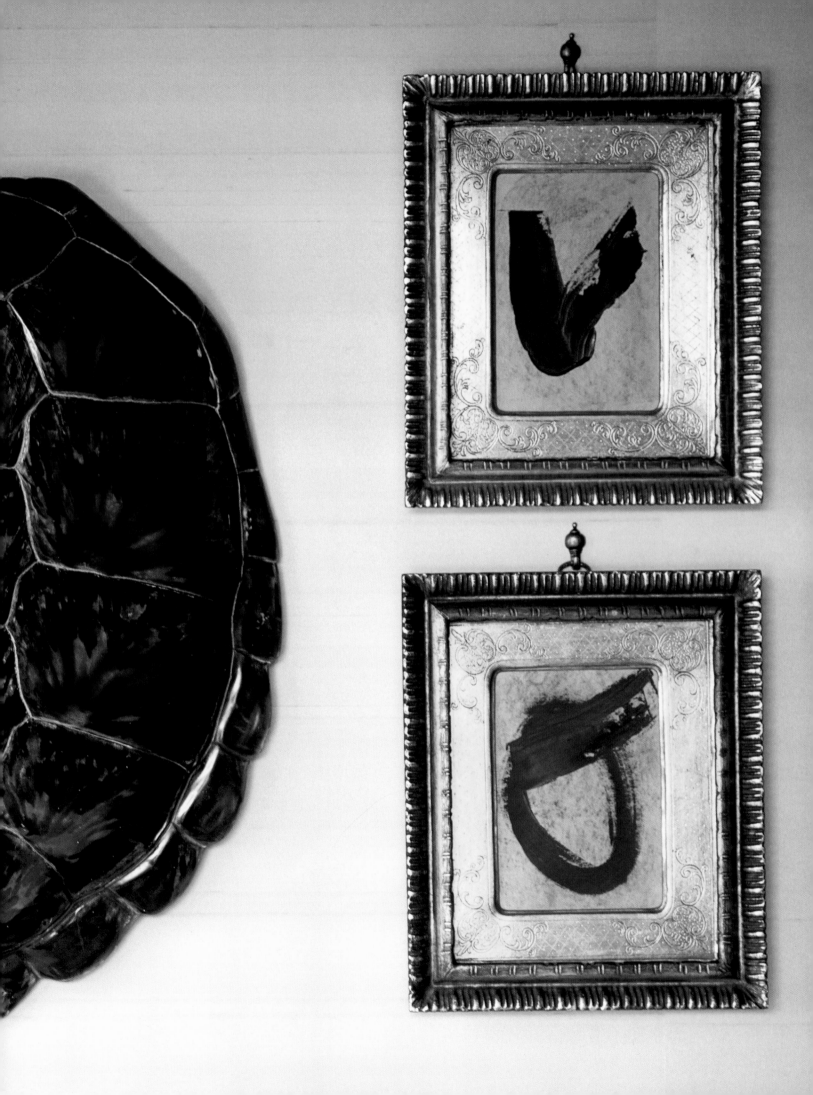

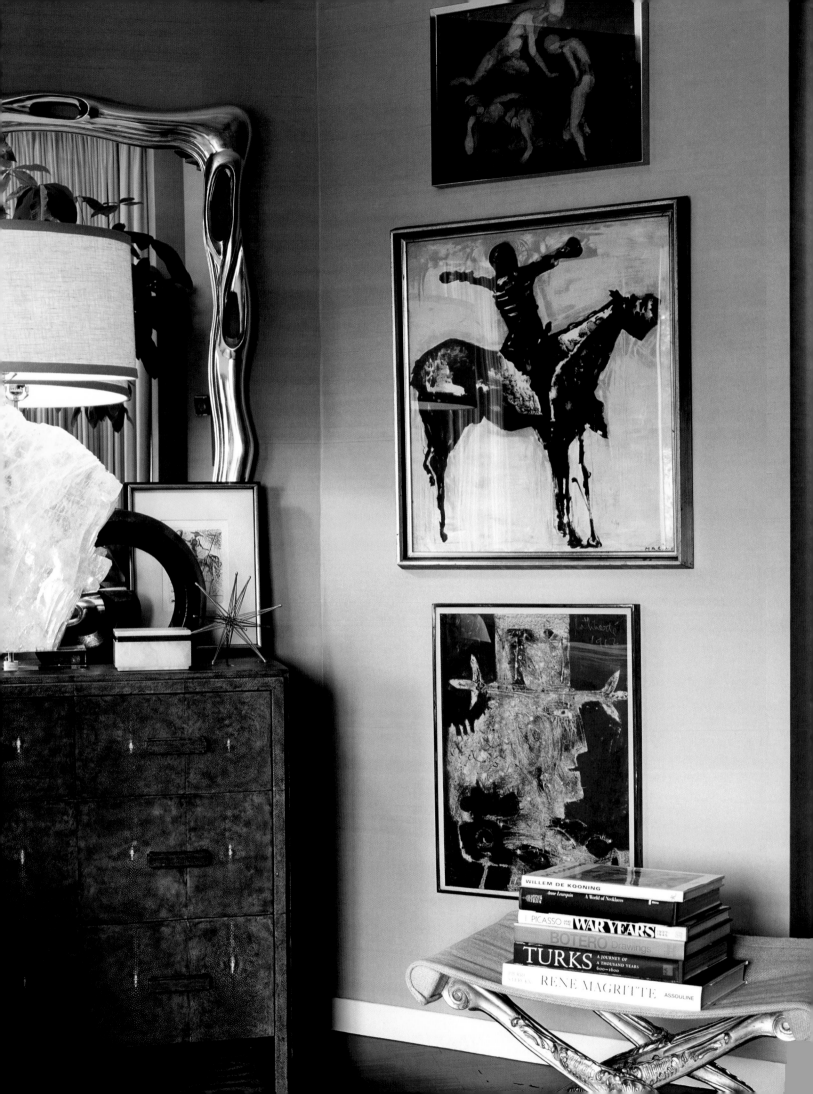

WILLEM DE KOONING

Anne Leurquin · A World of Necklaces

PICASSO AND THE WAR YEARS

BOTERO Drawings

TURKS · A JOURNEY OF A THOUSAND YEARS 600–1600

RENE MAGRITTE · ASSOULINE

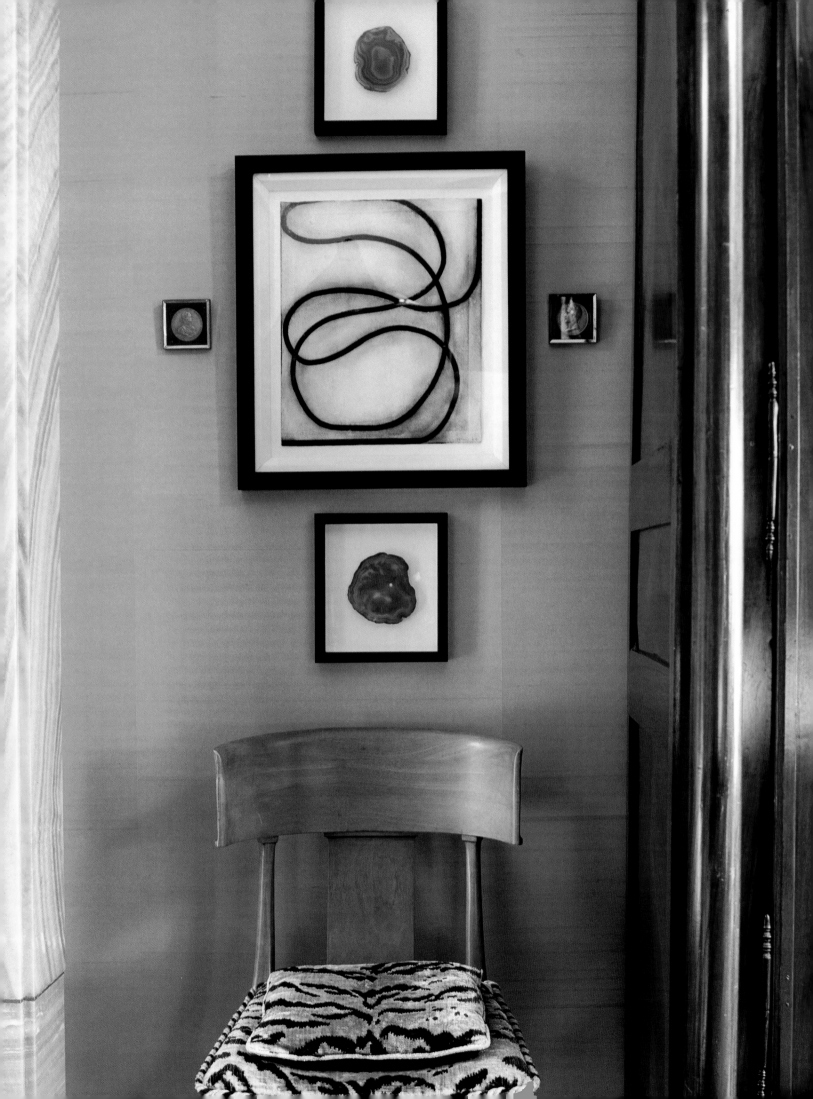

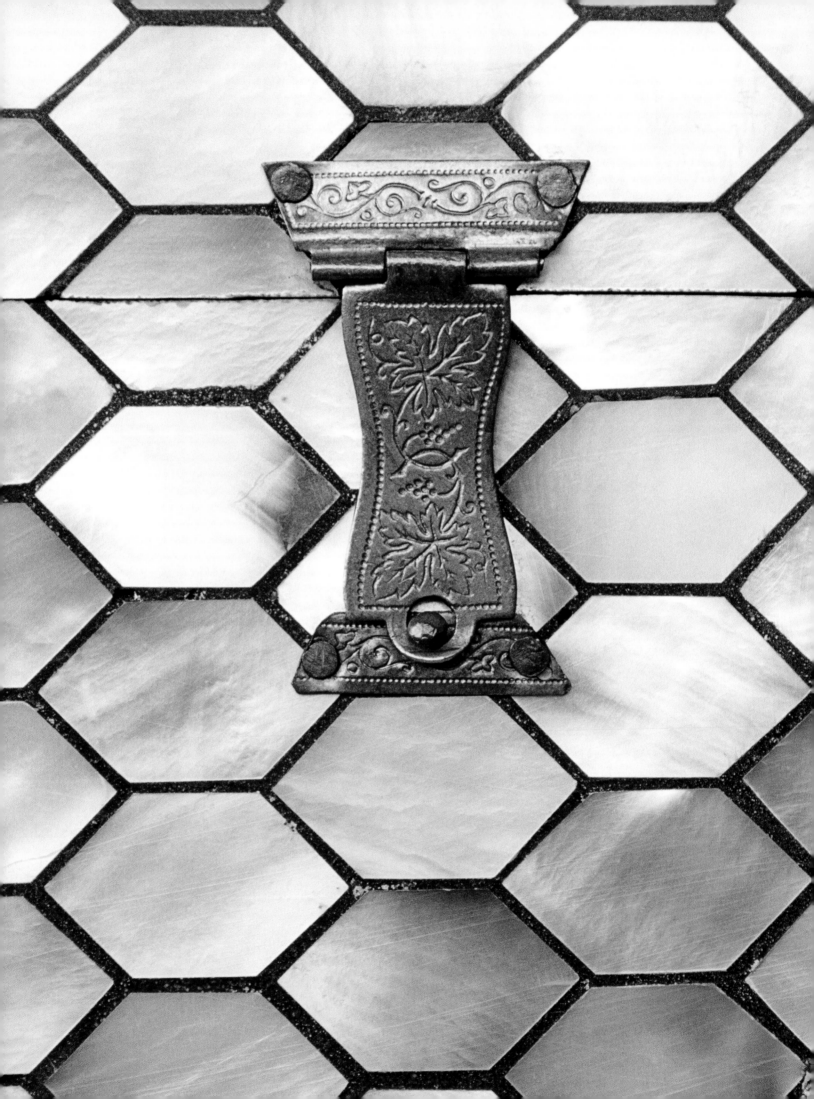

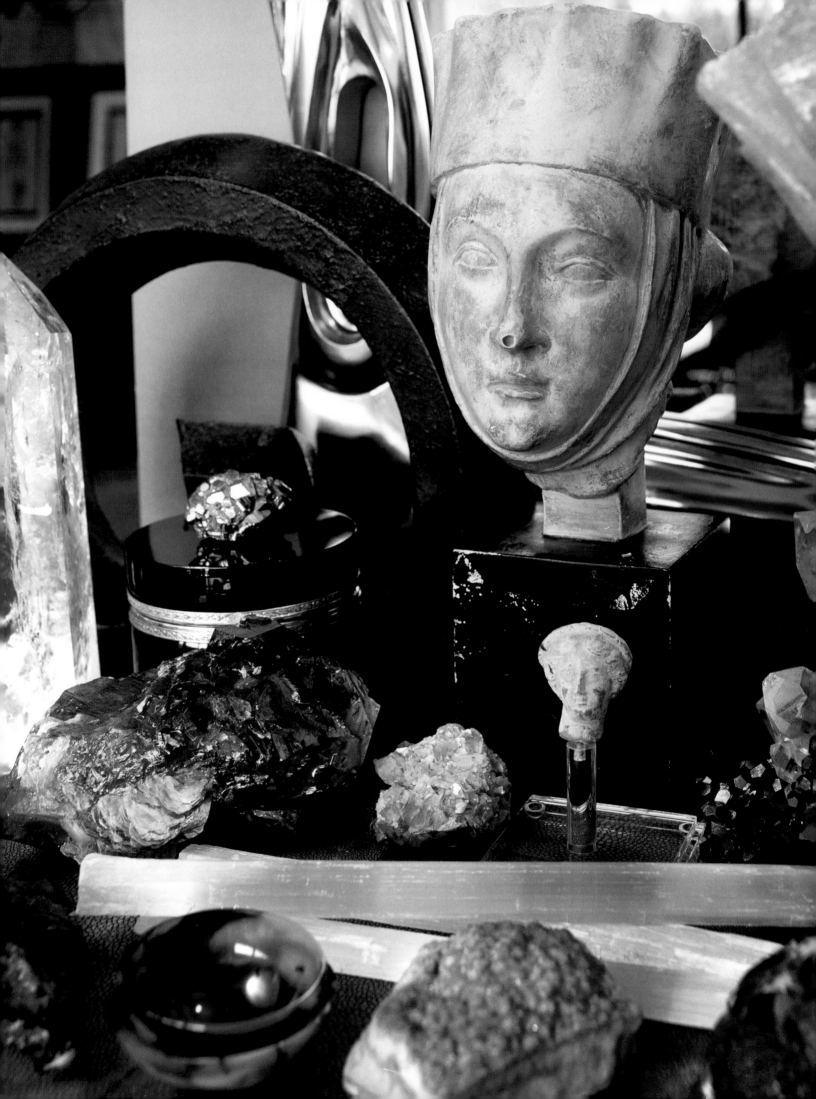

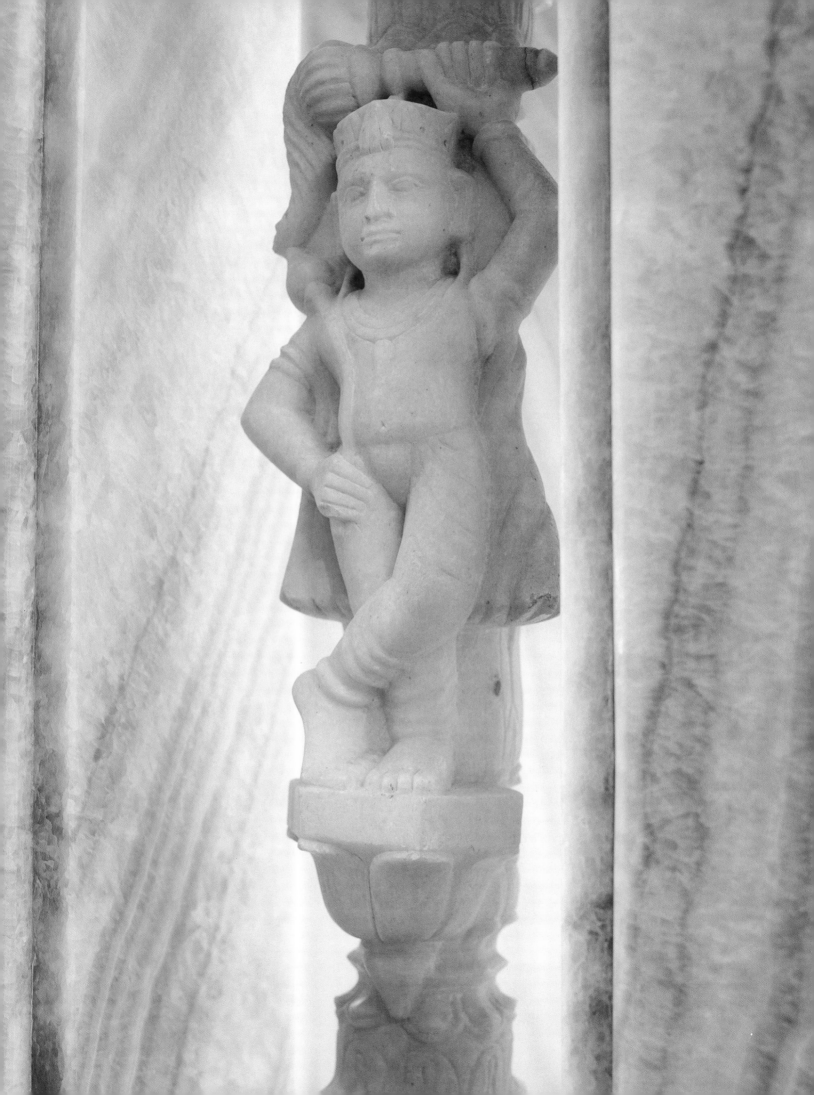

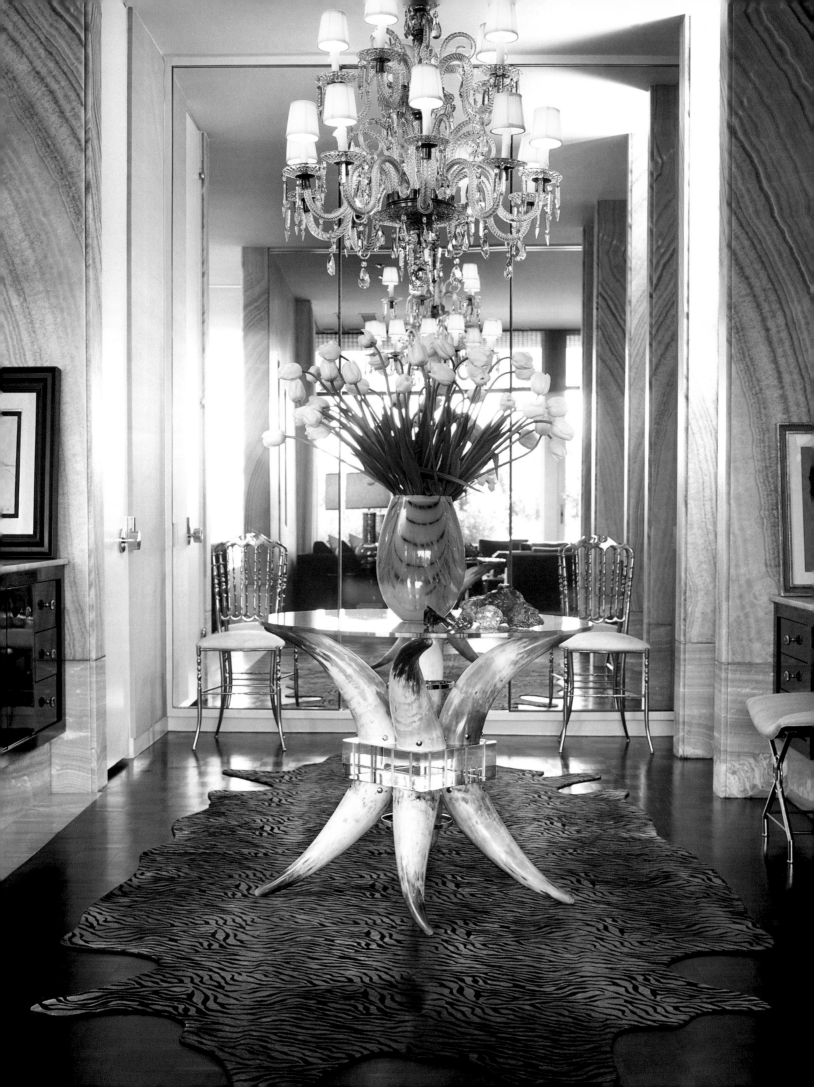

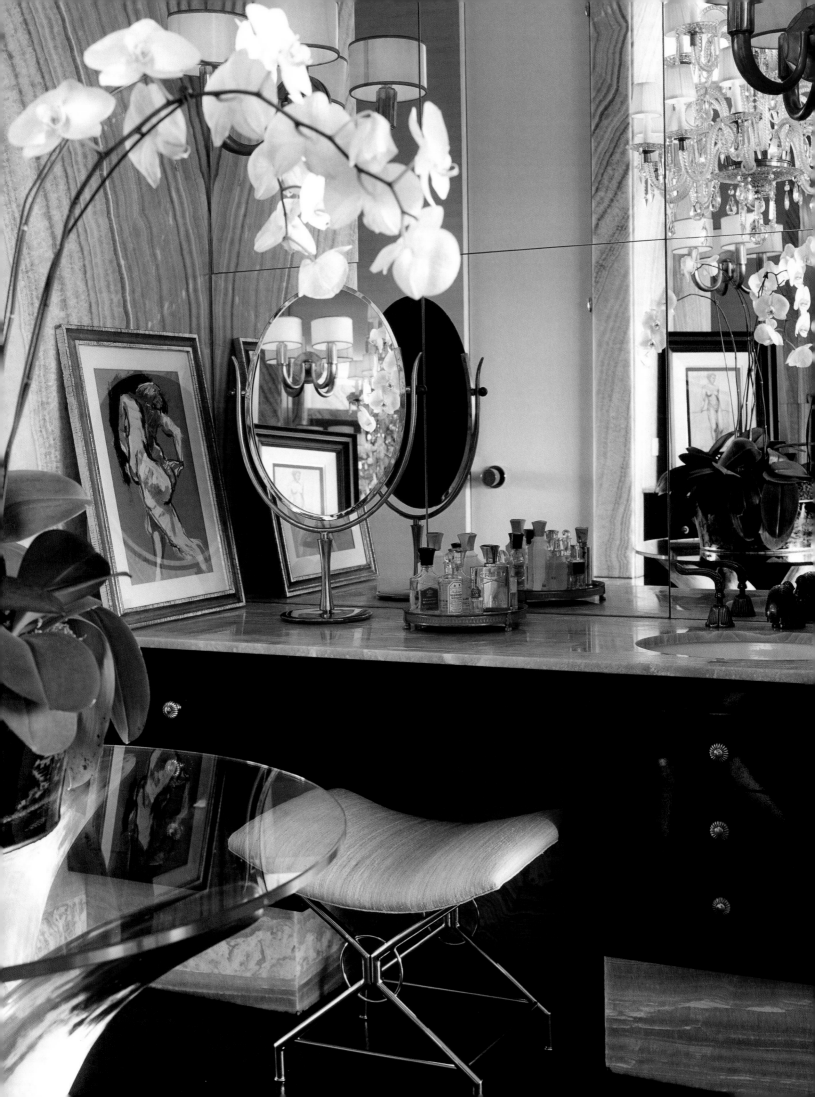

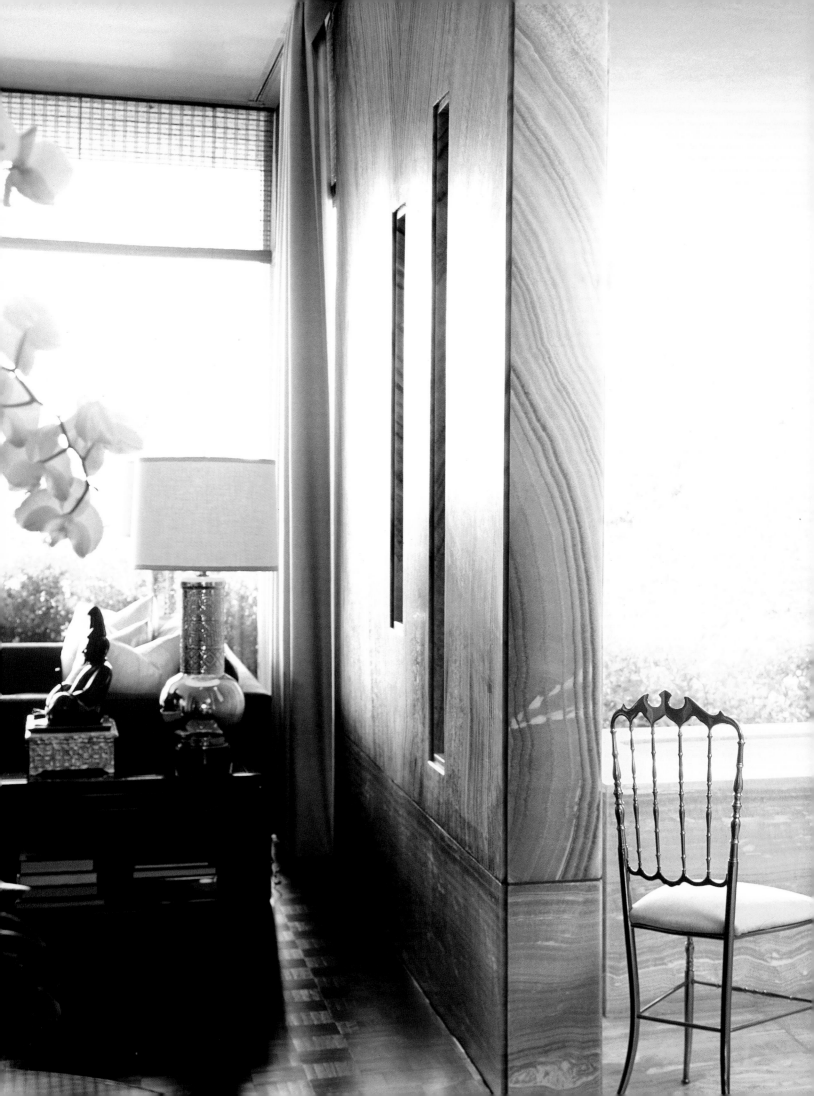

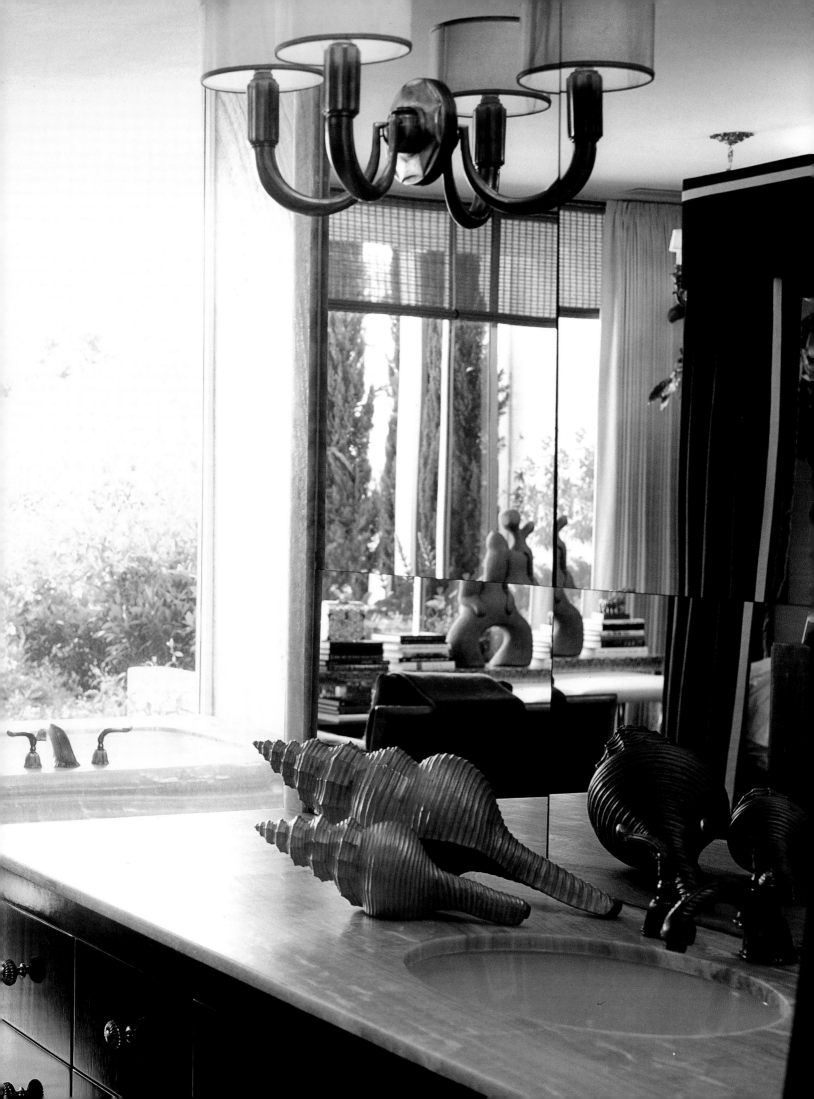

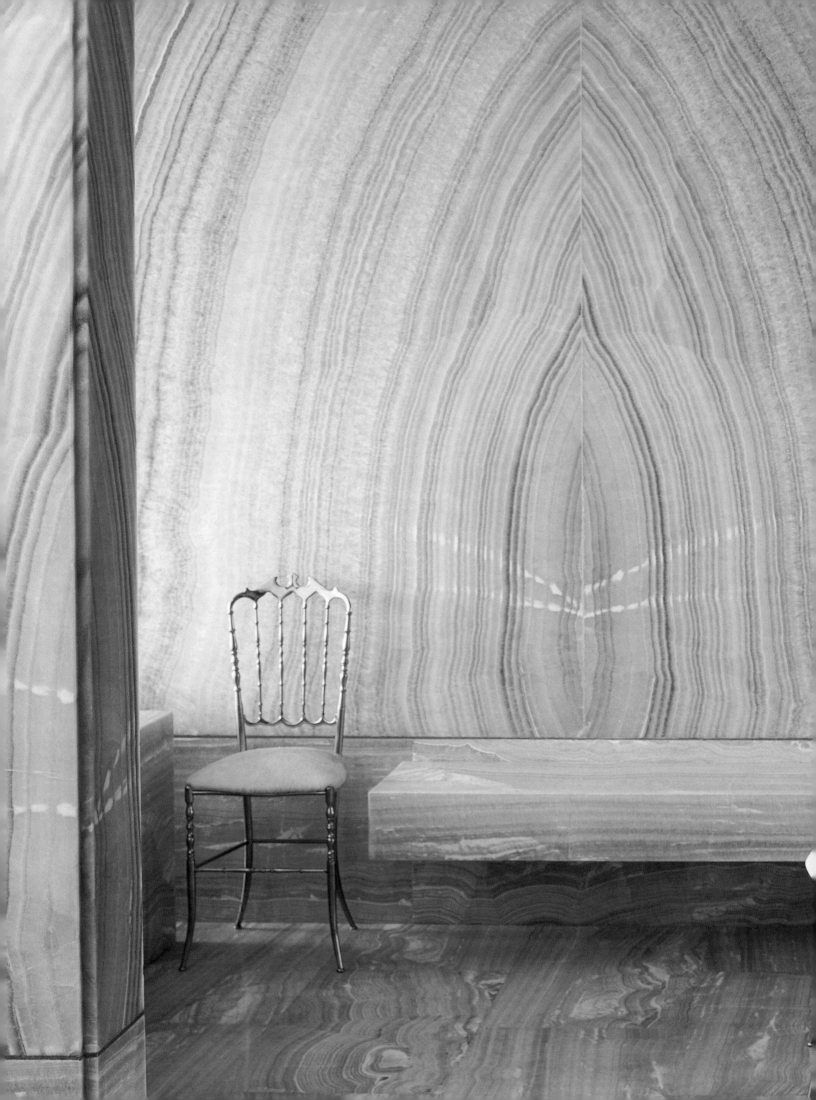

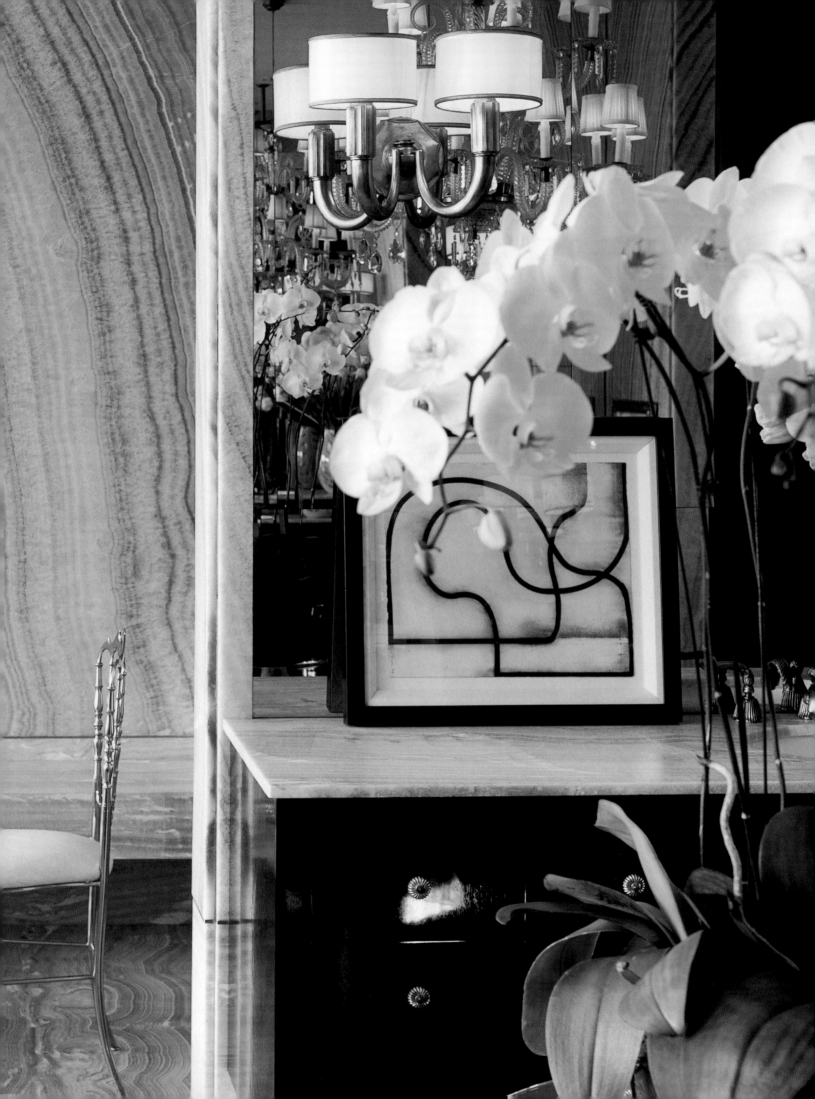

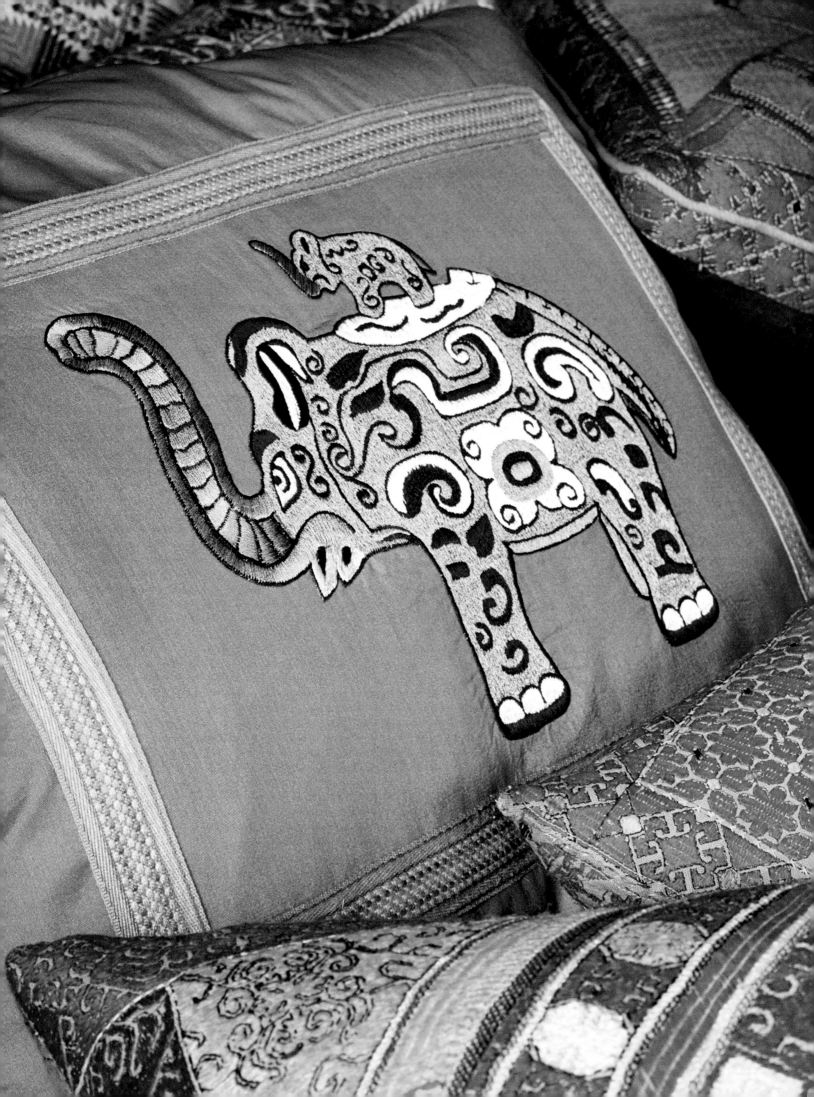

GUEST SUITE

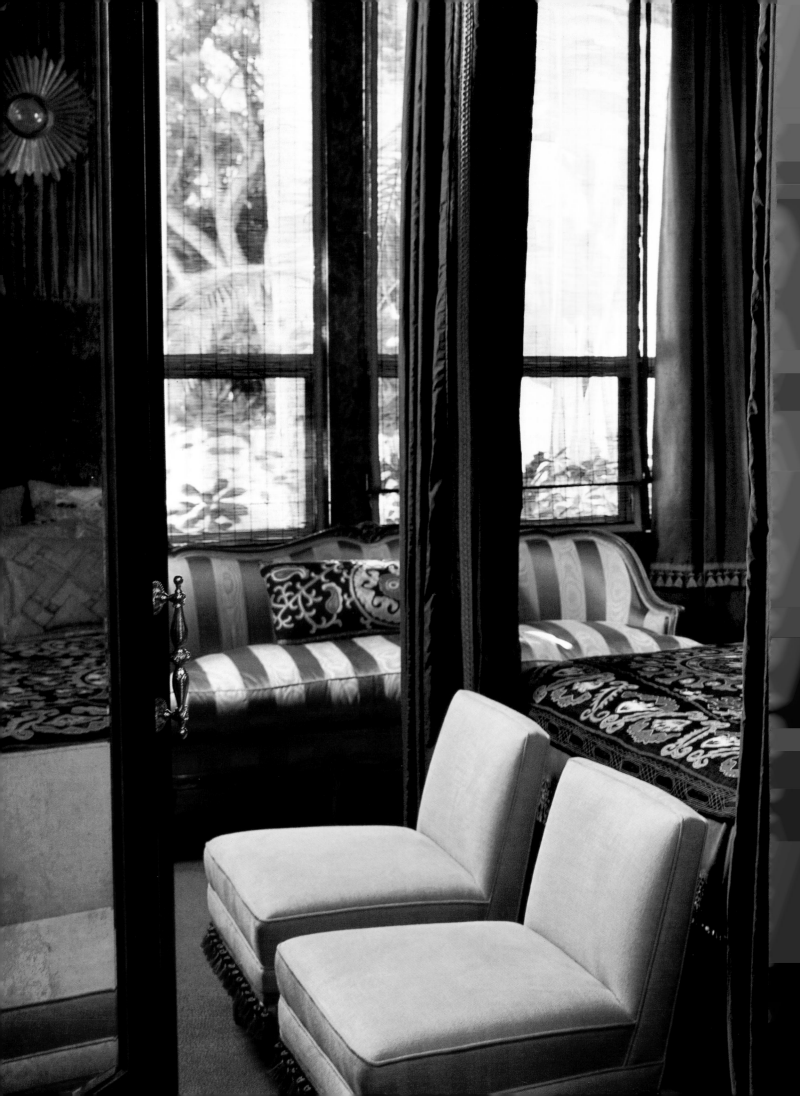

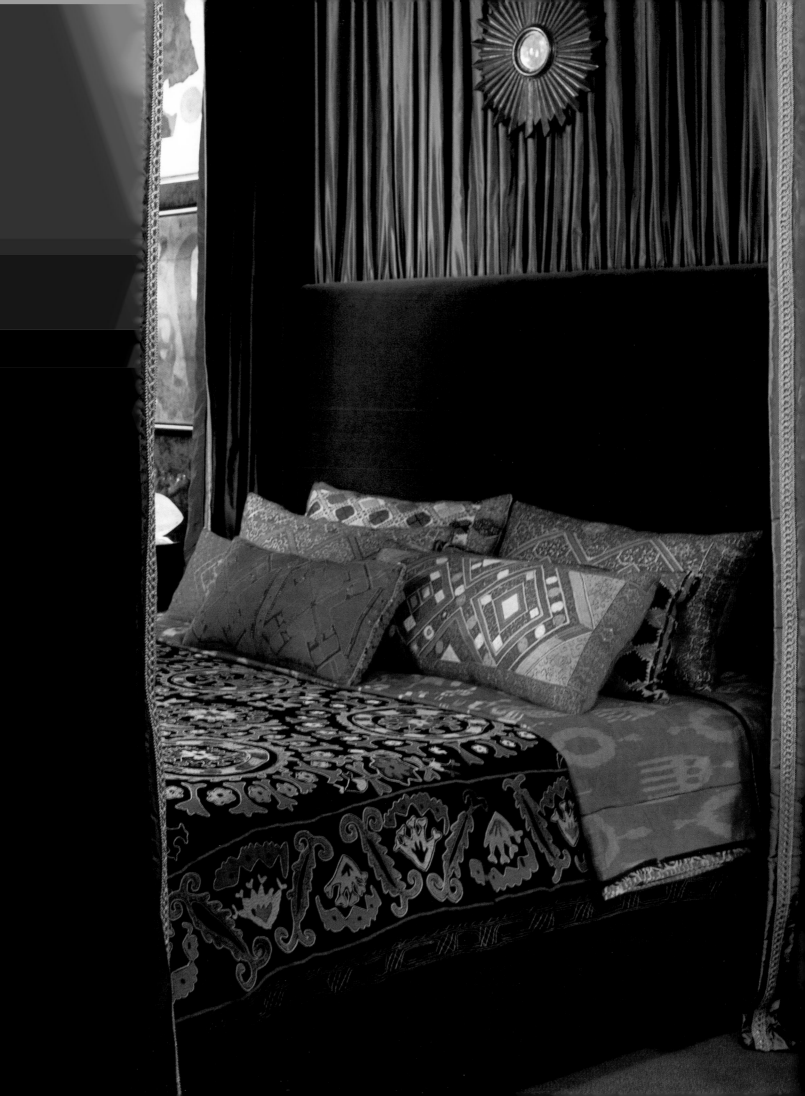

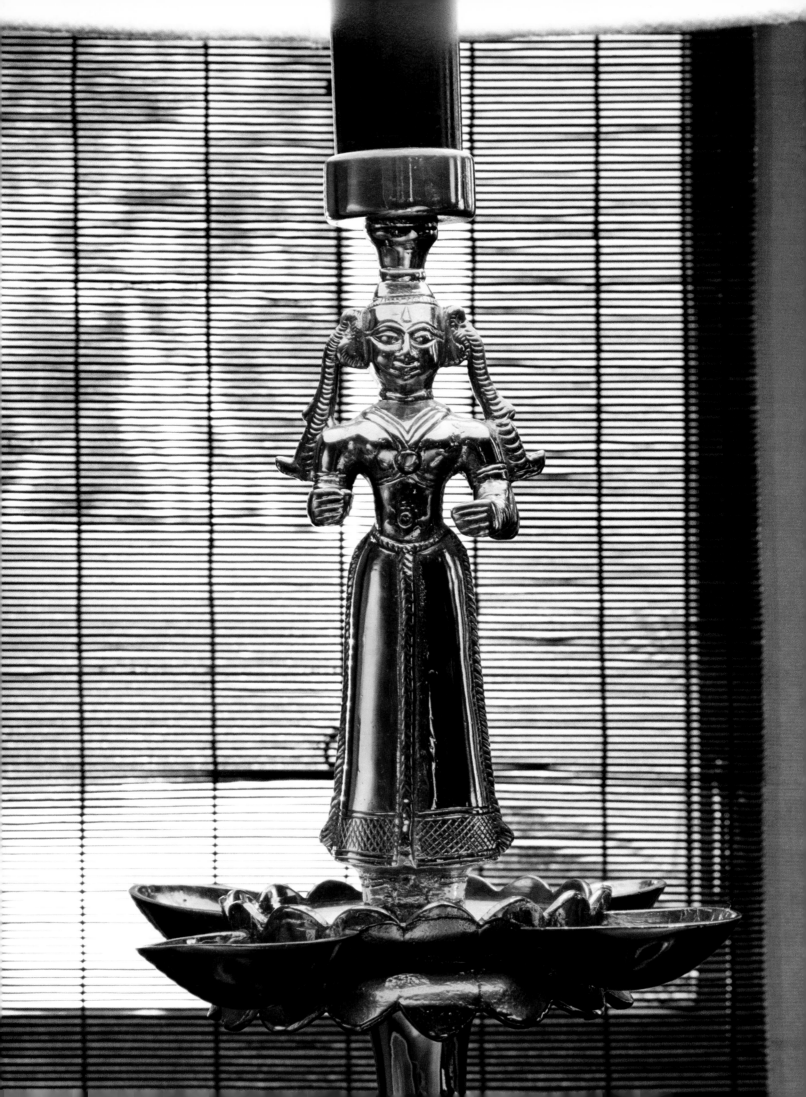

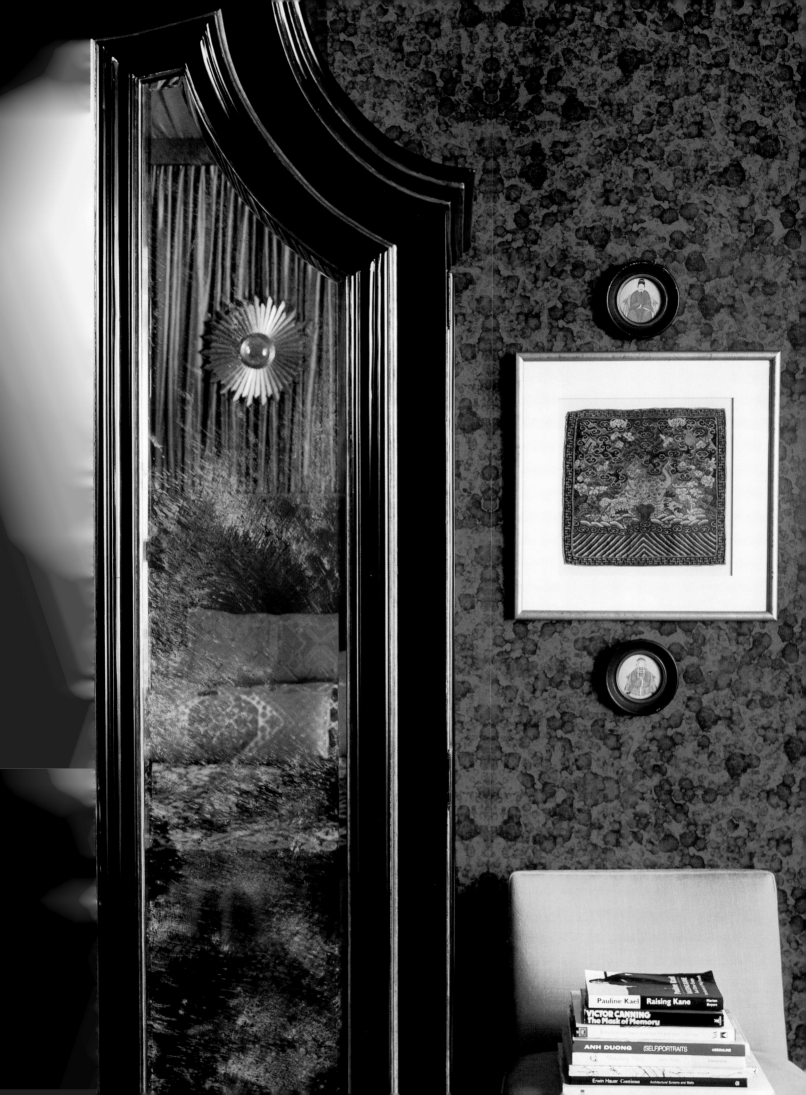

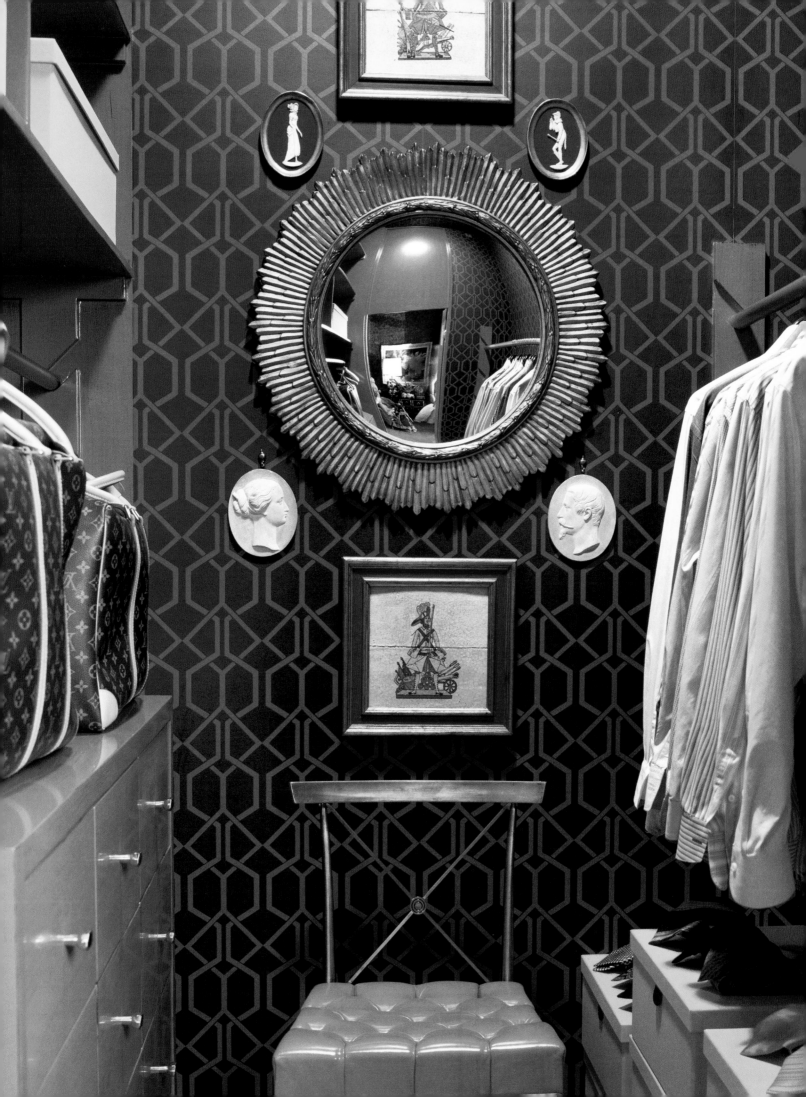

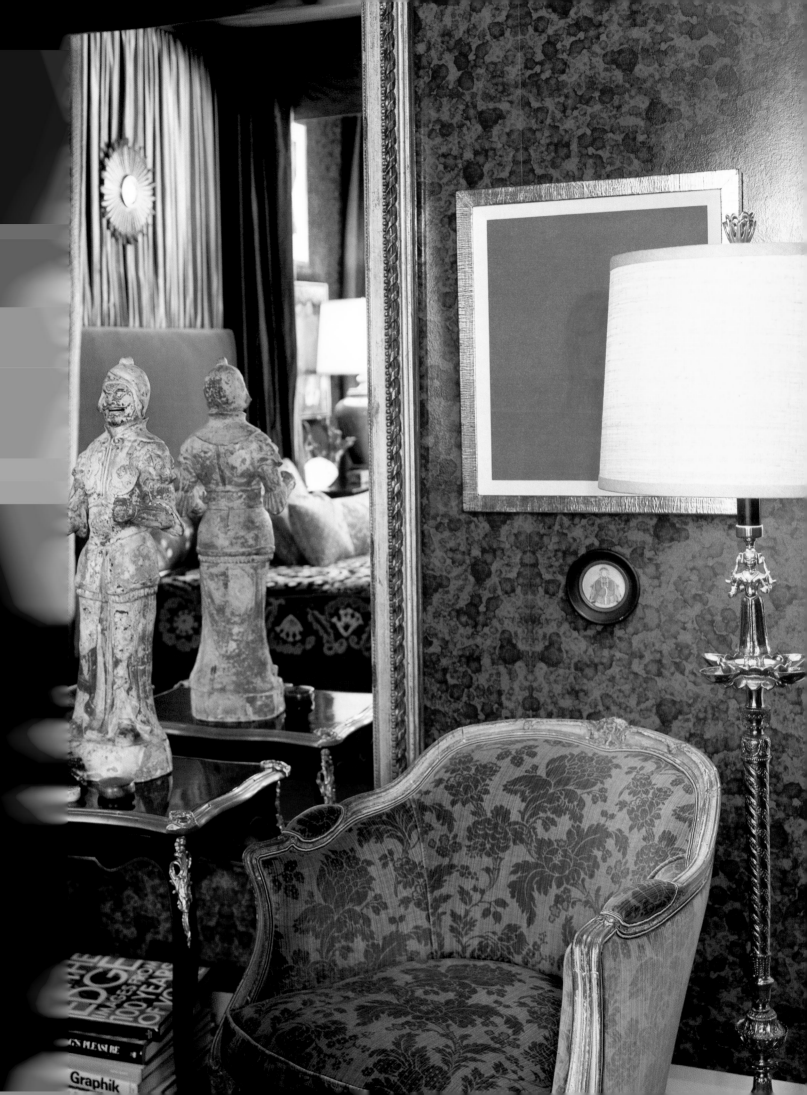

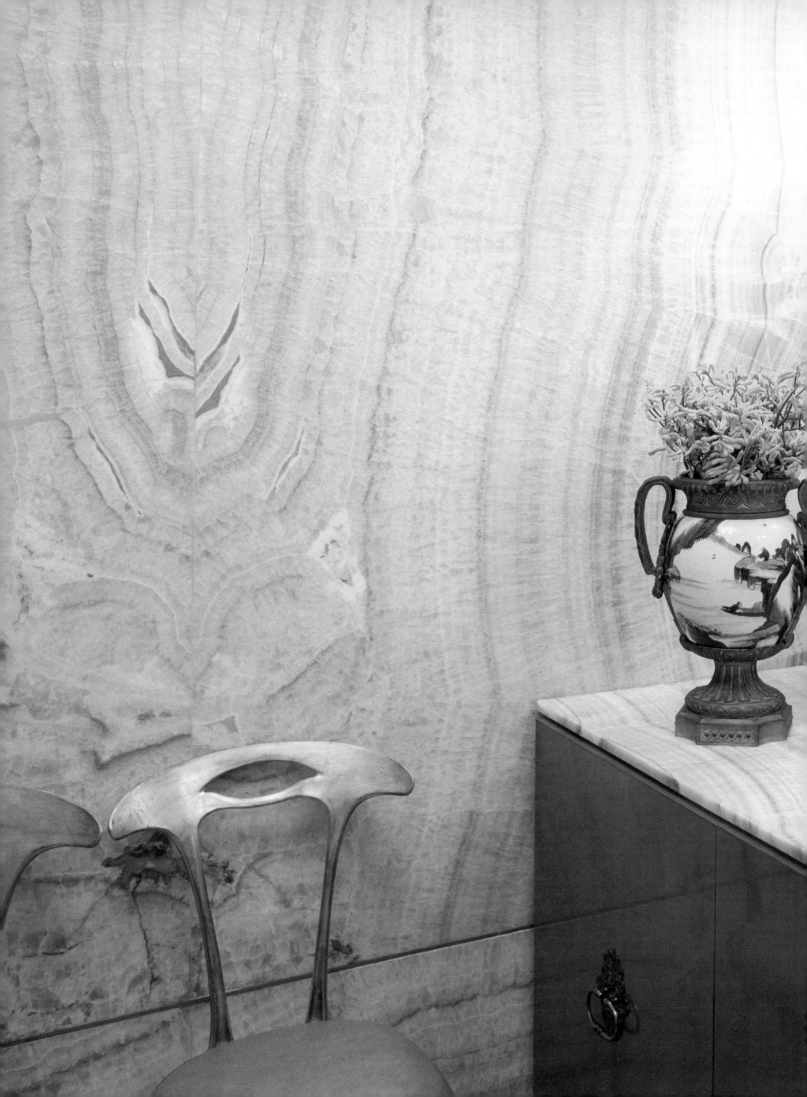

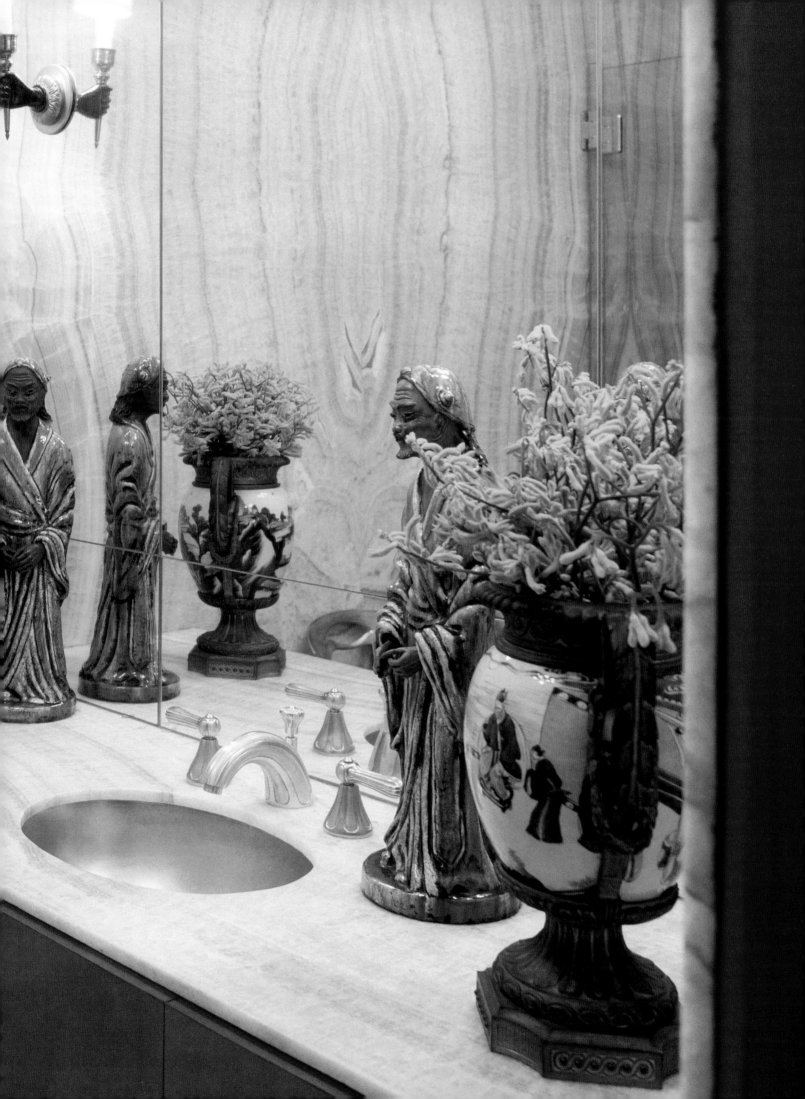

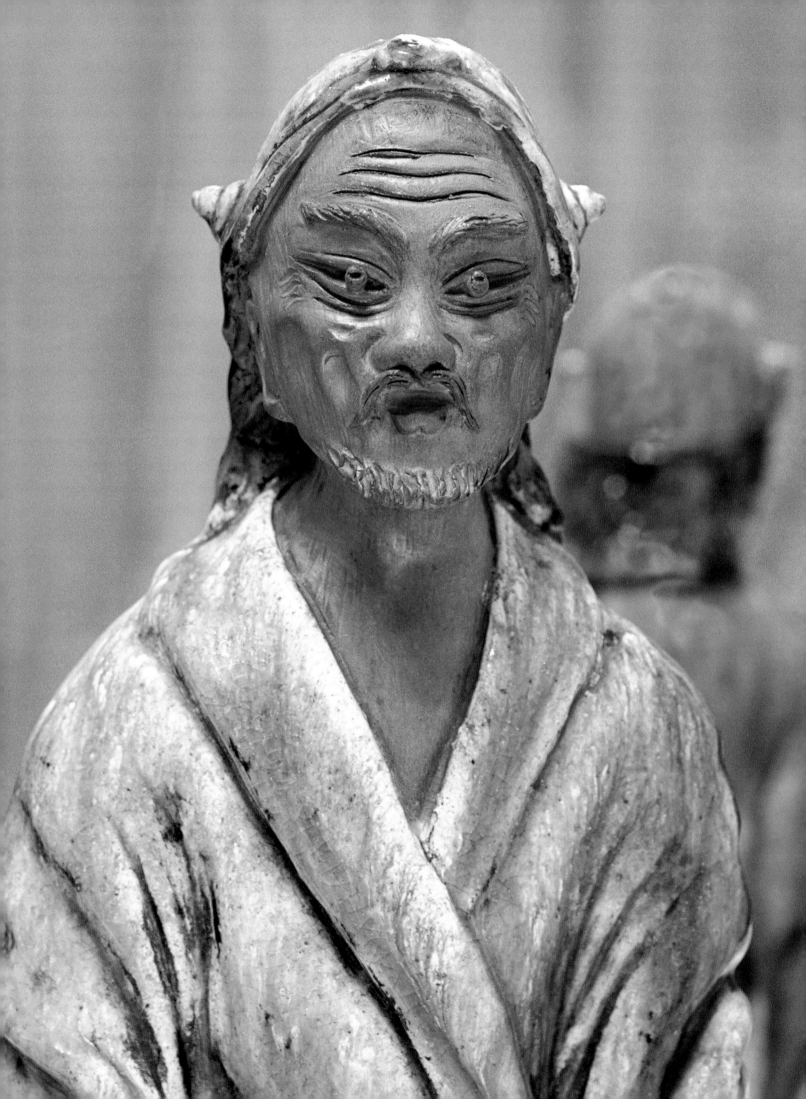

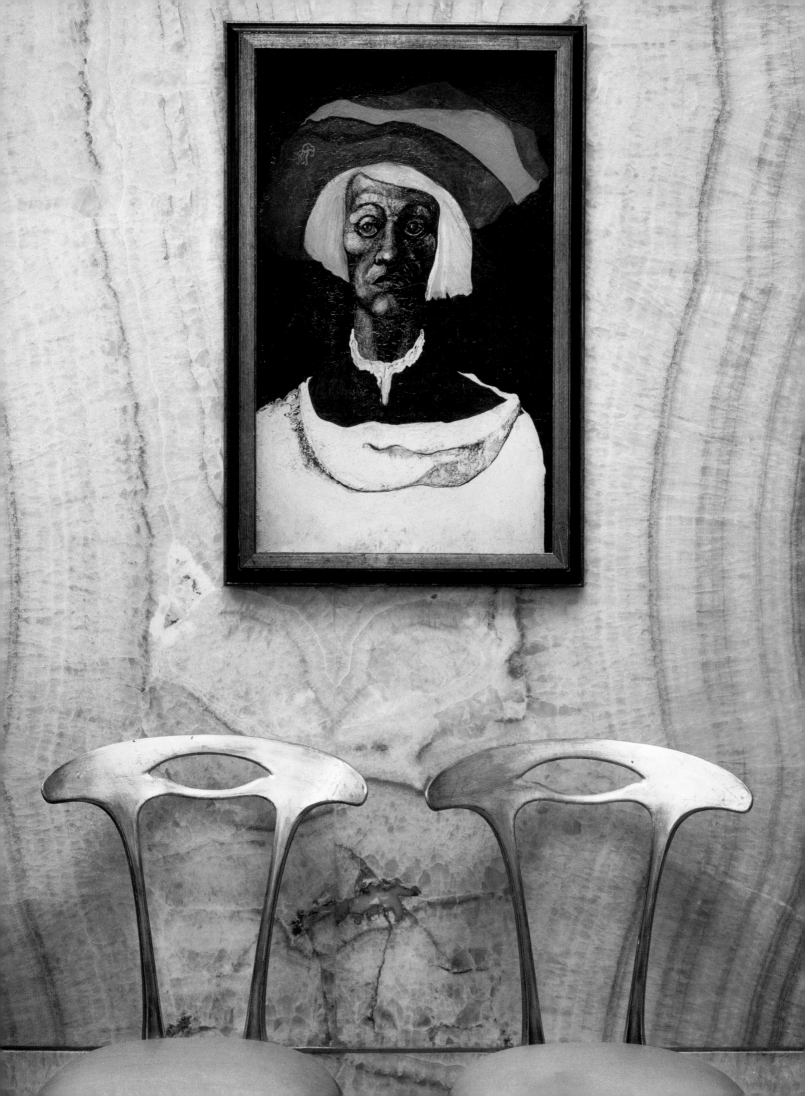

A bejeweled cocoon makes a perfect home for jet-lagged social butterflies and itinerant bookworms.

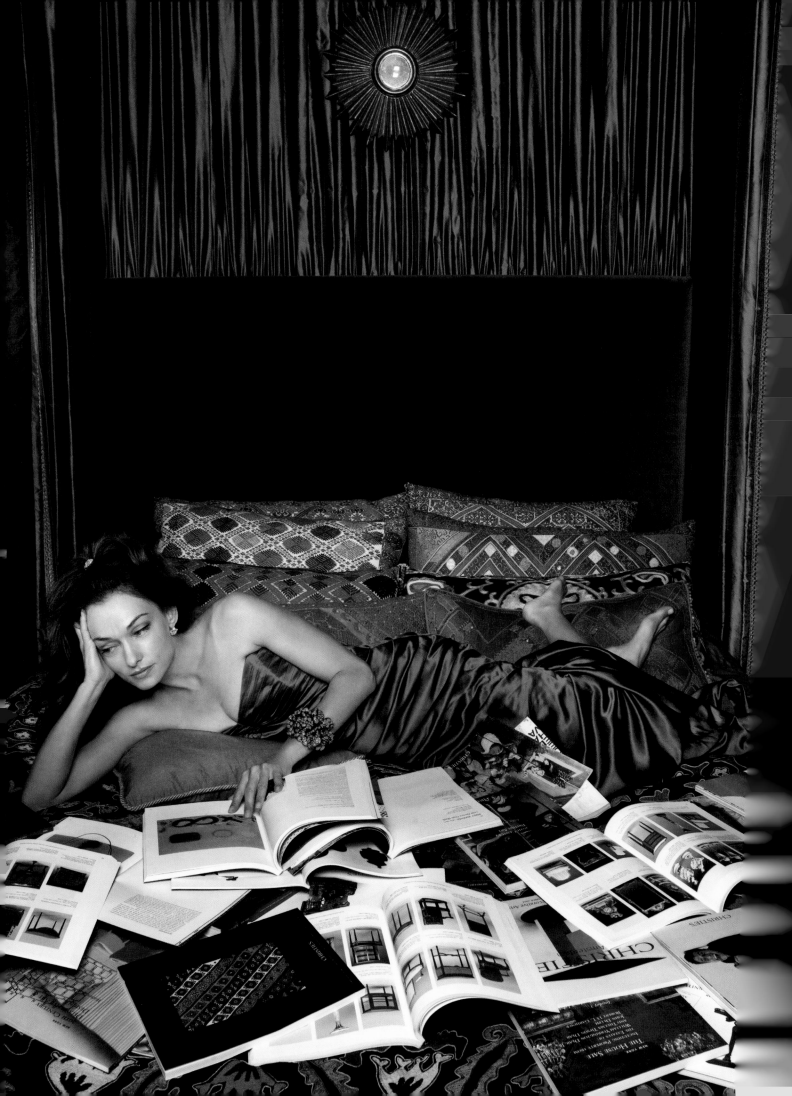

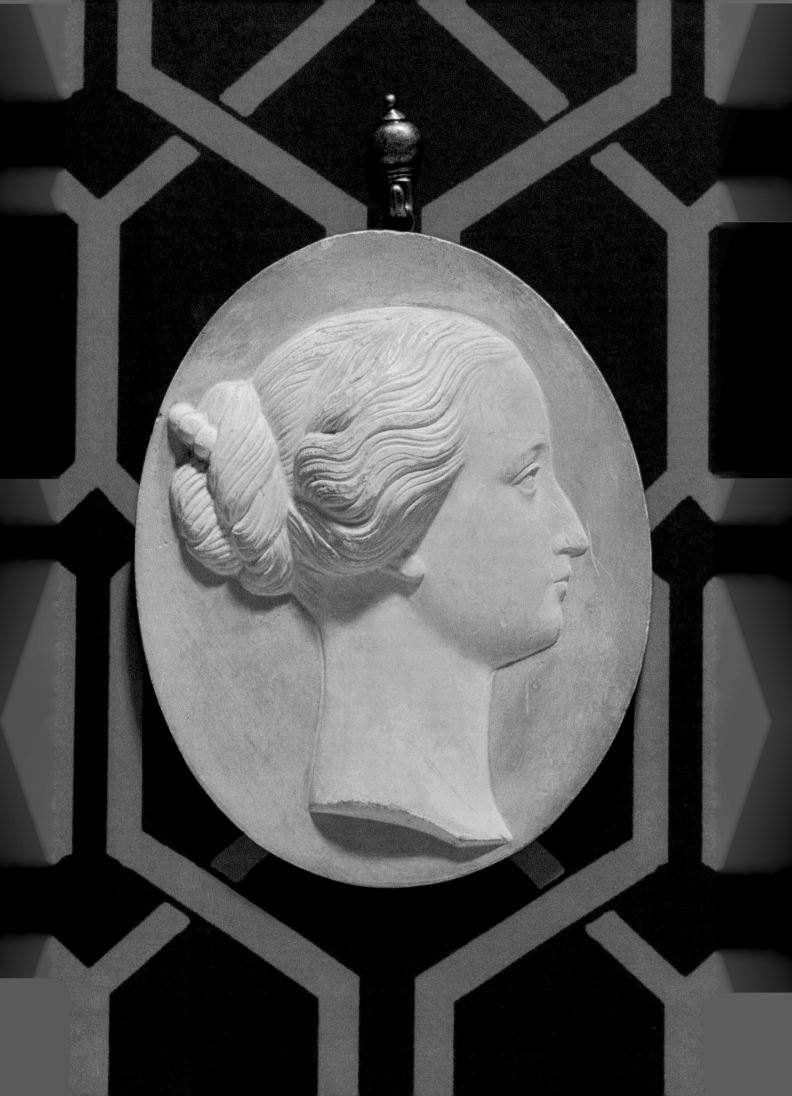

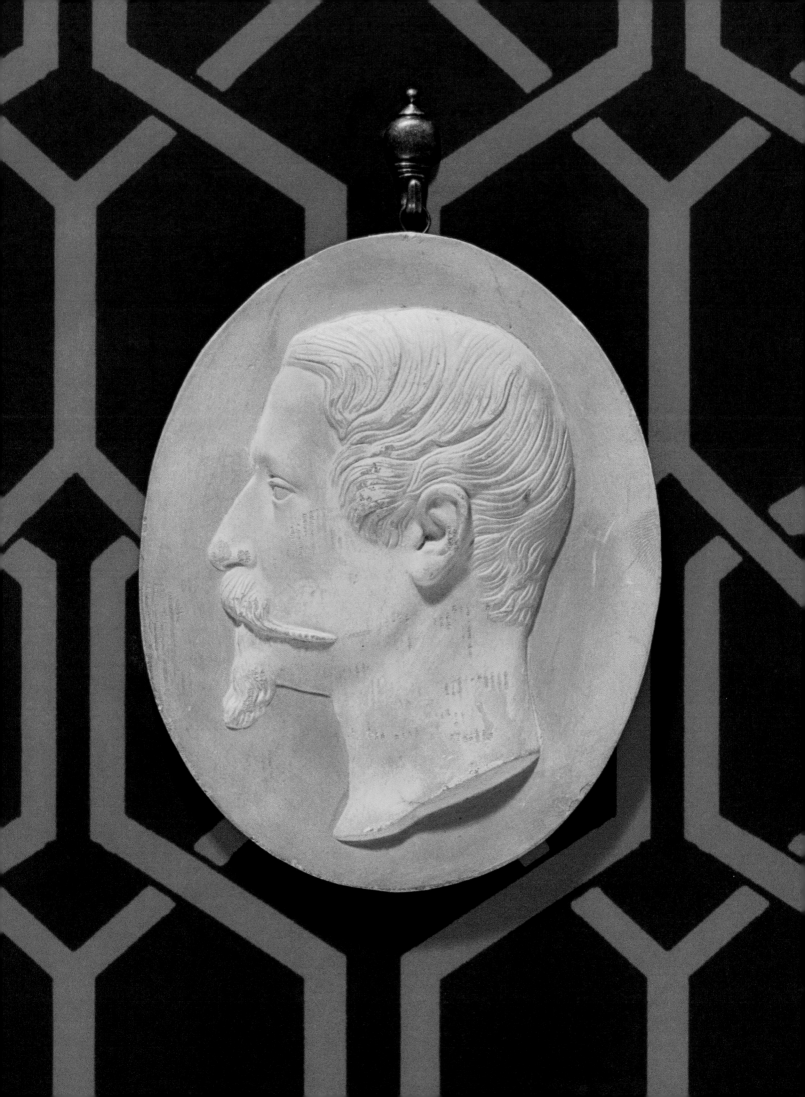

BOYS' VESTIBULE

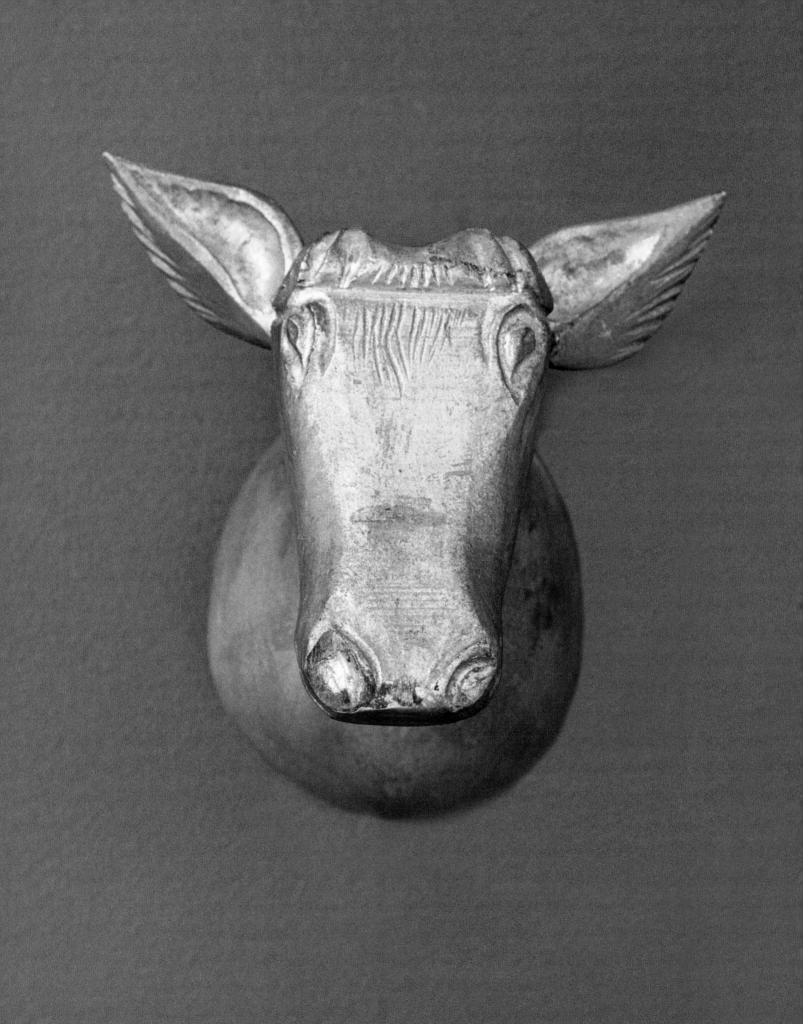

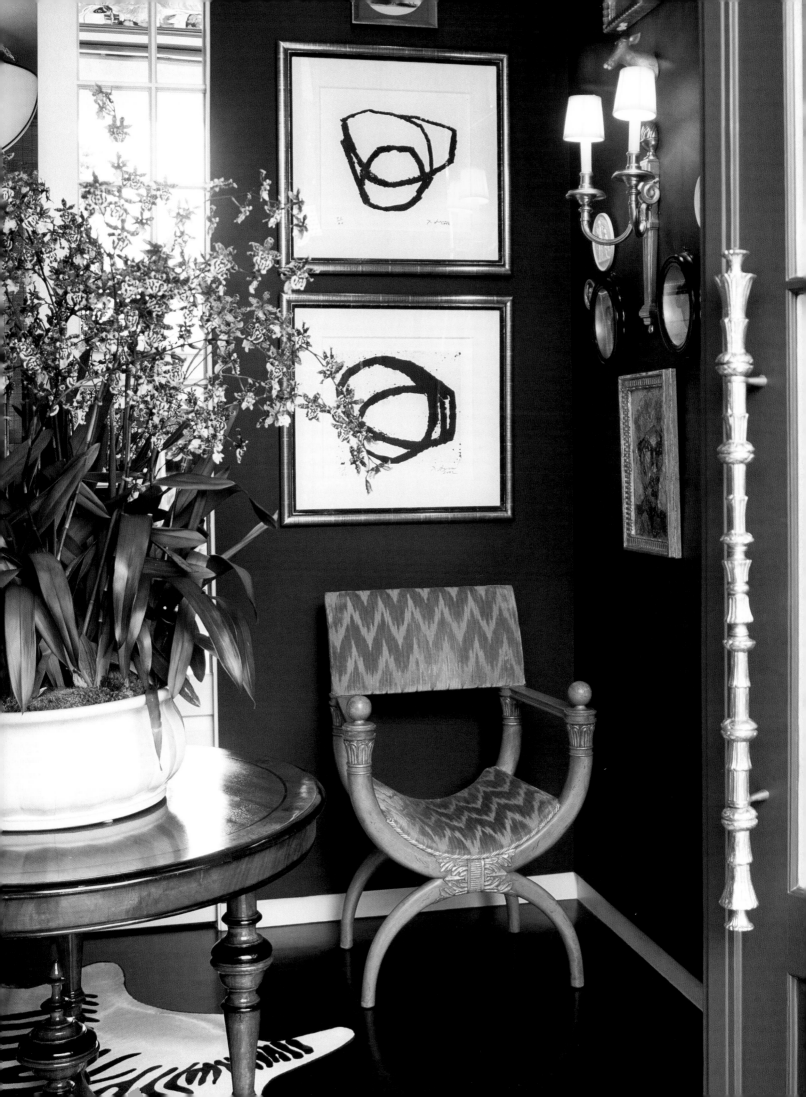

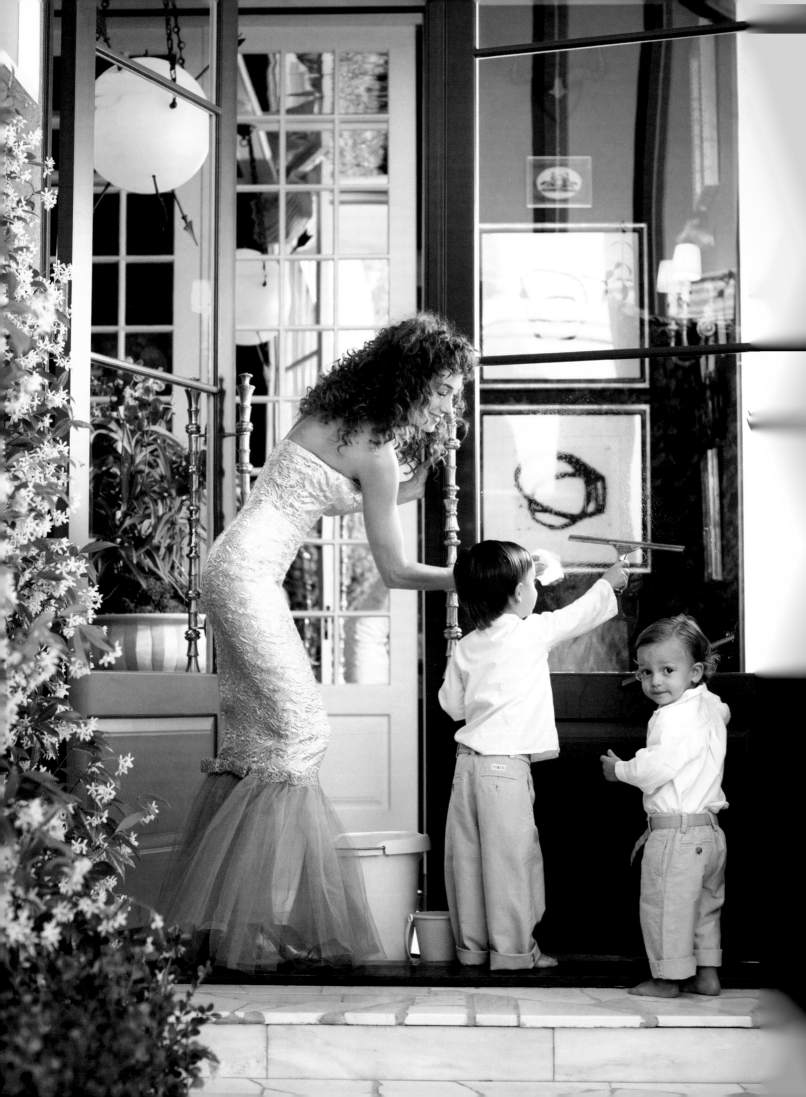

Child-rearing experts stress clarity in children's daily lives.
Fortunately, our house has a lot of windows.

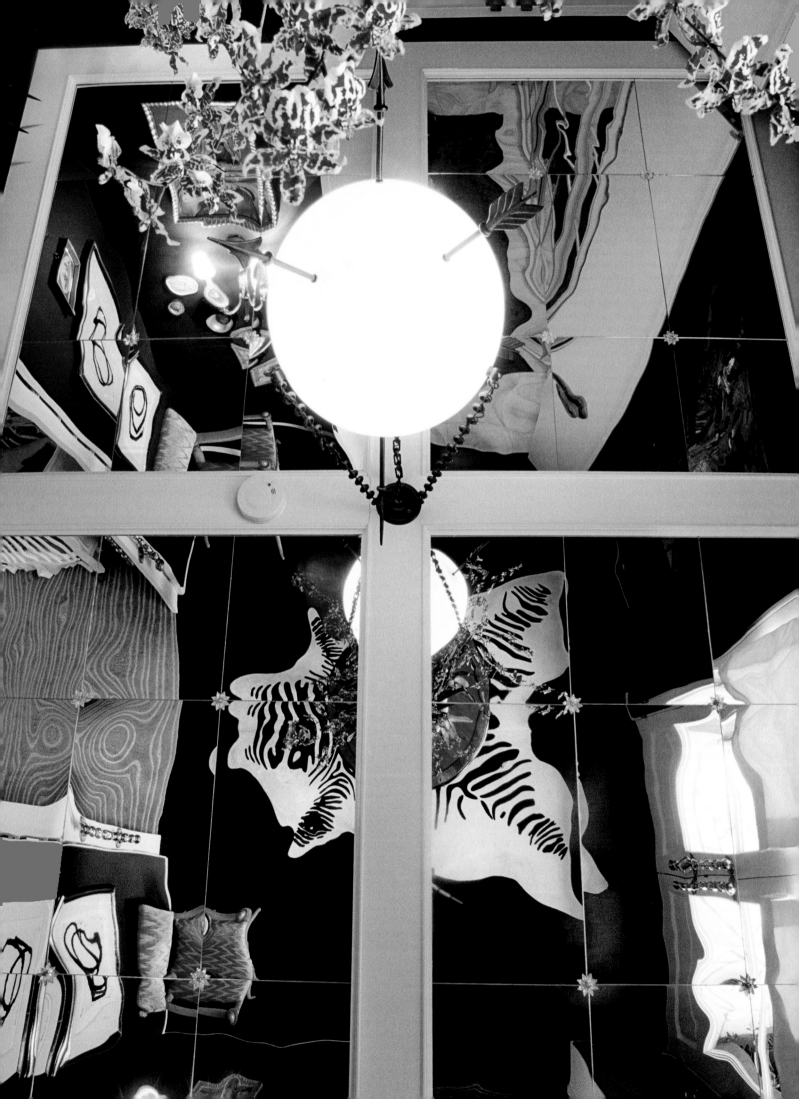

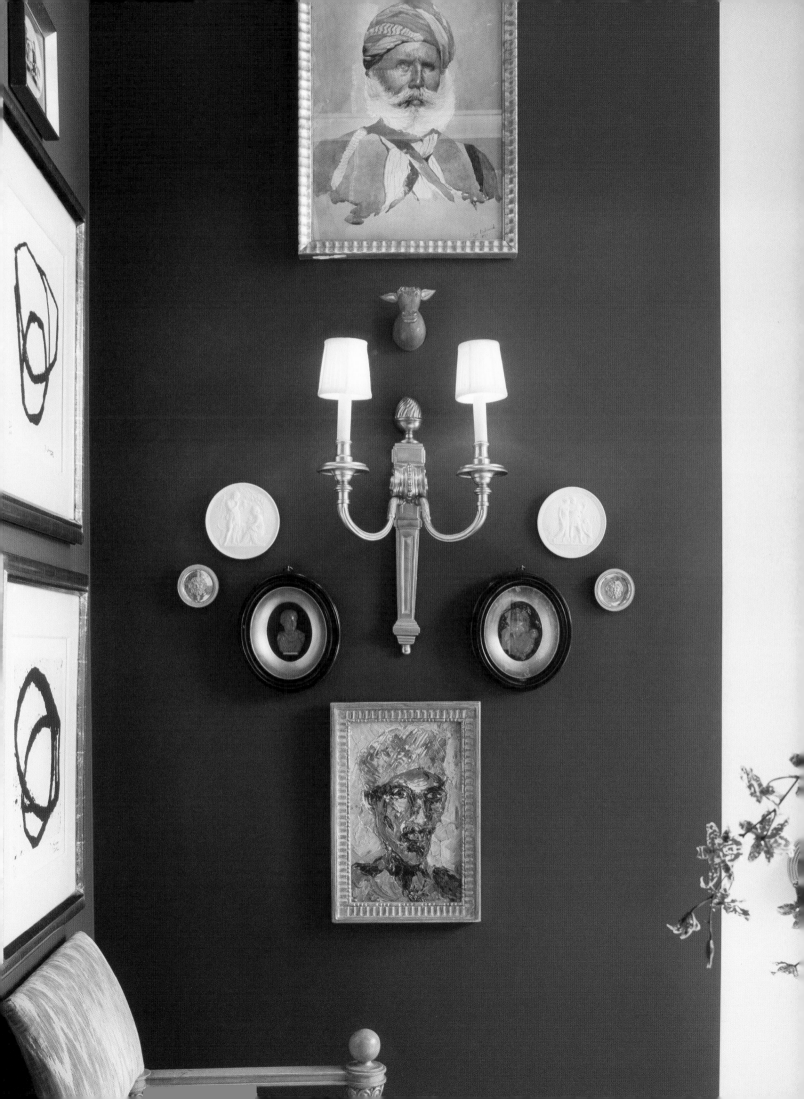

OLIVER'S ROOM

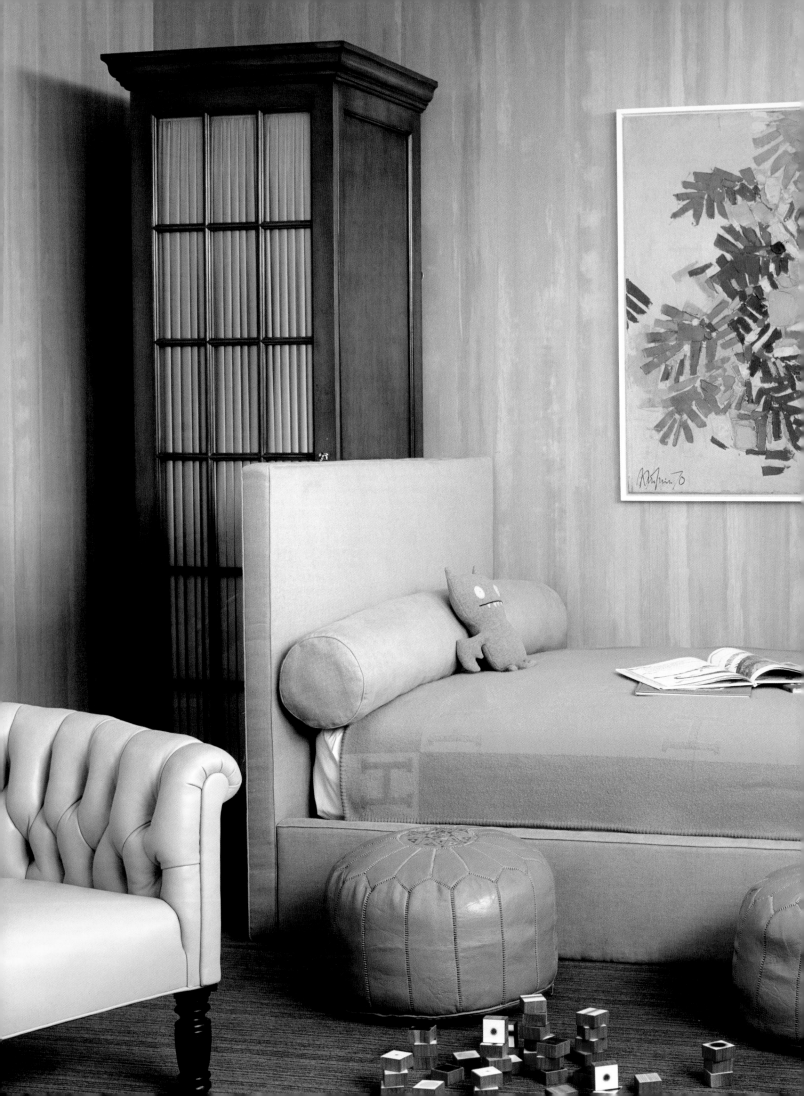

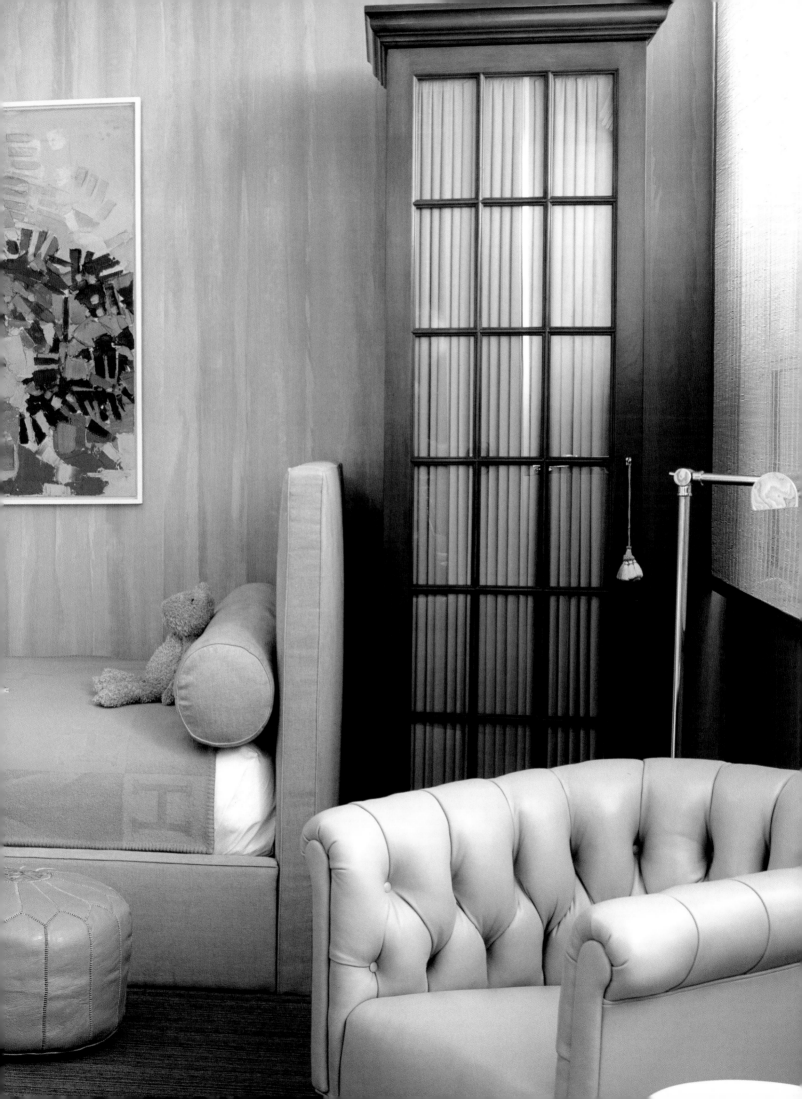

Colors are the letters of the visual alphabet.

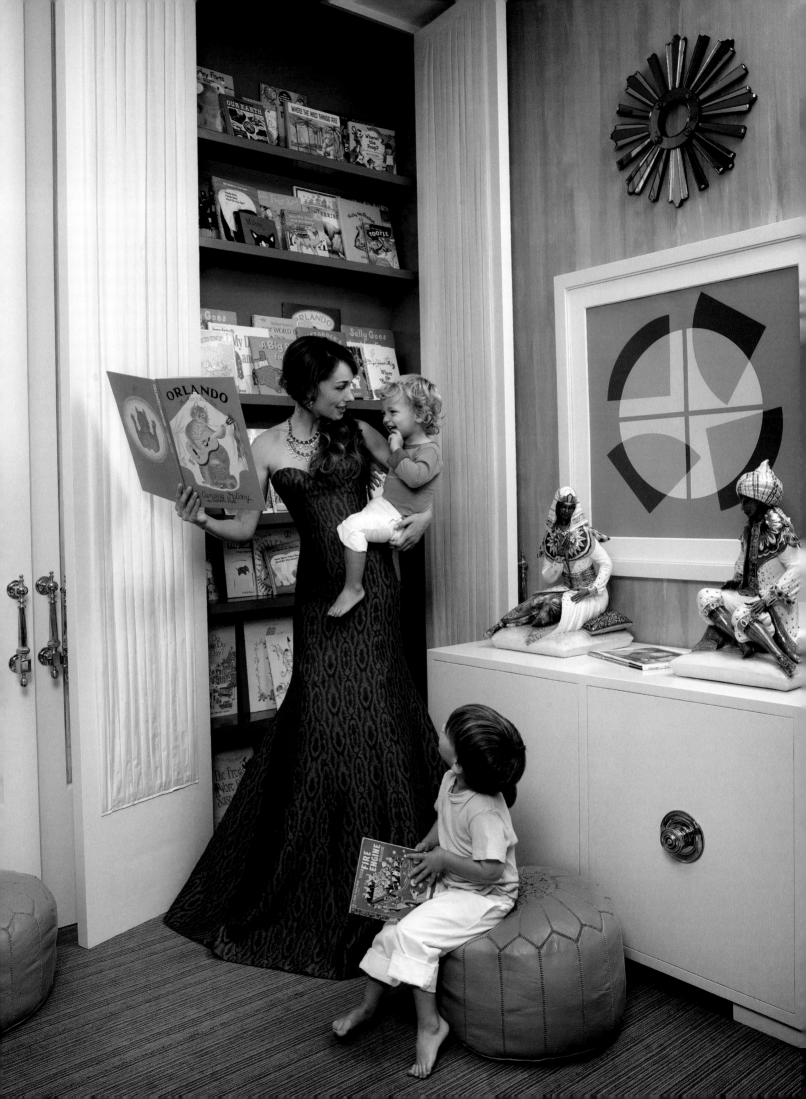

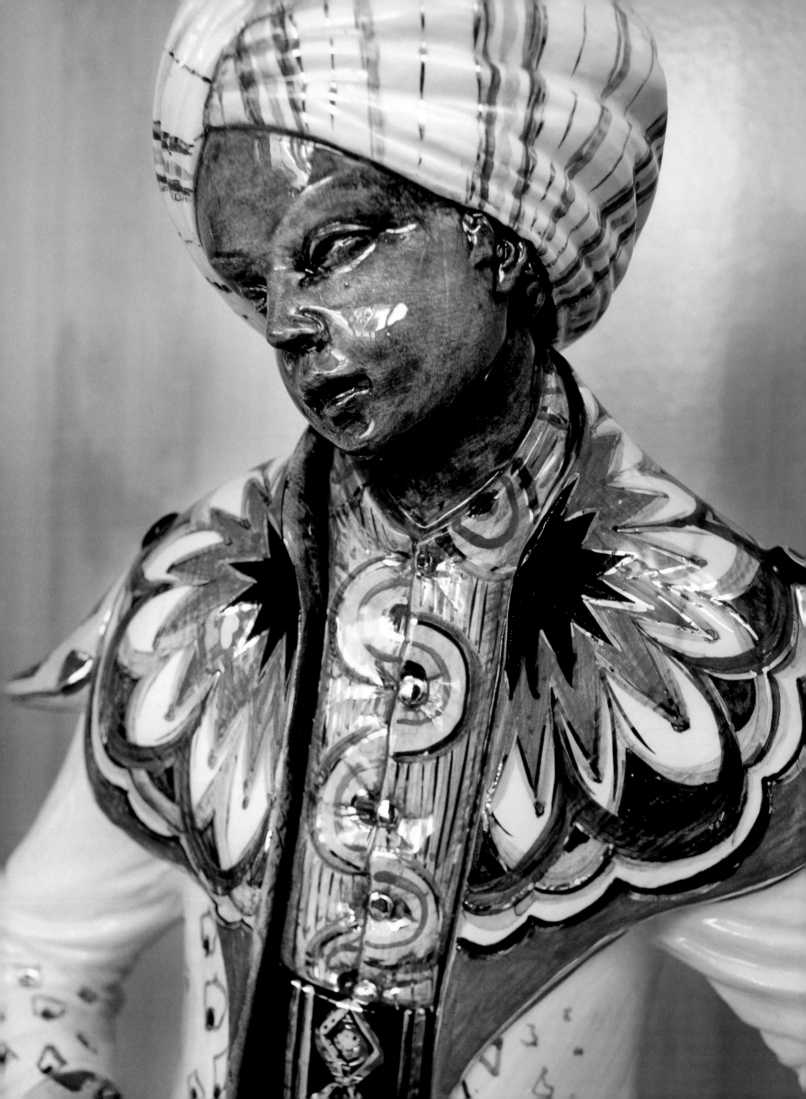

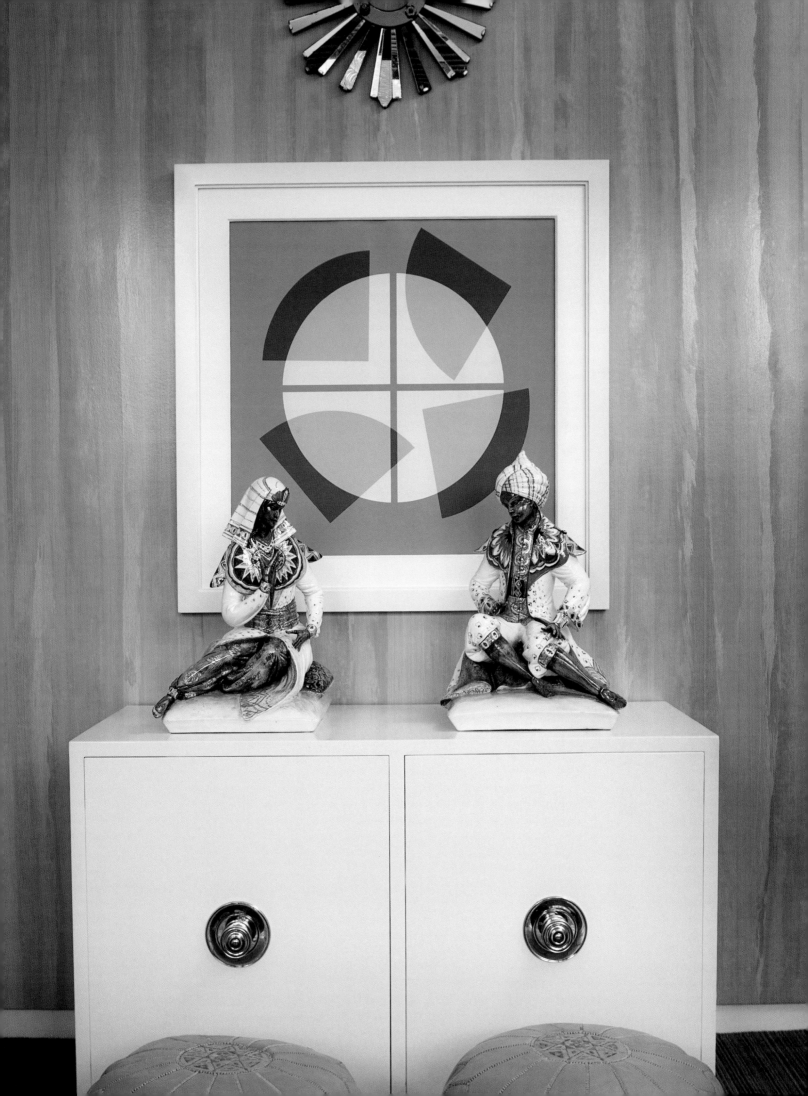

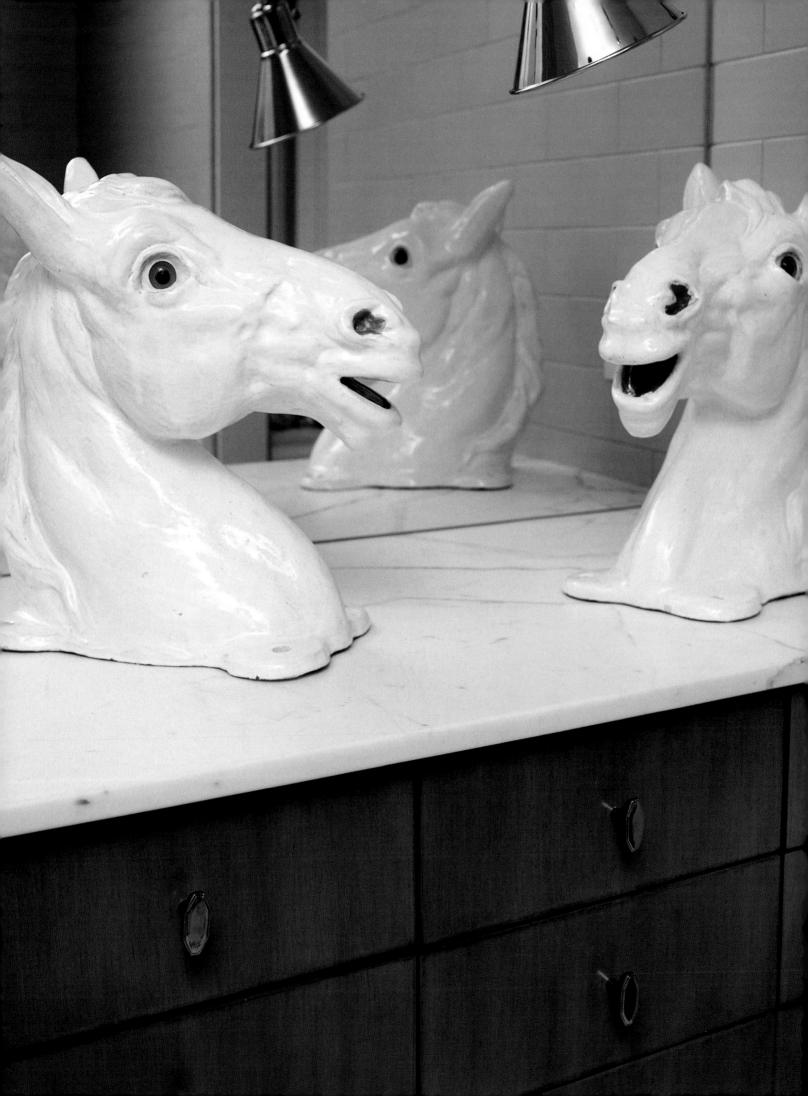

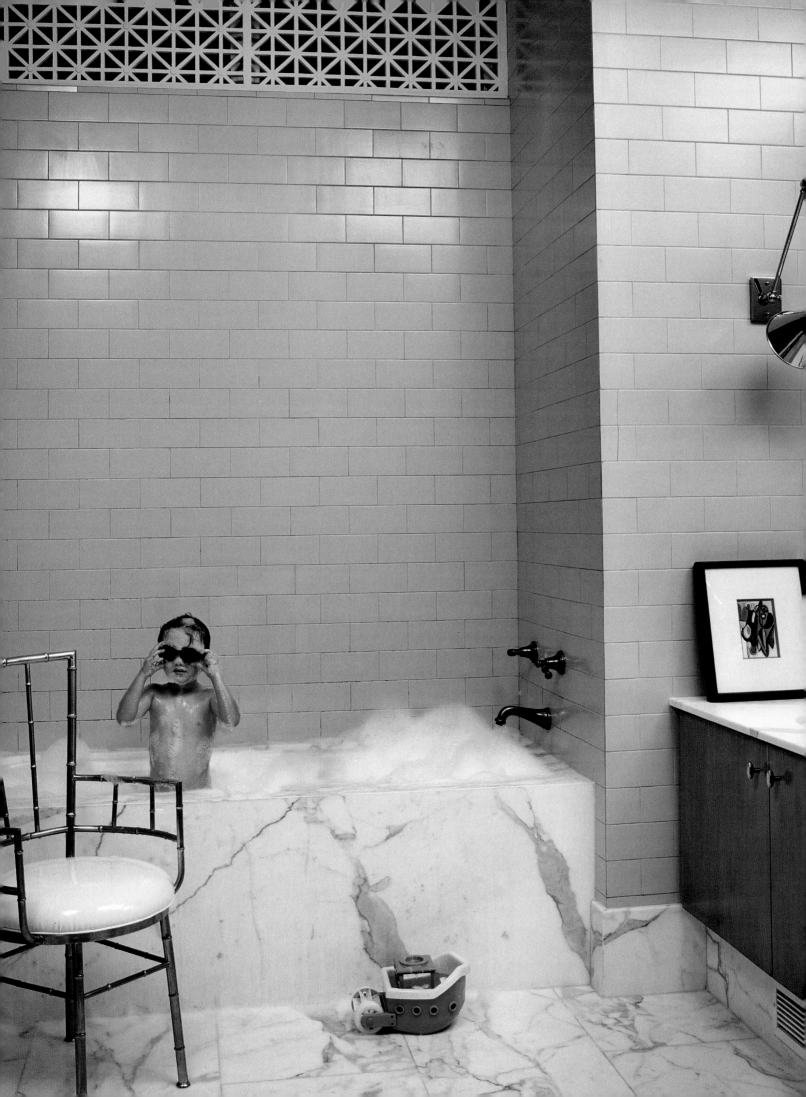

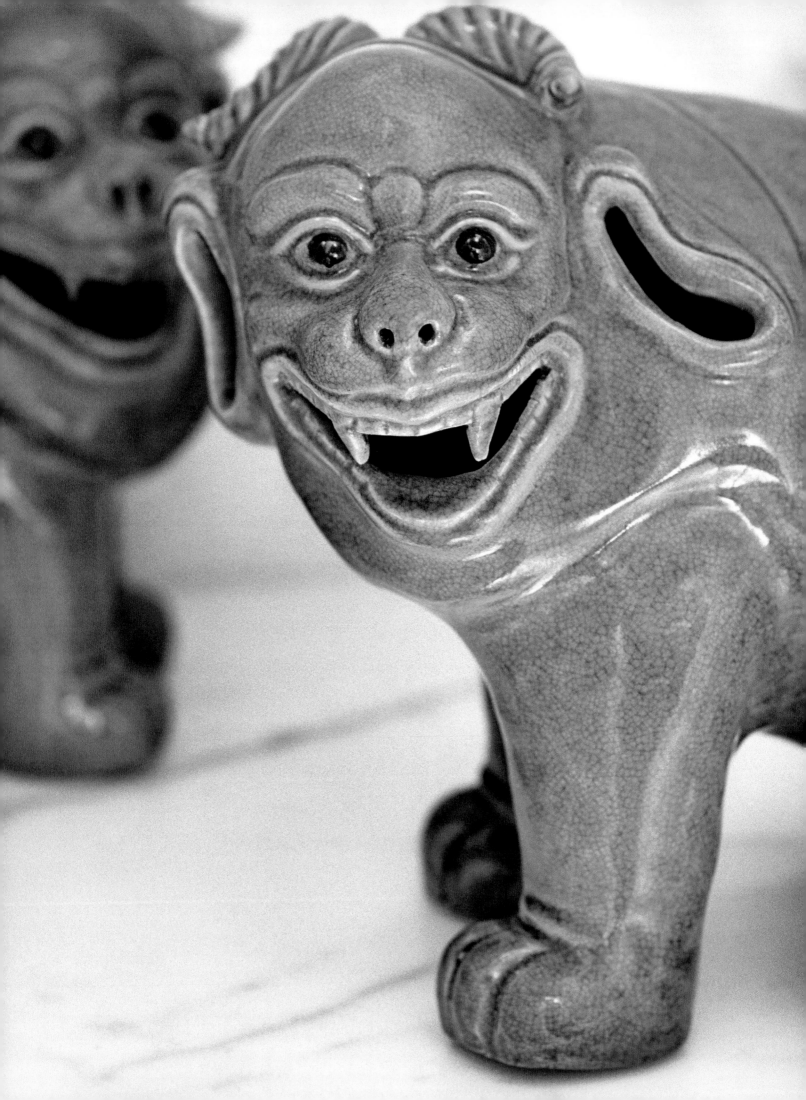

ELLIOTT'S ROOM

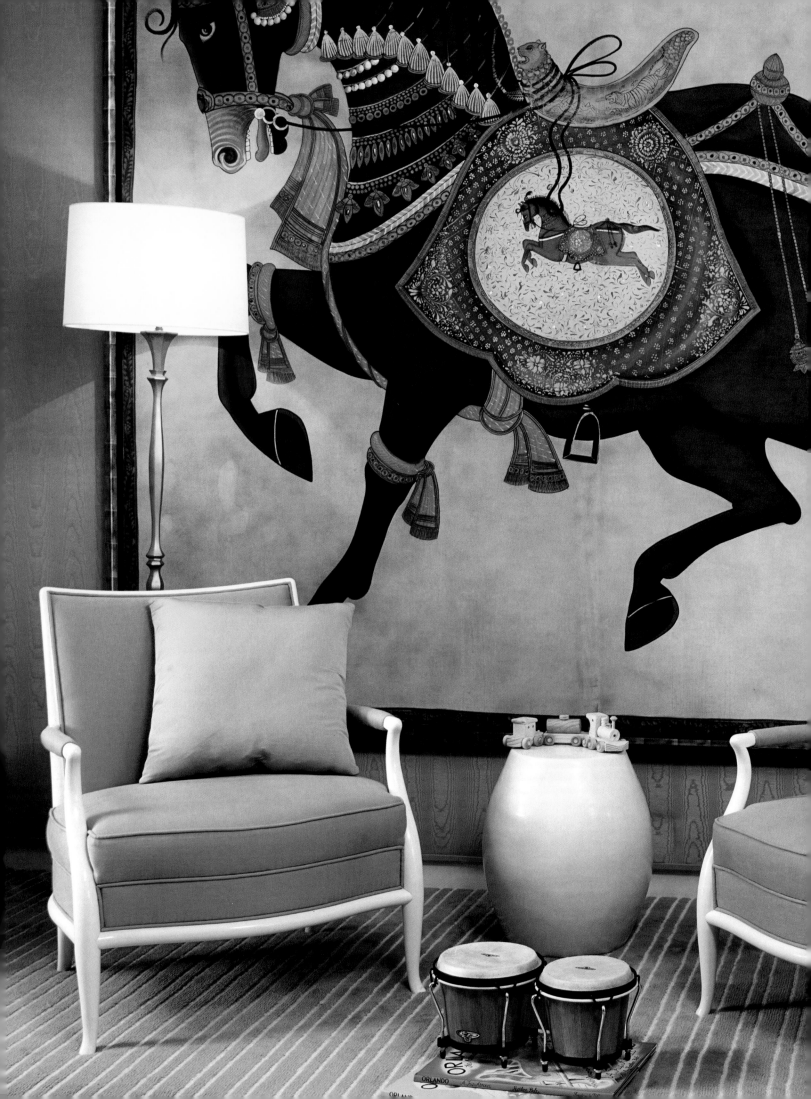

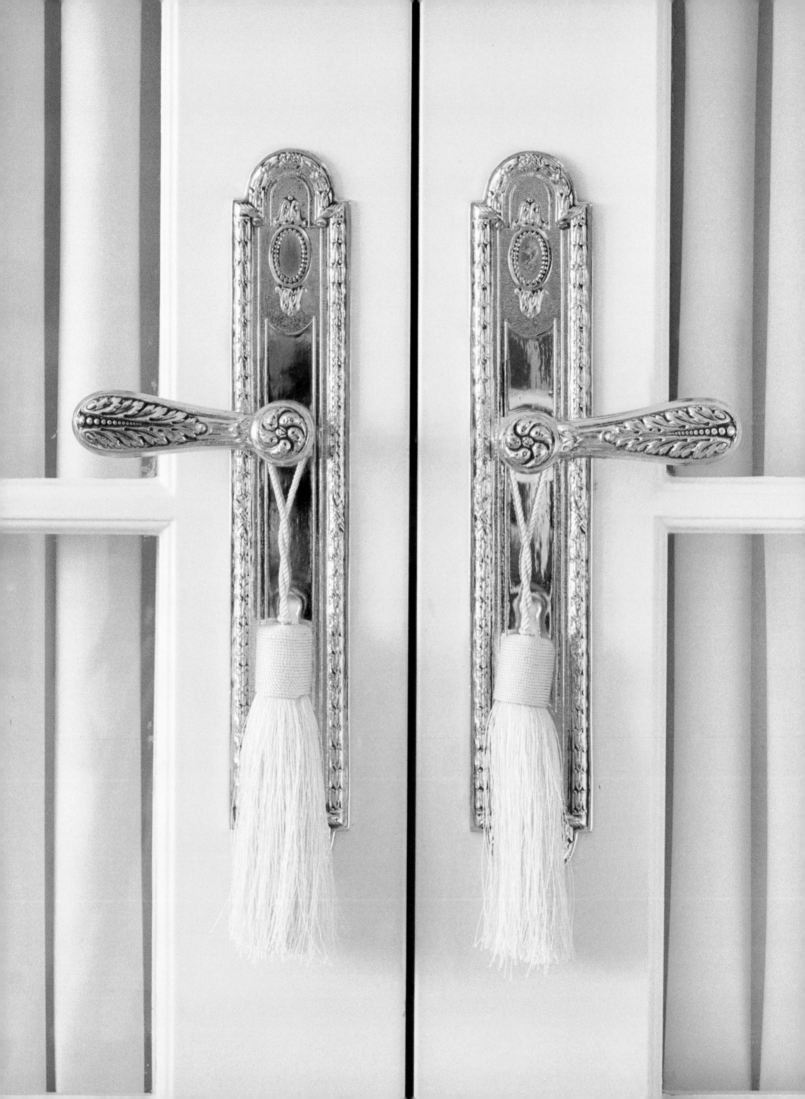

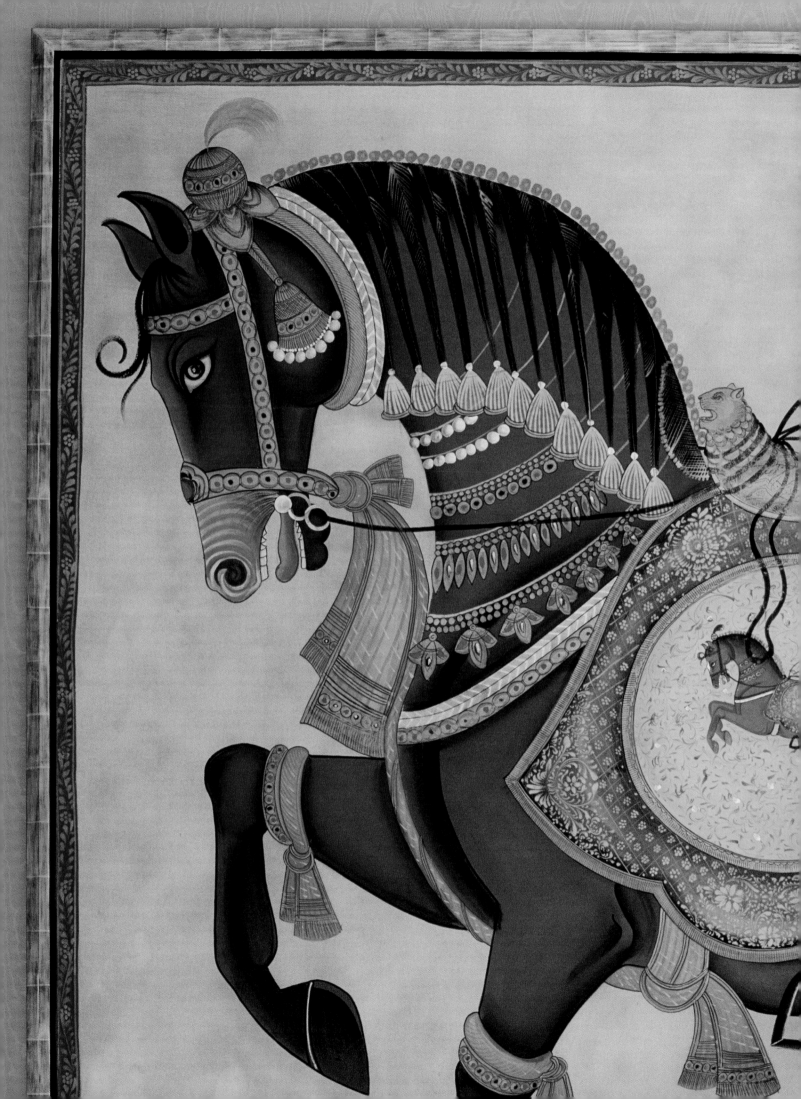

DEN

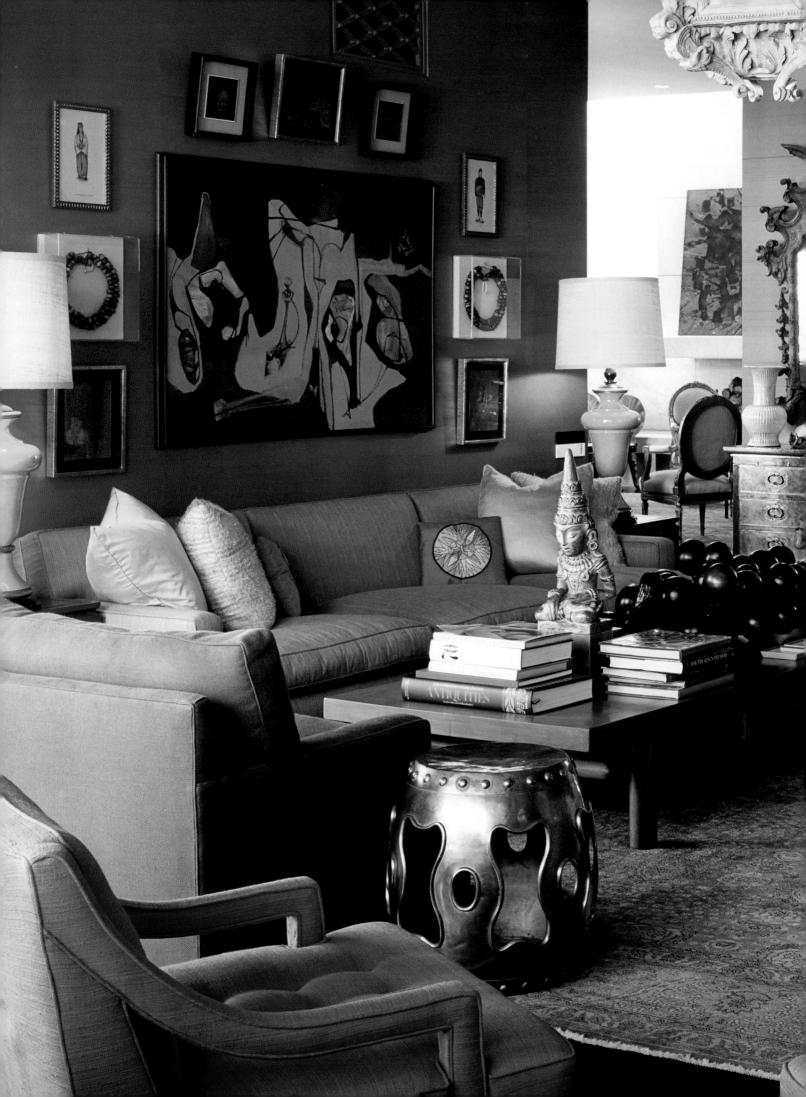

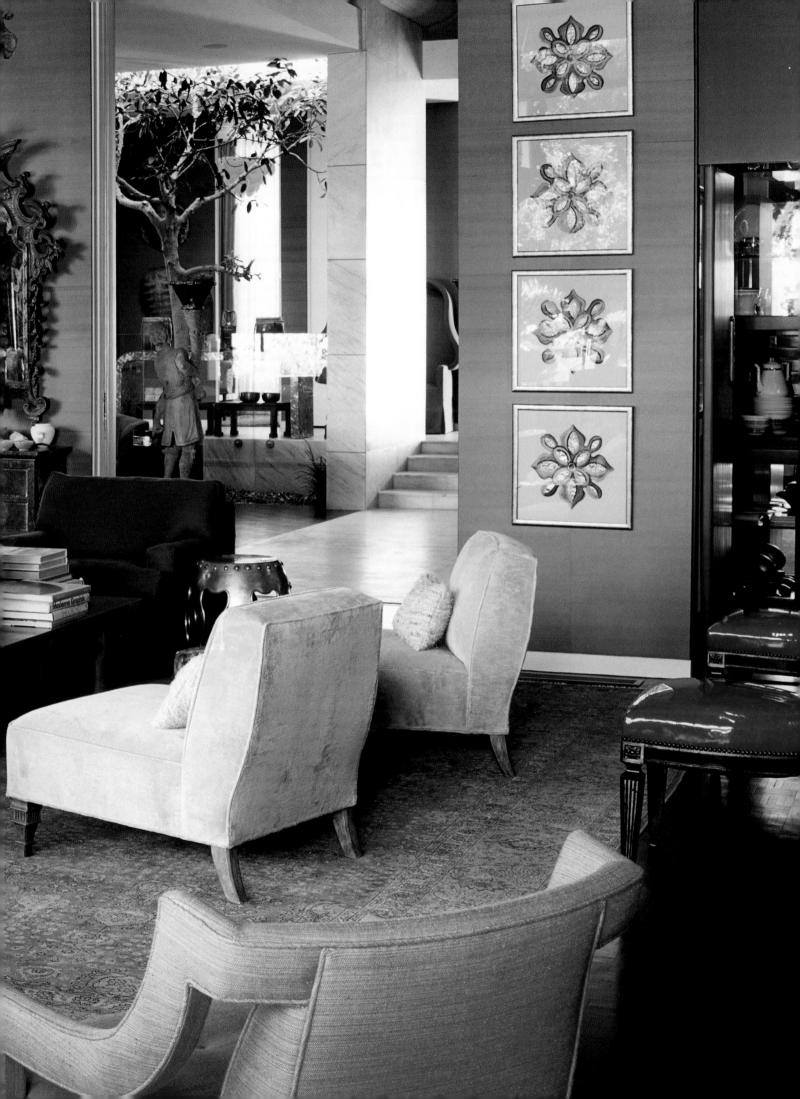

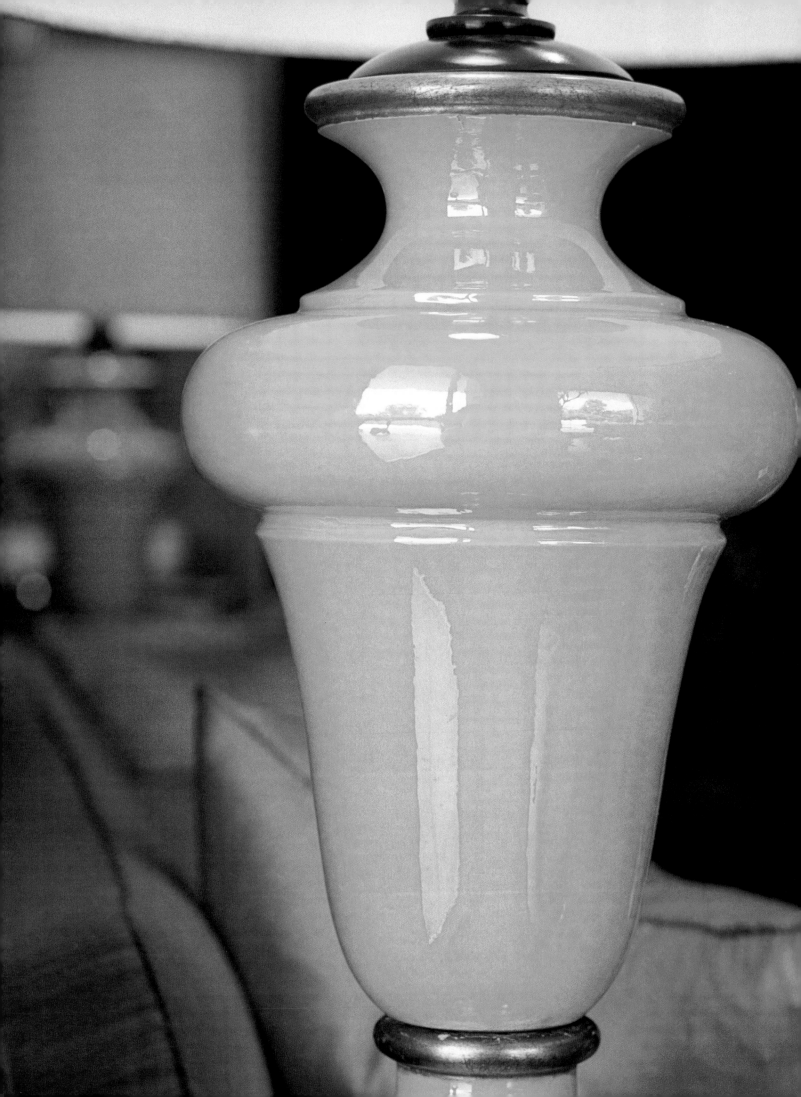

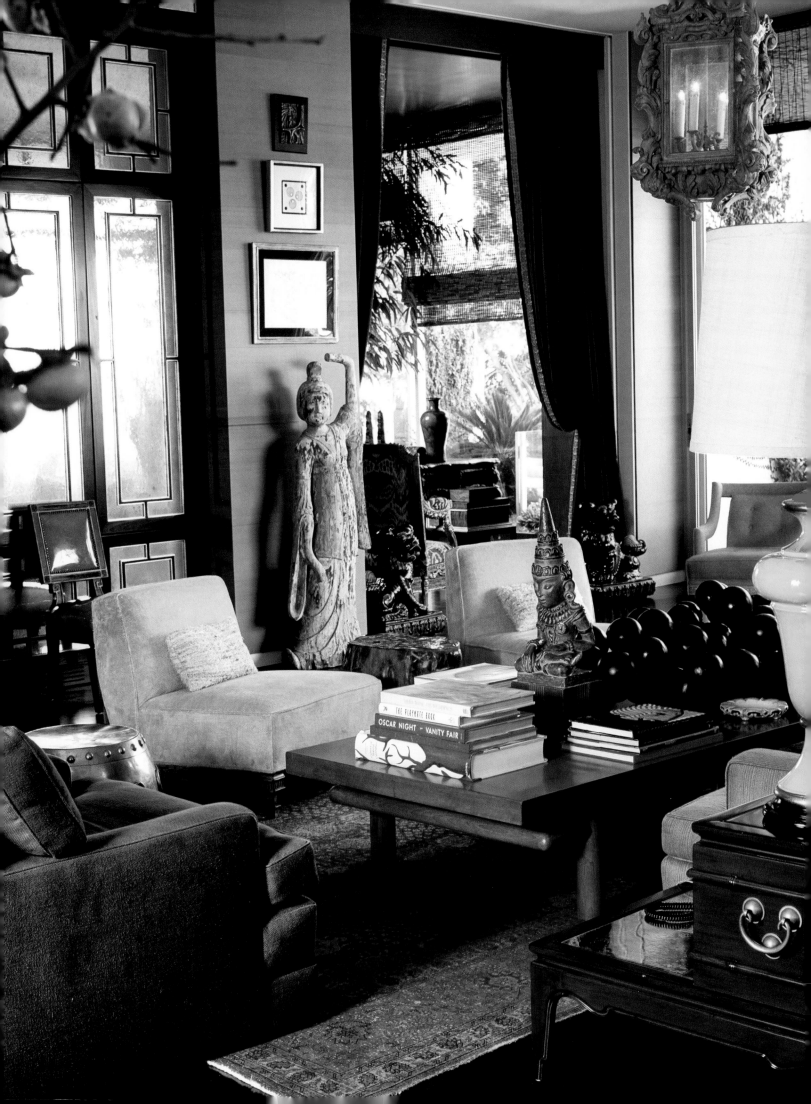

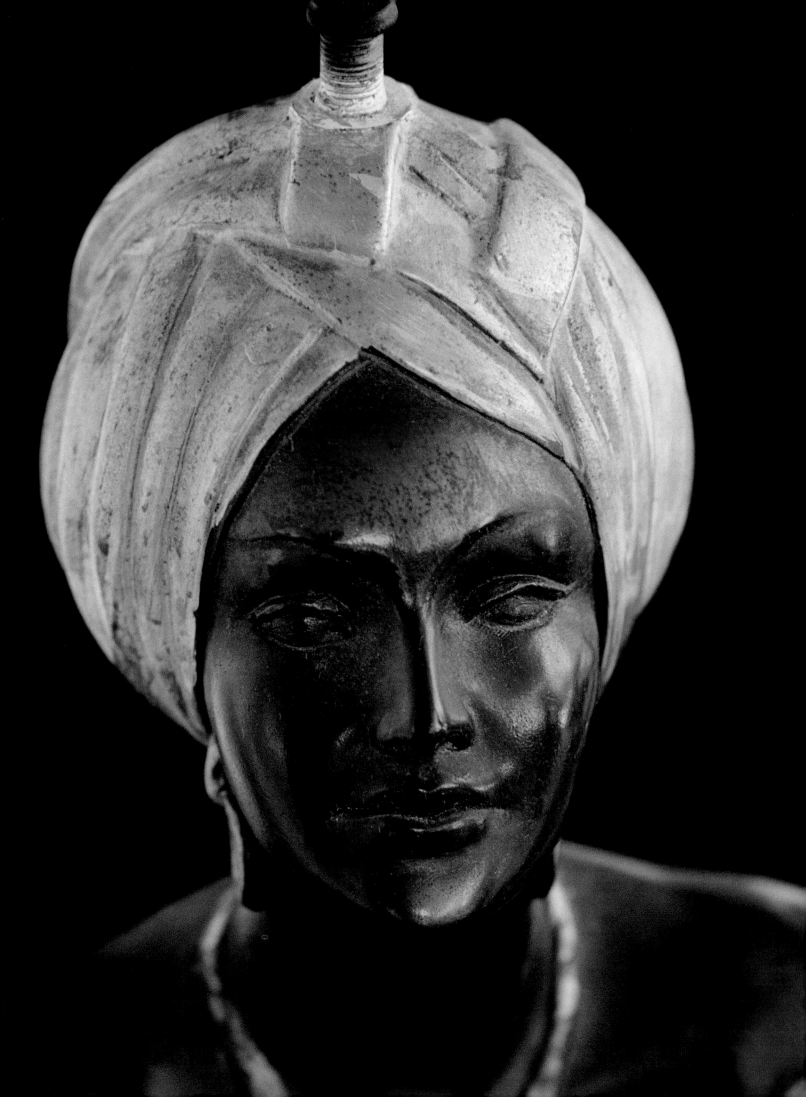

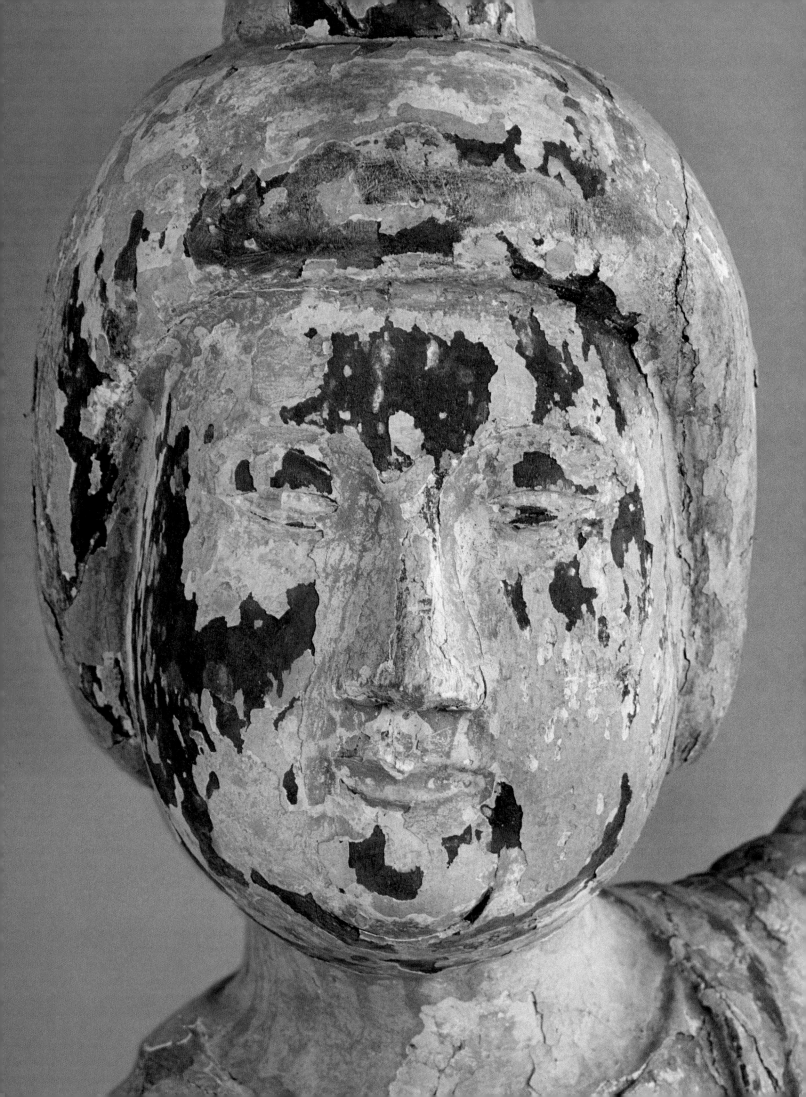

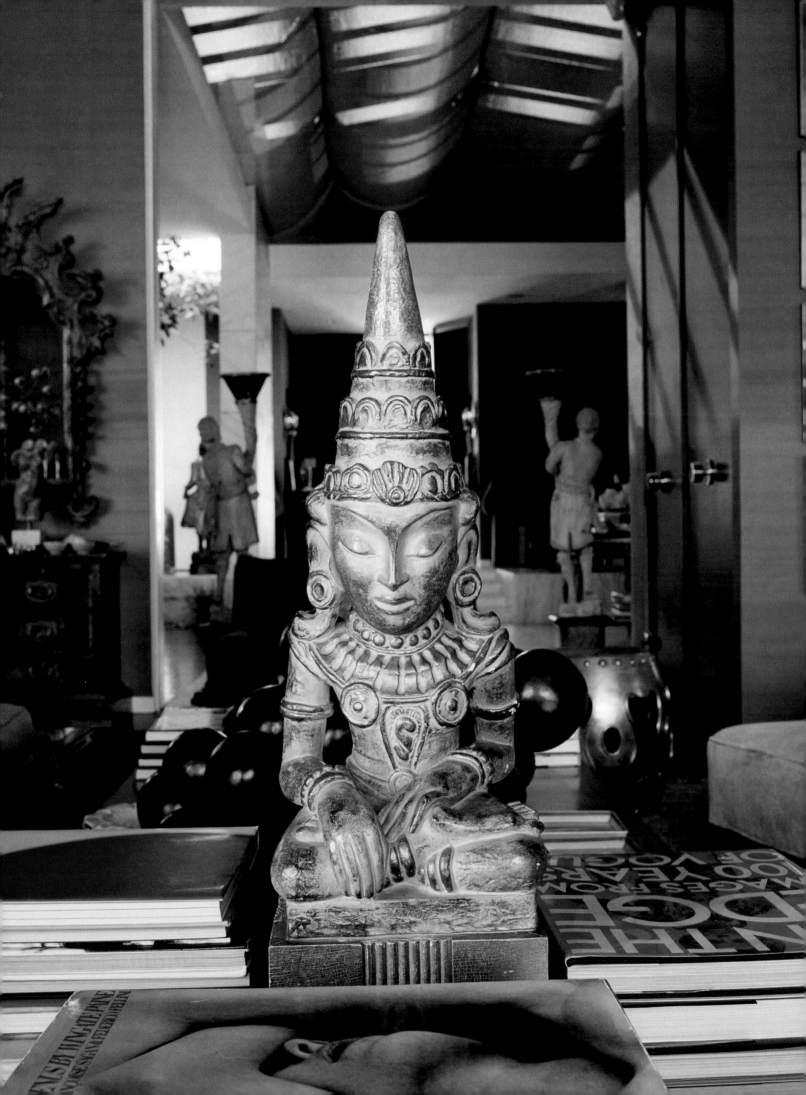

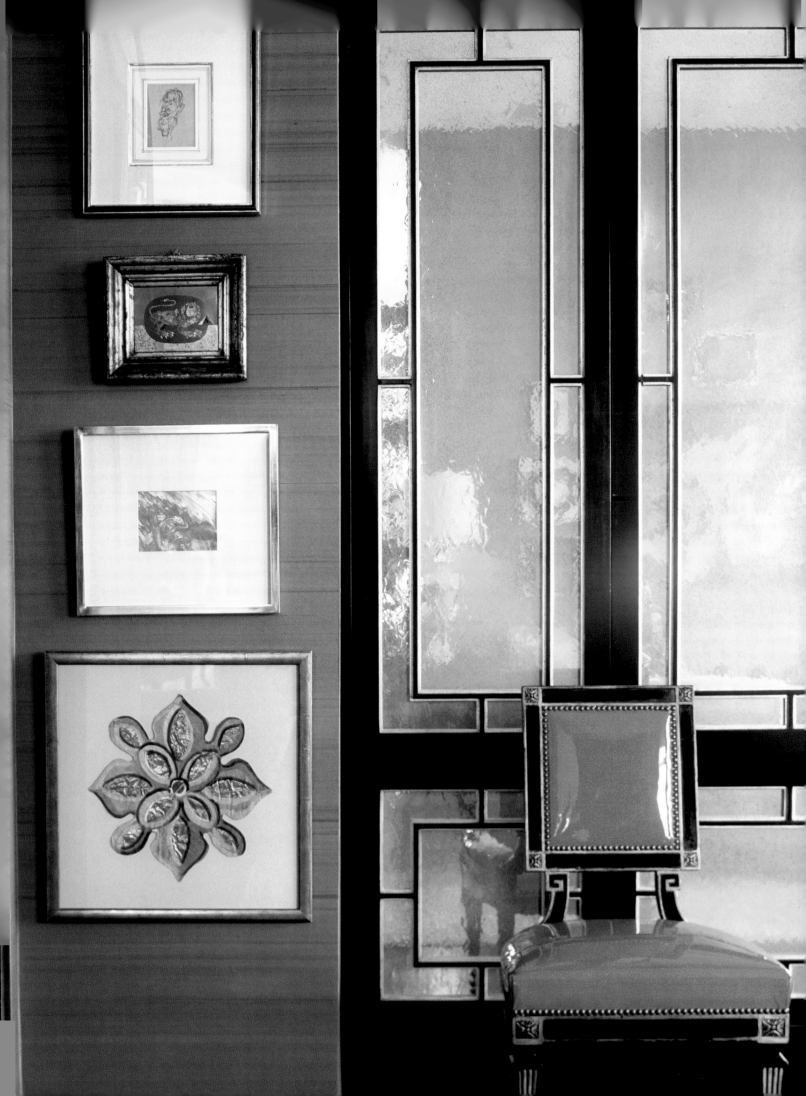

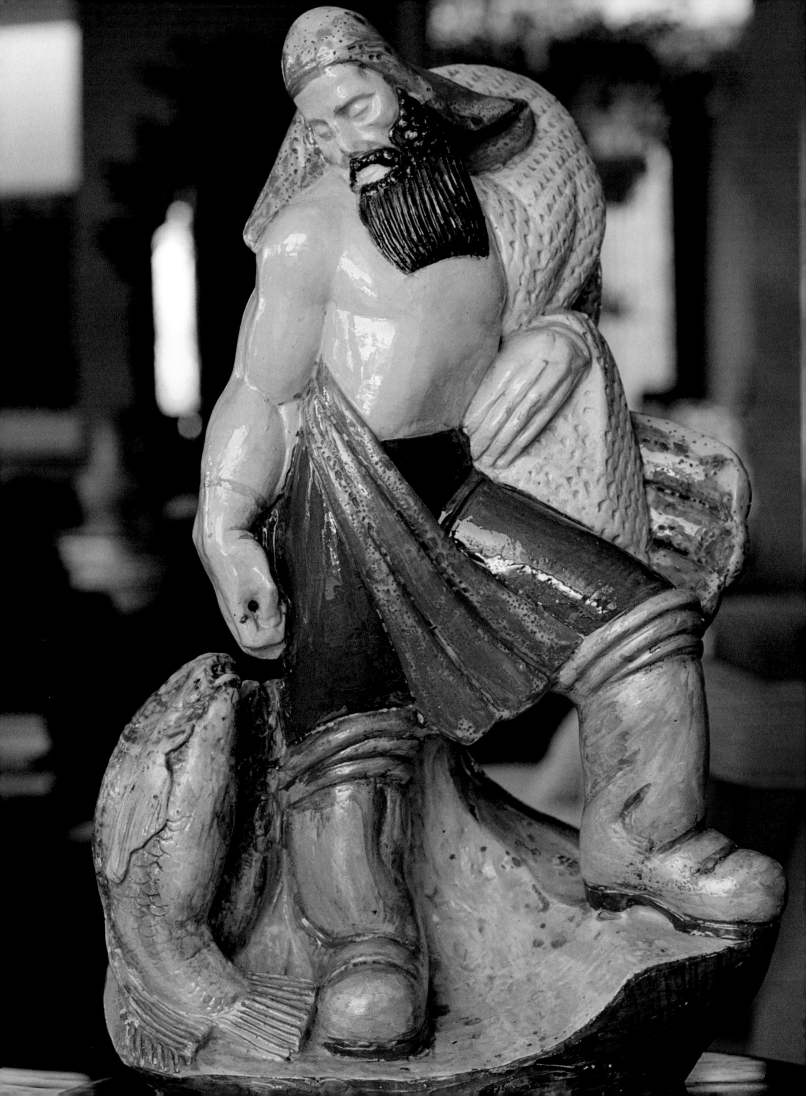

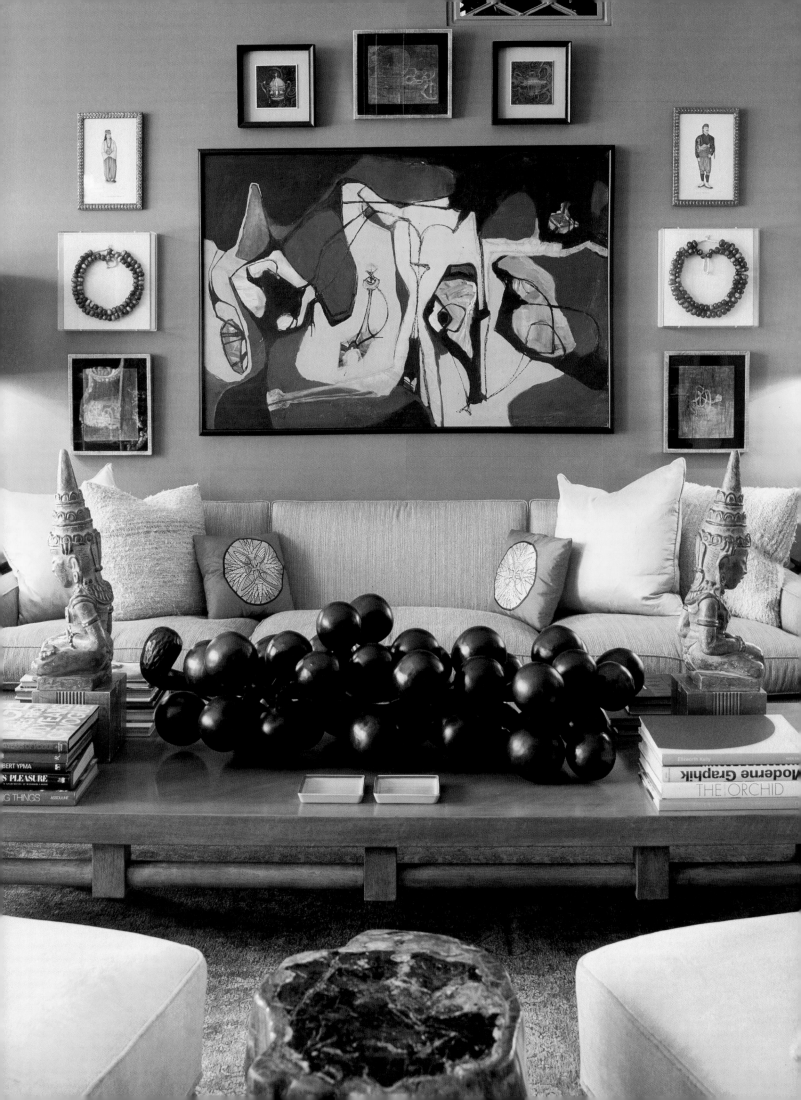

BREAKFAST ROOM

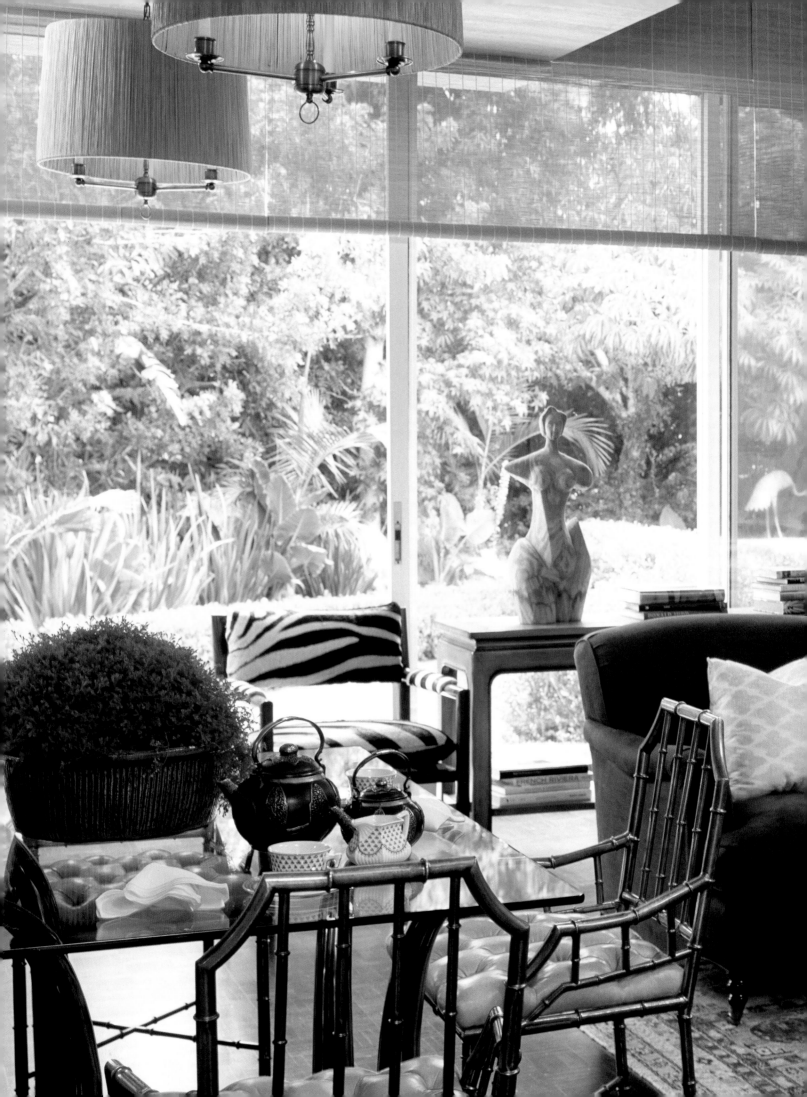

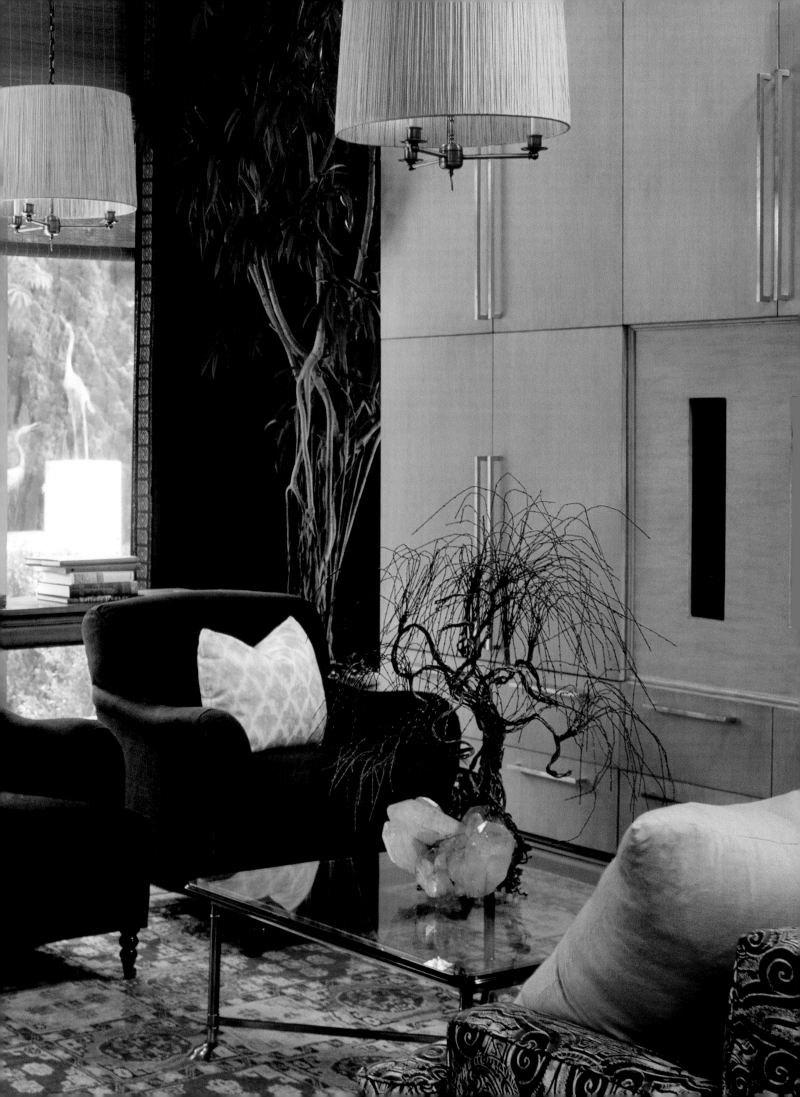

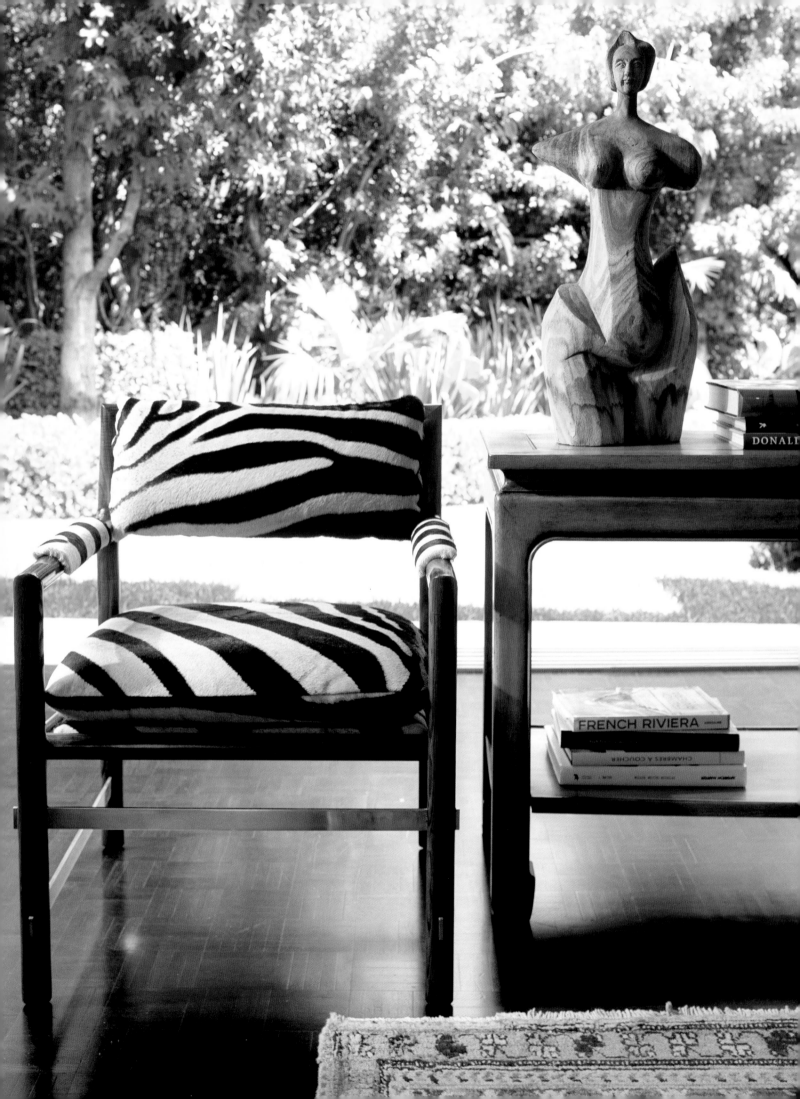

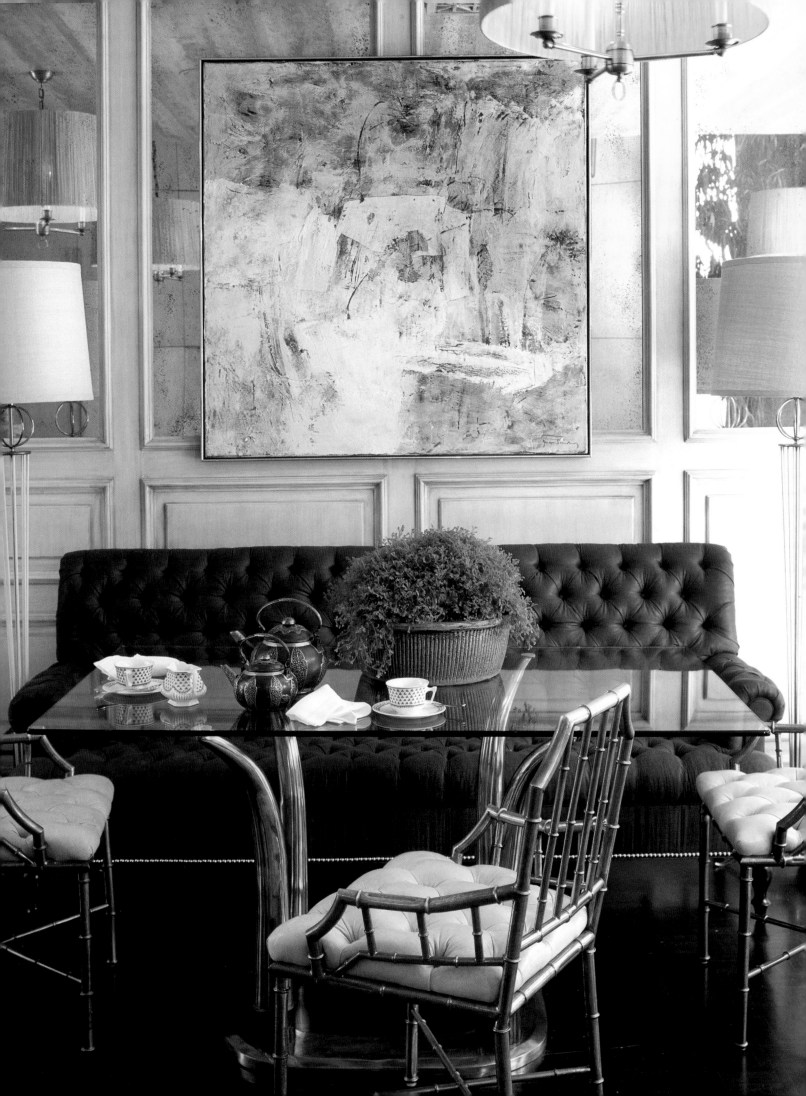

POOL TERRACE

What's gracious indoors can be glorious outside.

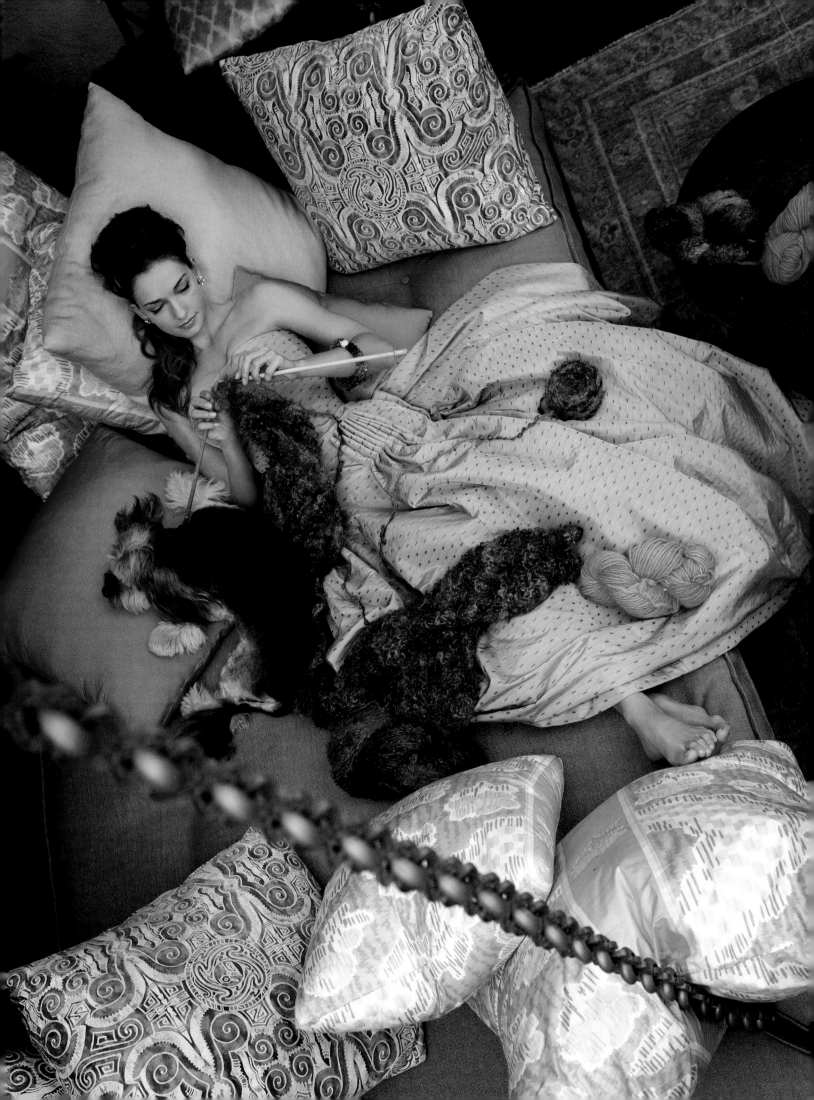

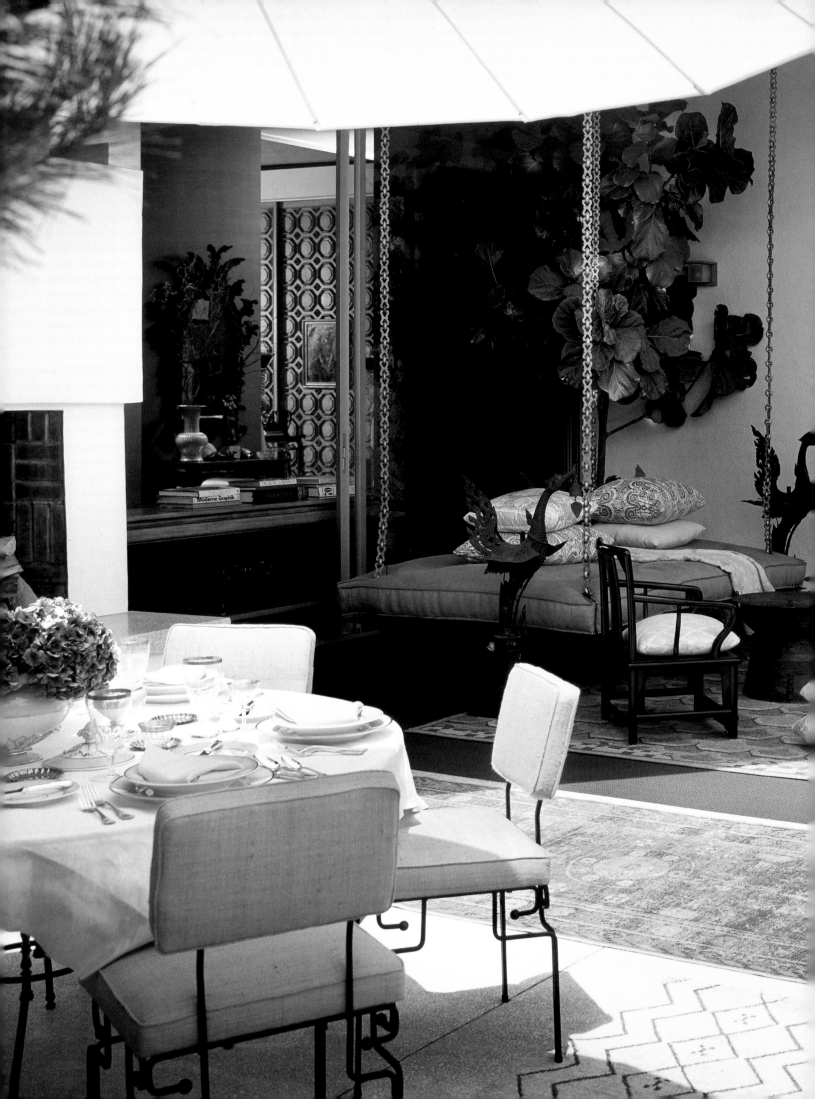

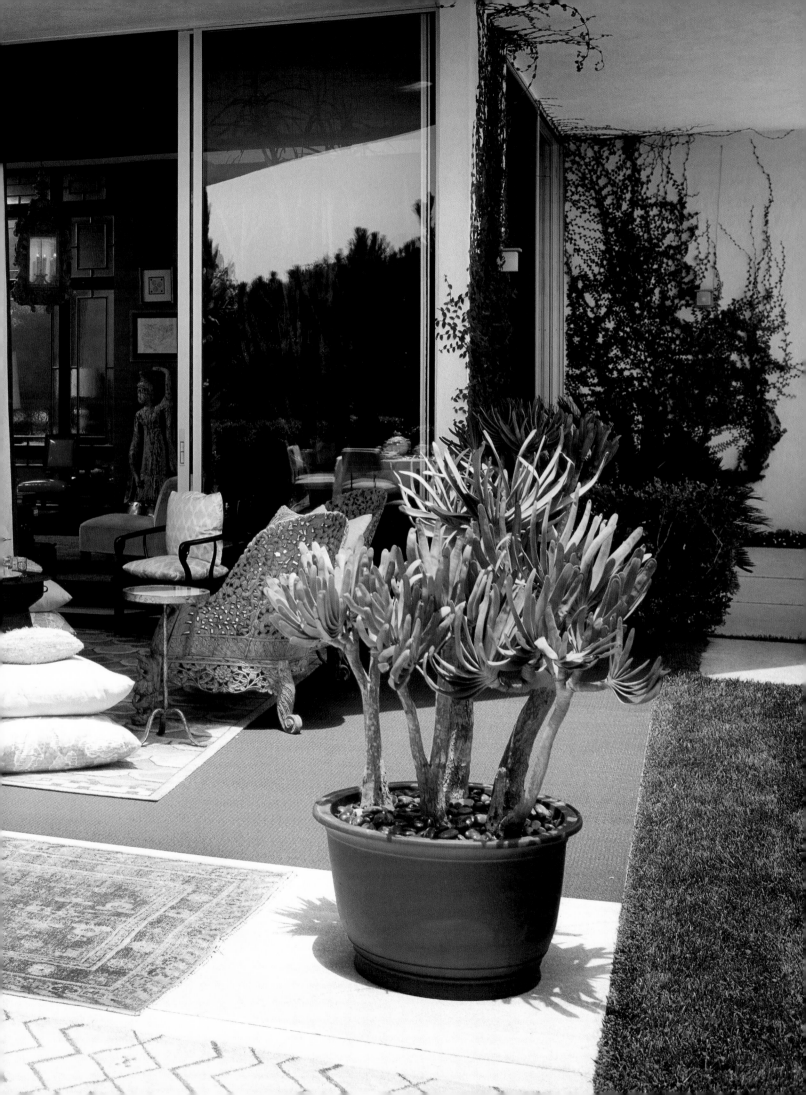

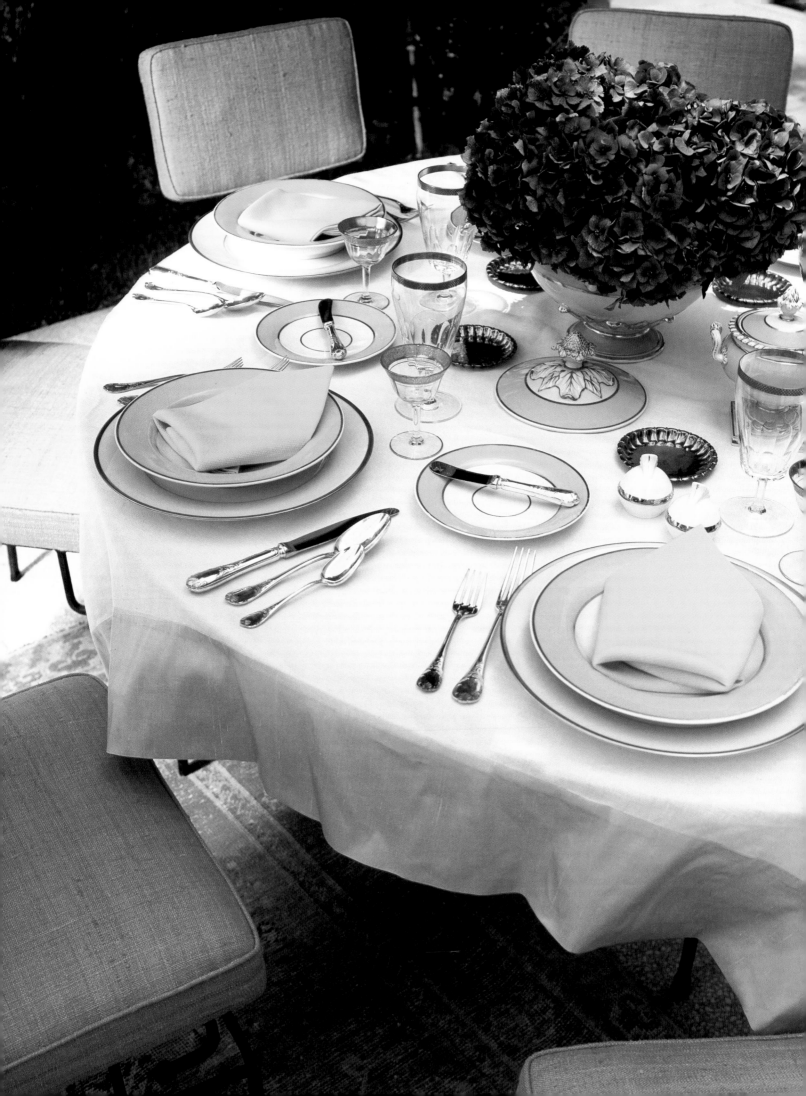

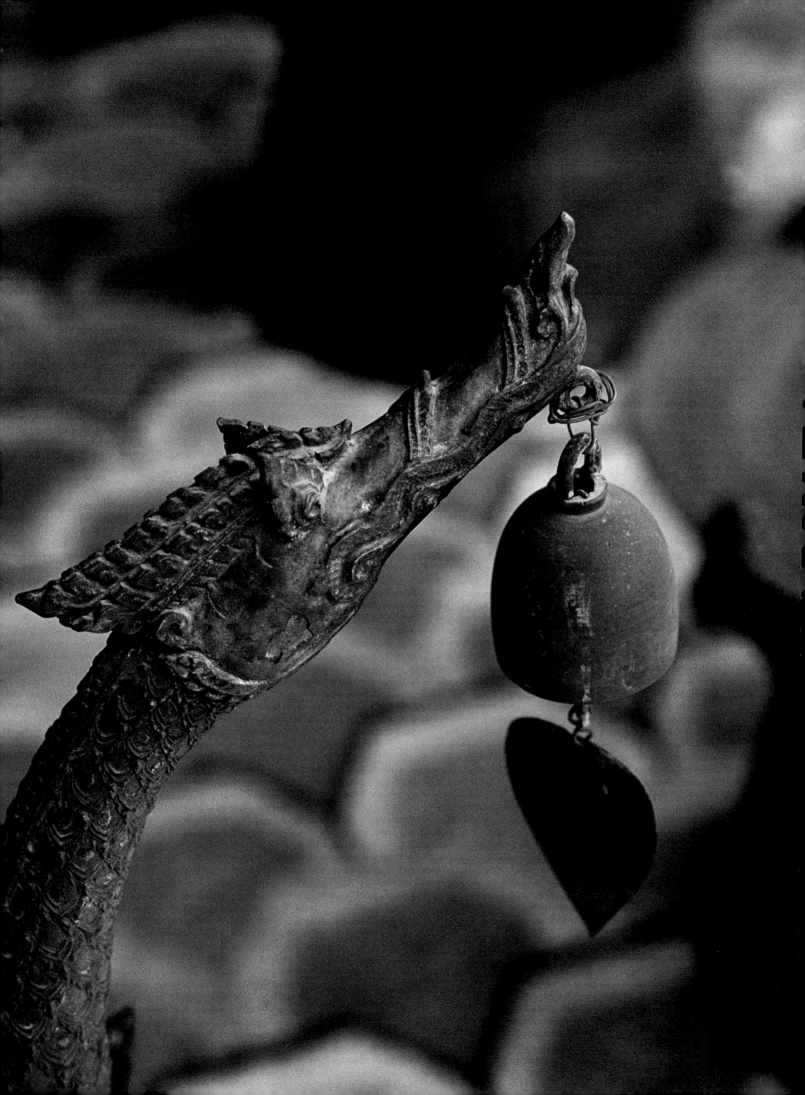

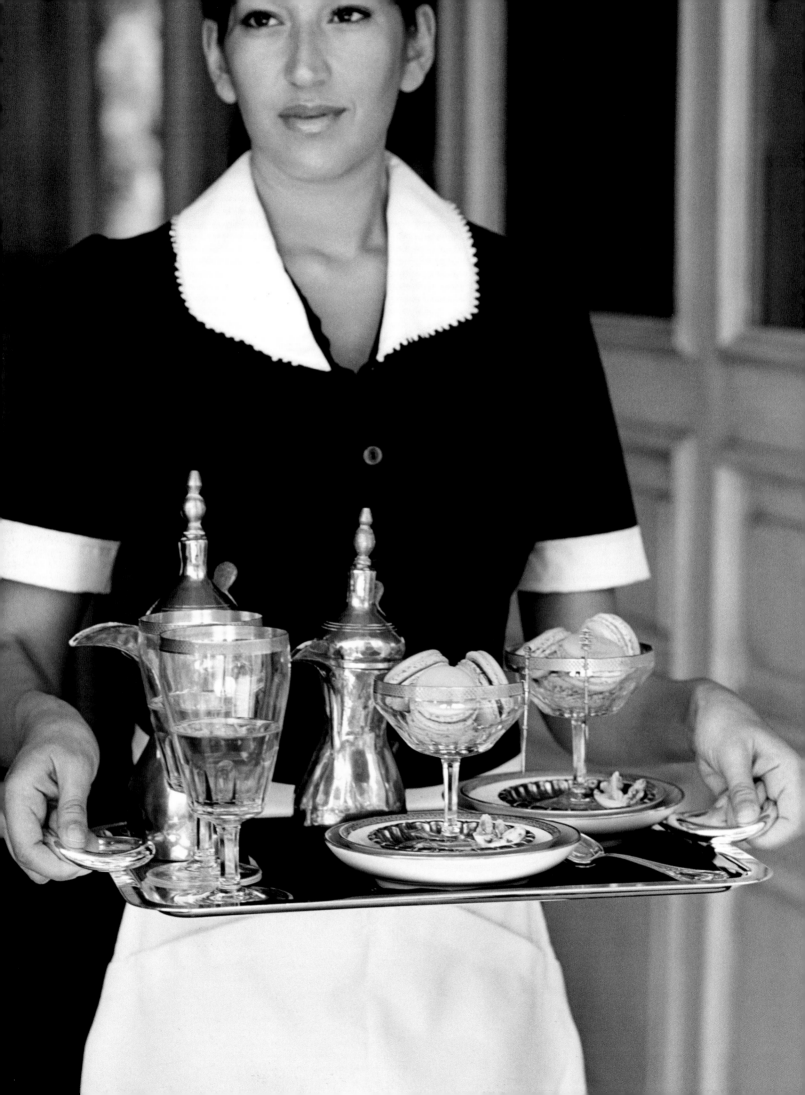

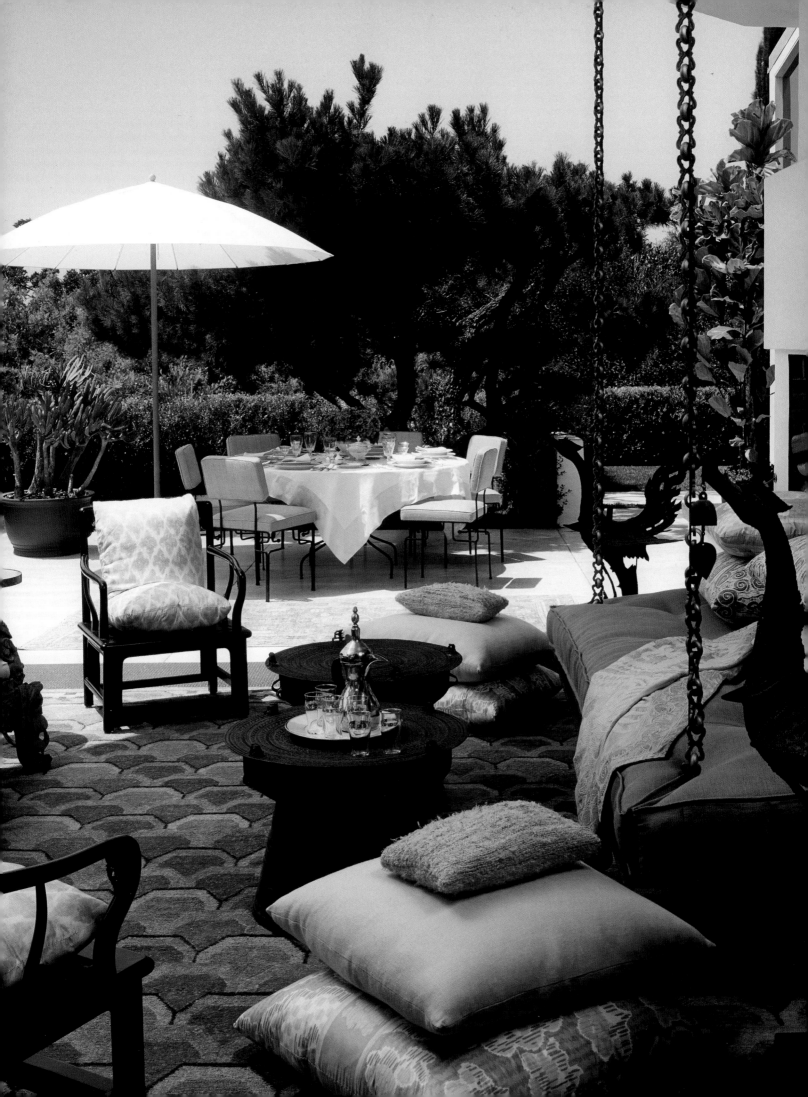

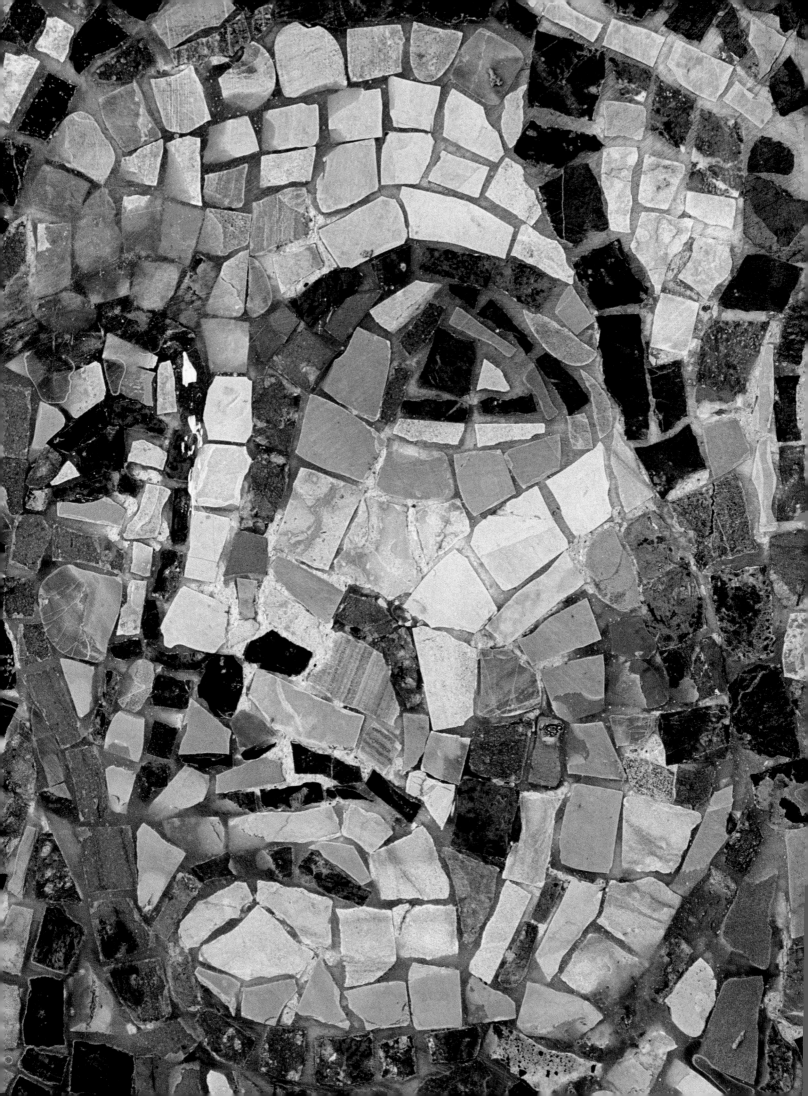

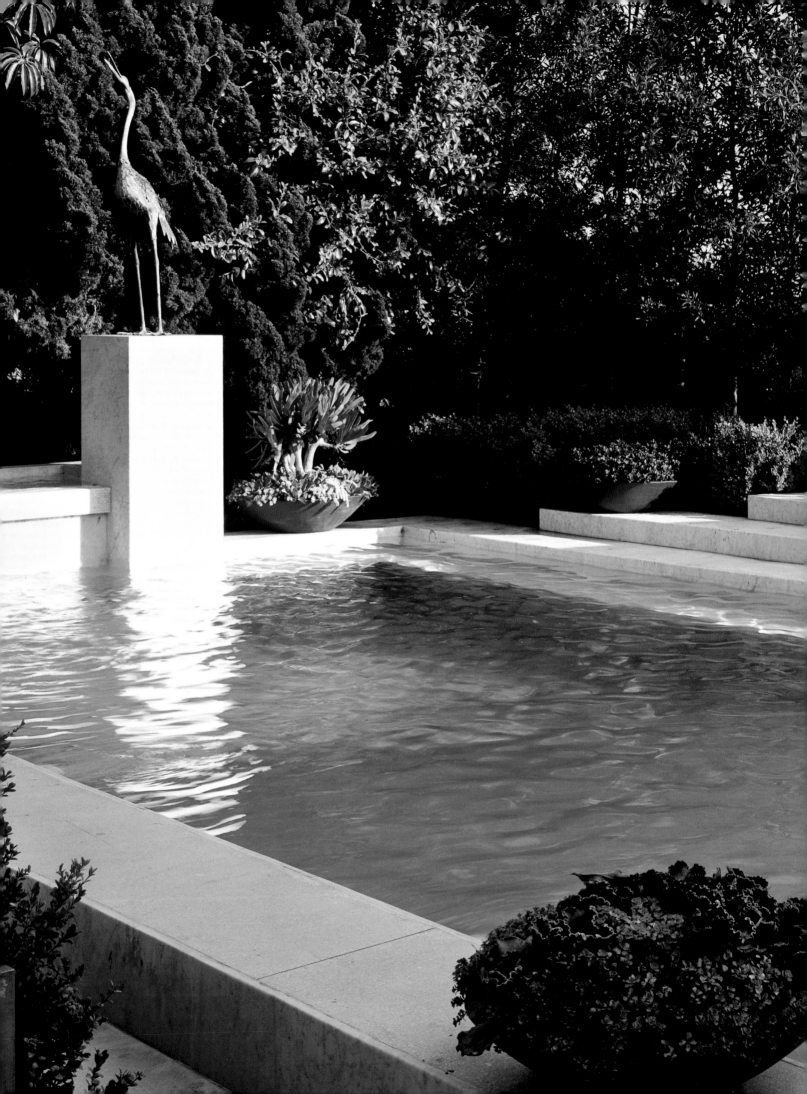

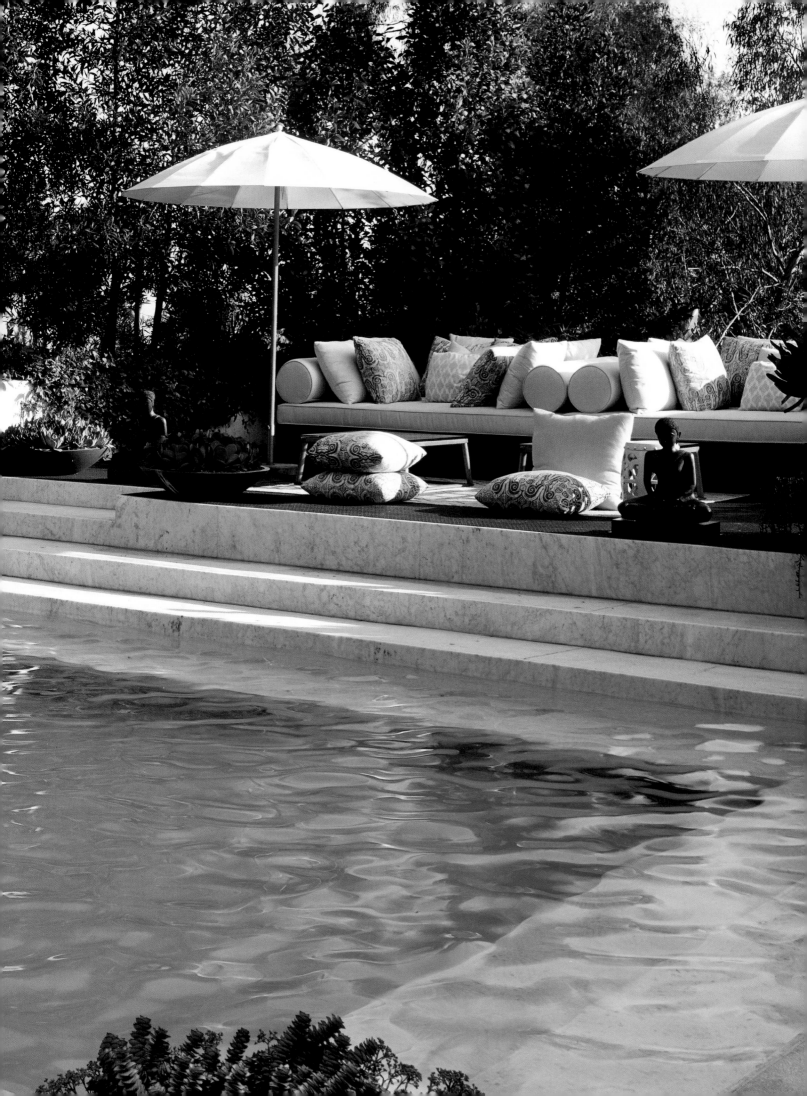

Light, love, and water make everything flourish.

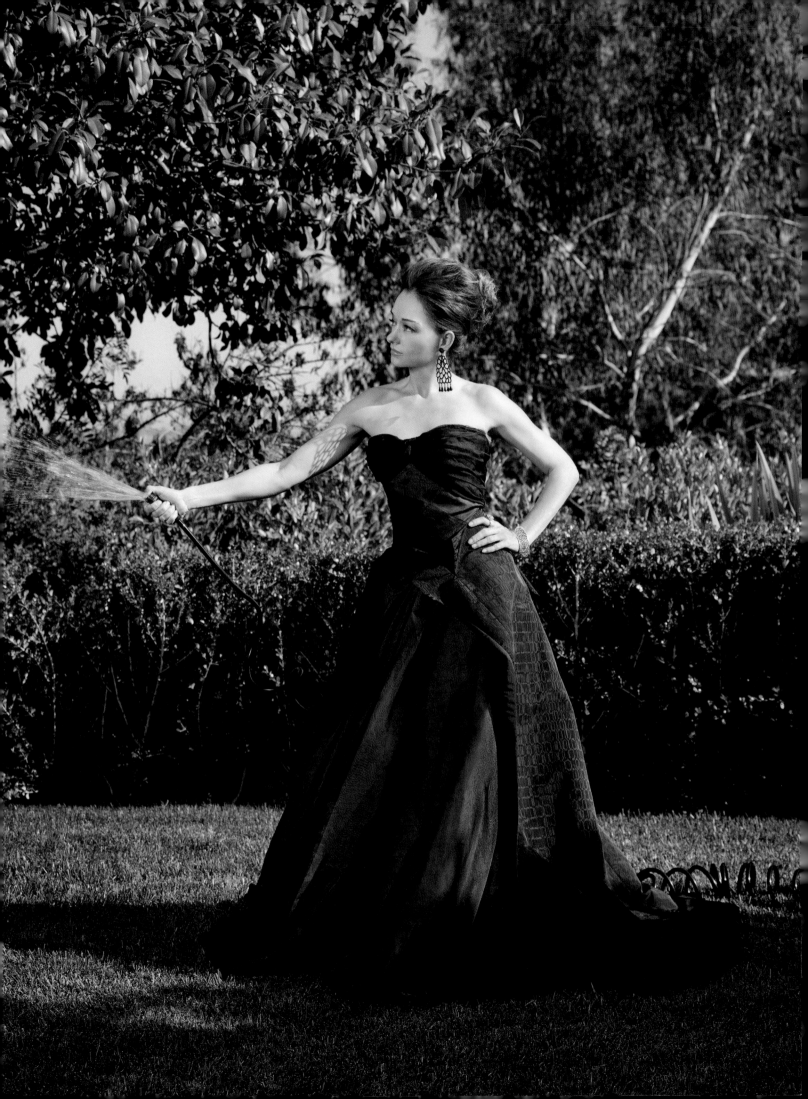

LIST OF PLATES

ACKNOWLEDGMENTS

Brad, Oliver, Elliott, and Brea Korzen; Nancy, Wayne, and Tami Talley; Carolyn and Erwin Korzen;

Judith Regan;

Mark Edward Harris, Grey Crawford;

Steve Crist, Kurt Andrews, Christopher Smith, Jane Bogart;

the late Hal Levitt, Brian Tichenor at Tichenor & Thorpe Architects, David McCauley;

Estee Stanley, Cristina Ehrlich, Keiko Hamaguchi, Jake Klein, George Clinton, Sticks & Stones, Anna Bolek, Hugh Milstein, Piyanari Scott, Ronn Brown and Justin Ruhl at Digital Fusion;

Azzaro, Chopard, Oscar de la Renta, Dolce & Gabbana, Carolina Herrera, Monique Lhuillier, Neil Lane, Ralph Lauren, Roland Mouret, Anthony Nak, Palace Costume, Elisabeth Mason at Paper Bag Princess, Rochas;

Melissa Bacoka, Jennifer Gonzalez, Sharon Gordon, Tyler King, Diane Krauss, Cristalle Linn, Paula Machado, Amanda Malson, Frank Medrano, Sargent Pilsbury, Leah Talanian, Linda Zarifi;

Alexandra Kimbel, Thibaut Biscos Perriand, Lauren Davis, Jennifer Williams, Marie Astrid Gonzalez;

Megan Beierle, Beth Coller, Lissa Hahn, Charchi Stinson;

Anna Duarte, Heidi Foley, Brenda Flores, Raquel Mendez, Felix Ortega;

Hermès, Christie's, J. F. Chen, Ben Soleimani at Mansour, Duane, Carlos de la Puente, Pegaso, Blackman Cruz, Paragone Gallery, Orchids de Oro, Berberian Kitchens & Baths, Creative Services, Doug Dalton Construction, Express Electrical, David Serrano and Robert Wilson at Downtown, Chapman Radcliff, Modernway, All New Glass, Waterworks, Chez Camille, Rubbish, Robert Kuo, Modern One, Michael's Company, Posse, The Residence, Embroidery Palace, Guillermo Maranon at Patterson, Flynn & Martin, F. Schumacher & Co., Decorator's Walk, Raul Diaz at Sunview Finishing, Raul Padilla at Ideal Cabinets, Steve Sellery at Robert Crowder Co., Bernard Gelbort, Don Felix, Jean de Merry, Paul Marra, Dragonette, Jerry Solomon, Barneys New York, Eccola, Fat Chance, Fantasy Lights, Carl's Lampshades, Claude Brunkow of Stone & Tile Masters, Coconut Company, Ian Tyson of Ty-Tec Fabric Interiors, Houlès, Elizabeth Hewitt, West Coast Trimmings, Fairfax Carpets, Peter Berger, Dolce Antiques, Tim O'Connor, Jim Thompson Fabrics, Kneedler Fauchère, Clarence House, Claremont Furnishing Fabrics Co., Randolph & Hein, Old World Weavers, Hinson & Company, Kravet, Donghia, International Silks & Woolens, Keith McCoy, Edelman Leather, Moore & Giles Leather, Pacific Hide & Leather, Scalamandre, Carter Hardware, Details, Crown City, the Skouros family, the Broccoli family, Steven Resnick, and Billy Rose.

Photographs by Mark Edward Harris and Grey Crawford

Apparel and jewelry by Azzaro, Chopard, Oscar de la Renta, Dolce & Gabbana, Carolina Herrera, Monique Lhuillier, Neil Lane, Ralph Lauren, Roland Mouret, Anthony Nak, Palace Costume, Elisabeth Mason at Paper Bag Princess, and Rochas

Fashion styling by Estee Stanley and Cristina Ehrlich

Coiffure and makeup by Keiko Hamaguchi

Tabletop styling by Jake Klein

Tailoring by George Clinton

Floral arrangements by Sticks & Stones

Digital production by Anna Bolek, Hugh Milstein, Piyanari Scott, Ronn Brown, and Justin Ruhl at Digital Fusion

Editor: Steve Crist

Writer: Jane Bogart

Design: Kelly Wearstler, Mark Edward Harris, Steve Crist, and Christopher Smith

Book design consultant: Marie Astrid Gonzalez

DOMICILIUM DECORATUS. Copyright ©2006 by Kelly Wearstler. All rights reserved. Printed in Japan.
No part of this book may be used or reproduced in any manner whatsoever without written permission except in the case of brief quotations embodied in critical articles and reviews. For information, address HarperCollins Publishers Inc., 10 East 53rd Street, New York, NY 10022. HarperCollins books may be purchased for educational, business, or sales promotional use. For information please write:
Special Markets Department, HarperCollins Publishers Inc., 10 East 53rd Street, New York, NY 10022.

FIRST EDITION
Printed on acid-free paper
Library of Congress Cataloging-in-Publication Data has been applied for.
ISBN 13: 978-0-06-114393-9
ISBN 10: 0-06-114393-6
06 07 08 09 10 TP 10 9 8 7 6 5 4 3 2 1